Art Festival Guide

The Artist's Guide to Selling in Art Festivals

Experience is the comb that nature gives us when we are bald.
Belgian Proverb

This book is dedicated to every artist, selling or not,
who, against odds and circumstance, makes art because they must.
Keep making art, lots of good art!
I owe much admiration and gratitude to all the brave artists on the art circuit.
Knowingly or not, you helped me make this book a reality.

Keep smiling, everyone, and I will see you down the road.

Art Festival Guide

The Artist's Guide to Selling in Art Festivals

A book for brave artists
Who embark on the treacherous
And most wonderful adventure
Of selling artful creations in art festivals
And generally directly to the public

by
Printmaking Artist

Maria Arango
1000 Woodcuts

1st Edition – February 2007

Art Festival Guide
The Artist's Guide to Selling in Art Festivals
1st Edition – February 2007

ISBN: 978-1-4303-1976-4
Published by Lulu - www.Lulu.com
Printed On Demand by Lulu.com in USA

All text, illustrations and photos designed and produced by Maria Arango, except quotes credited to their respective authors.
Graciously edited in part by M.J. Cole of Beech Grove Paperworks.
Cover art based on photograph of the ArtFest of Henderson, photographer Doug Hawkins, courtesy Frank Maguire & Associates, www.888artfest.com.

Art Festival Guide:
The Artist's Guide to Selling in Art Festivals

Table of Contents

Art Festival Guide

The Artist's Guide to Selling in Art Festivals

"Each is given a bag of tools,
A shapeless mass and a book of rules.
And each must make, ere life is flown,
A stumbling block or a stepping stone"
–R.L. Sharpe

Introduction

Who I am

I am nobody, really, but this first section will let you get to know me a bit better. I make woodcut prints, which makes me a printmaking artist. Sometimes I bind them in books, which would make me a book artist. Yet some other times I like to sell my original carved blocks and make sculptures out of them, which doesn't make me a sculptor. I like to just call myself an artist, although if I were to choose my specialty I would say that I am a printmaker. Why is that important? I guess you should probably know where I'm coming from since if I were a jeweler or a monumental work sculptor this book might be written differently, but perhaps not so much. I have no pretenses about my art, other than I think it has reached the point where I feel comfortable enough with the art I make and people seem to like it. You can see my work on the web at **http://1000woodcuts.com** and learn all about woodcuts and some about me.

A while ago I found that art festivals are a perfect fit for me. This was an important revelation because I never before had *really fit in* whatever venue I chose. I went to school and found myself standing alone as someone who actually *liked* to learn. I did the corporate thing and found that people will bite at your heels just because they like biting (and not working much). I finally decided to be an artist, a life long love, and

when I started doing art festivals I came to the conclusion that all those management jobs and all that love for traveling and camping and all that self-drive and energy and desire to work myself to the bone had finally met a perfect match. I do art festivals and will continue to do them probably for as long as I hold up, because I have finally found my true fit.

Other than art festivals, I faithfully send my work to competitions and exhibitions and have had good fortune with getting my work exhibited in museums and galleries across the country. I have shown in various galleries in the Southwest. As an artist, I am always learning and growing. I like to experiment. I'm not famous, I'm not rich, and I don't really think very often about those things. I firmly believe that if you put your entire soul into your work good things will happen. If they don't at least you can say you put your entire soul into your work. I tend to do things on my own rather than farm them out. I let my mom help me in the studio from time to time and think about hiring an assistant but I really enjoy working by myself. I enjoy doing menial things and I'm so short I don't think there are any tasks that are beneath me; they would have to be awfully small tasks. I have a lot of energy (everybody tells me so) and recommend that if you want to do art festivals, you get some energy too. I want my epitaph to read: "Dang! She worked *hard*." Work is everything to me, I love to get things done but there is also something very special about the act—the process—of working. When I'm not working I'm hiking or kayaking down the river or doing stuff around the house or taking a long drive. There, now you know me.

What I am that is important to this book is *very observant*. I am a scientist at heart, having a couple of university degrees to show for it, and enjoy analyzing situations and observing things and people. In Psychology we would say that I'm trying to perceive the world in a way that will allow me to predict future events. Sure, as long as things are predictable. In the art festival world, things are not always predictable, but gaining control over what I *can* predict has made me more successful than not, more often than not. The fact that people that have been doing this for much longer than I have don't realize some basic things that I realize, surprises me. I am also a realist and have a good grasp of how things really are. I tend to be very practical and inefficiency bothers me, especially my own. I hate wasting time on stuff that could be done more efficiently without compromising quality or results. So I wanted to jot down some thoughts about fine tuning the art festival life mostly for my own benefit and peace of mind—and suddenly, there was a book.

When I first started this festival life I had no guidelines, nobody to ask, no way of knowing what would work and not. I asked and people told me things, not because they knew, but because they wanted to say something. That was not good! I learn by reading a lot, and there was hardly anything to read on how to do this art festival thing. That

bothered me. I also learn by doing, jumping in head first while others test the waters for a while. Other than a few bumps in the head, this particular method of learning usually produces an accelerated learning curve. I observe and learn, but I already said that, so let's move on to the task at hand, and that is to prevent you from getting bumps on the head, even if you do decide to dive in head first.

About the book

I had been mulling over the idea of writing a guide for artists who want to embark on the awesome adventure of entering the art festival circuit. Mulling didn't get it done, so I planned to start during those rare lulls in this business (Lesson 1: Art Festivals are addicting), perhaps during the summer months. Then it occurred to me that the best time to get this done was during the time when I am most engaged in these wonderful events, right in the thick of things, so to speak.

So I jotted down some notes on a scrap of paper between customers, then I proceeded to wash the scrap of paper in the laundry along with a rare two-dollar bill also residing in my jeans pocket, probably since 1978. Undaunted by such minute obstacles (Lesson 2: Every obstacle is minute and surmountable) I rewrote the notes again between festivals; this time I was able to hold on to that little piece of paper and soon had an outline. Loosely organized and flexible, the outline itself became an analogy for how these festivals go most of the time and also the best basic advice I can possibly give someone, that is: be loosely organized and flexible.

Consequently, this book is a loosely organized and flexible guideline of how to *successfully* (key word) launch a career as an art festival artist. Although everyone will do different art, the basics covered in the coming chapters should be a good solid blueprint on how to go about taking the first step. Once you learn the basics and get a couple of festivals under your belt, you will be able to come up with your own strategies and follow your own lead. I should also say that I don't do everything that I talk about, but I have seen other successful artists who do. I still learn something new every festival, and hopefully I also teach someone new a few tricks of the trade.

You will note from time to time that there is an artist-bias to the book (that's as opposed to crafter, much more on that later). Right you are. I am an artist and I consider everyone I have ever met in art festival *artists*. I think many so-called craftspeople of all kinds are artists (although some are not) and so I will call everyone "artist," just to be all inclusive and efficient. We will get to the matter of diversity of art shows and diversity of art and craft, but for now know that when I say artists and art I also mean craftspeople and craft. My own woodcut printmaking is a hybrid of the two as I design, carve, and print from blocks of wood, and I consider the artist/crafter division a bit silly. My own experience is neither with very high end nor very low end products but somewhere in the middle. I have talked to hundreds of artists and craftspeople and the guidelines in this book can loosely apply to all, as they were learned by observing and listening to all.

This book is *not* a step-by-step exact procedural methodology. It is merely a guide, a helping hand that will guide you through an art festival, before, during and after. There are a thousands variations of any one of the guidelines I offer and I will try to point those out as I go along. Take some of them to heart, discard what doesn't suit you and, most of all, learn by doing on your own— and by observing. I am certainly not claiming this is the *only*, let alone the *right* way to do things. As I have learned through the years, there are many ways to approach the business of selling art in art festivals. And for goodness sakes, take it all in good humor, because you will need plenty of that to get through your first art festival and every festival after that.

Before embarking on the great art festival adventure, do visit some. This is a must do, not a loose guideline. Get out there and look at actual artists, show up early and watch the artists set up if you can, talk to some of them without asking them if they make a lot of money. If you sculpt, look at a sculptor's display and check out their prices and quality of work. If you are a printmaker or a jeweler or a paper artist or a metal artist or a potter, find one and look at their set-up and ask a few polite questions *without* blocking their display from real customers and preventing a sale. Don't just walk around like a customer (well, do but just a little), but keep your artist eye on the overall appearance of booths, check out what you like and what you don't. Make a mental note of good ideas to try and bad ones to avoid. Take it all in because it gets harder to observe once you are knee-deep in tent poles and cable ties trying to set up your own booth for the first time.

I don't know about you, but lengthy introductions tend to make me skip ahead, so without further fanfare, I will start with a diary of sorts I wrote last fall during an adventure in the Bay Area in California. Then we will proceed with all the gory details. I'm hoping to bait you into reading on, at the same time giving a prospective artist a glimpse into the world of art festivals.

How to Use This Book

Never cut what you can untie
— Joseph Joubert

I personally would start by reading the whole thing cover to cover, after all I tried like heck to make it entertaining and useful. This approach will answer 90% of the questions that I have been asked by those artists that wander into my booth curiously inquiring about the art festival life. After that, how useful the book can be really depends on who you are. I think everyone just starting out might benefit from reading the first two chapters to get the "feel" of the business. These chapters cover the good and the bad of art festivals, sort of an up close look at art festival artists and the traveling life.

If you have never done or even visited an art festival, the best next step might be to then focus on the chapters that are a guide to "how to get started", Chapters 3, 4 & 5. These will be more in depth coverage of all the things you might think about and others that you will absolutely need in order to get going. Once you have a festival or two under your belt (poor thing), then refining marketing and sales deserves a really good look because your back is going to demand by now that every festival better be worth your while. Chapters 6 and 7 will serve to fine tune those skills.

After a few more shows, the rest of the book, from Chapter 8 to the end, will come in handy to streamline, set goals and generally refine your approach to the whole business, as well as figure out plans for the future and how to tell your family you are now a full fledged gipsy. Wait, I think I left that last part out; I will let that be entirely up to you.

Finally, keep the Appendices handy for definitions and humor and a bunch of useful stuff like possible configurations for displaying your wares, checklists so that you only forget a few things rather than a whole bunch of things, and the all important list of

sources and resources for spending all your recently earned money on more art festival stuff.

Disclaimer

I have faithfully tried to guide the new artist onto the world of art festivals. This book is not a step-by-step guide, a self-proclaimed "bible", nor is it certainly the last word on how to approach this nutsy business.

The book contains my experience and that of other artists, close observations of the business, and principles and suggestions that have guided me and many others through the treacherous waters ahead. This is not to say that I have weathered every storm or sailed every sea, or that I have ultimate and complete knowledge of all aspects of the business.

Simply, I wrote the book as a guide because a lot of artists have asked me a lot of questions, which leads me to believe that something like this is needed and will hopefully be useful to many artists.

I will say this later but repeat it here: I am not an accountant, I am not a business manager, I am not a tax attorney. I am an artist, with good years of management experience and about twelve years in the business of being an artist as a sole means of support. I stand by my good eyes and ears, a fair dose of common sense and will stand proud behind every word in the book.

As in hiking, I highly recommend experience as the best guide, although hiking is safer and much more fun when you have a sketchy map, a good compass, and the guiding words of someone who has been on the trail before. As a good guide should, I hope to either enlighten you a little on the virtues and perils of this particular trail or to scare the bejabbers out of you; either way I will have done my job.

Diary

Anatomy of an Art Festival

"Make voyages. Attempt them. There is nothing else."
—Tennessee Williams

The primary purpose of this jumbled diary is simply to give an overview of what an artist goes through, hour by delightful hour, during an art festival. Hopefully some misconceptions will be dispelled and perhaps I can talk other artists into, or out of, this wonderful life.

Pre-Day 1: Preparation and anxiety

You would think that the ball starts rolling on Day One, but, as many things learned in these art adventures, you are wrong. One thing that I learned quickly is that creativity and flexibility come in handy. I'm not talking about artistic creativity, although you must have that also, nor the ability to touch your toes (although this latter is also necessary!). No, creativity in this context refers to the ability to "think on your feet" and, absorbing a set of sudden circumstances at the blink of an eye, decide on a course of action. Flexibility, again in this context, is the ability of adapting to whatever these three to five days might throw at you, which could mean getting up at 2:30 a.m., sleeping in the truck, going entire days without hot food, reading a map while pulling a trailer through the one-way street maze of downtown San Francisco...you get the idea.

But long before all that, comes pre-day-one, so let me back track to that.

I am now assuming that I have a good load of art in "show-room ready" condition; such preparation comes on the days before pre-day-one (we could call this pre-pre-day-one, but that just gets too confusing). Point is, I have a bunch of work to sell and such work is in Sunday wear. Pre-day-one entails really getting everything ready. I start with such minutia as the SUV-trailer combo that is the work-horse of the trip,

changing oil, checking tire pressure and so on. In fact, as I recall, on this day I made a list with some odd 23 items on it and blindly followed its course until all the items were crossed out.

Other than the work horses (vehicles), the poor trailer has to be loaded with freshly framed prints, outdoor gear was dumped in favor of the indoor gear as this was an indoor festival. Food, clothing, maps, cameras are among other things that had to be gathered, as well as finishing on the weekly tasks of the home that won't get done while I'm away (haven't quite worked out the "two places at one time" thing).

Doesn't take long to write, but start adding things up and soon it is around 9:00 p.m., my head is spinning hoping that I have not forgotten something essential and wondering about things like weather, road conditions, enough socks... By this time I'm fairly tired, mostly from the loading task, and anxious to get on the road. A glass of wine and an attempt to get a full night's sleep in preparation for the 11-hour, 550-mile drive to San Francisco.

Day 1: Getting there

Hopefully getting there is uneventful. Pulling a trailer is no big deal once I got used to the task of driving a bit slower (no swerving in and out of traffic either), although working a horse to capacity is never completely stress-free. I only broke down once so far (knock-knock) and didn't really "break" down so much as having to deal with an electronic vehicle going completely dead while driving 60 miles per hour. In case you haven't experienced this, power breaks and power steering don't work in such circumstances, so I was forced to coast to a stop muscling the steering wheel to guide the vehicle gently on the side of the road. Once my heart stopped thumping out of my chest due to the perplexing act of pushing on the breaks and receiving no response, I had the presence of mind (read: insane recklessness) to try the ignition again and get back on the road. As we all know, God protects drunks, fools and traveling artists, so I made it to my destination that time.

But on this fine day, absolutely nothing happened. Road-day is like a day off if you fancy driving as I do. A big chunk of America goes by rather quickly; much as I travel the same roads new things appear every time. Always on the lookout for coyotes and hawks, both seem to make a living cleaning up the roads. Always on the lookout for strange lights, cloud formations, fields of gold and emerald, unusual trees in the middle of nowhere...always something to see, even on the most boring trips. And while the trip was uneventful it did take away 11 hours of my life, just like that. I stopped just short of S.F. leaving the stress of parking and hustle bustle of the city for the next day, as it turned out, a smart move. A walk to stretch my cramped body and another good night of rest rounded up the first leg.

Day 2: Moving-in day

Today is moving day. This is the day when I'm supposed to find an unknown place in unknown streets (most of them one-way streets, someone forgot to warn me) of an unknown town...by 7:30 a.m. That is why *they* make maps, conveniently with an N and an up-arrow indicating where North points. Yeah right.

I expected a crowd of artists already elbowing each other's motor homes for unloading space. Usually if I get up at 6 a.m., I find that the motor-home crowd got up at 5:30, but this time I found only that most of the streets run only one way, that the buses are wider than their allotted bus-lane, and that my keen sense of direction can get turned around after...turning around a few times. But I got there without taking out any bike riders with the tail end of the trailer, so I consider myself (and them) lucky enough.

Double lucky, as I also found a parking space about 20 feet from my booth, which never ever has happened before, ever. One small drawback: the booth is indoors inside a convention center, three long and painful steps up from street level. At the tender age of 40ish, the body seems to protest quite a bit more than it used to, especially when completely emptying a very full 8' x 6' x 5' trailer only as a warm-up for what comes next. What comes next, after the unloading, is building a small gallery of sorts.

As if by magic, walls of a 10' x 10' booth rise up from the floor, lights get hanged, display racks stand proud in a configuration that seemingly always deviates from the worthless piece of paper where I designed it last night, and approximately 60-120 pieces of my work go up on the walls. This "magic" that took a sentence to write, takes about all of the morning, several fingernails (why did I forget to trim them again?), a few chunks of skin and much more glycogen than a person my size can possibly store in one single set of muscles. The "magic" of building a booth also leaves bruises in all kinds of strange places and a delicious soreness that lasts well into the next couple of days, disappearing only a few hours before tear-down. In any case, after such heavy "magic" the only possible course of action is to replenish the food stores and blood sugar levels, which means that it is time to eat—eat much food and very quickly.

But it is magic that when I showed up roughly 5 hours ago there was only a 10 x 10 empty floor space with my number on it and a chalk line where my corners are destined to be. Now stands a proud little gallery complete with lights, carpeting, and even a "back-office" where I will sit and carve. Works have been dusted and straightened and carefully placed to hopefully attract the attention of potential buyers in the seemingly distant Day 3 of the adventure.

Before then, though, comes the adventure of seeking food, shelter and the all-important hot shower to get rid of the kinks. Exhausted and dirty, I set off to find the hotel in a labyrinth of one-way streets and an annoying forest of NO-PARKING-HERE-EVER signs. I'm still pulling a trailer, now empty of weight, but still faithfully attached to

the back of the truck, preventing me from simply zipping in and out of tiny streets. Somehow the adventure comes to a stop for the moment and I find myself full of food, smelling like Super-8 soap, clean and resting in a horizontal position. The entire day seems to have taken about 92 hours, but it is really only around 6 p.m. I find myself completely unable to move anything except the finger that works the remote and the hand that brings ice water to my lips...okay okay, a beer to my lips.

I sit reclined on a mountain of pillows watching some poor lion cub calling his mommy in the Discovery channel, soon to drift off to sleep (let's organize that sentence: the cub is in Africa, the Discovery channel on television, me in the motel drifting off to sleep). A speedy recovery is paramount, because tomorrow I have to face the public and that takes much energy, a different kind of energy, grant you, but still can't just sit there with bags under my eyes and barely coughing up a smile. Selling takes much positive vibes, and they all come from me.

Day 3: Showtime!

Customarily things start out so slowly that I start thinking I will never make a single sale. Well, at least I saw San Francisco again...and at least I saw what this show was like...and at least people seem to like my work (or at least they say they do)...

...And just when I think nothing will ever happen folks start warming up to the idea that this is an art festival and that I built a gallery just for them and that everything is indeed for sale. If I am patient and keep up the good energy aura about me ("they" sense those auras!), eventually "they" trickle into my booth. Then a funny thing happens: art speaks to people and they want to get it and own a piece of my soul. Because everything you do must come from the soul, and it is then that they will want a piece. "They" then pull out that substance we call money and an exchange takes place. "They" have worked all week to earn that substance and you have poured yourself into your art. The exchange is fair and satisfying to both parties, and it feels darned good that someone will part with a bit of their life for a bit of mine.

More on the practical sense, I get many compliments and some insults, and I often sell enough woodcut prints to make the show well worth-while, although this was not always the case. What actually happens all day is that I sit all day inside my booth (outside the booth if space permits) and demonstrate "the art," talk about my influences, where I learned to do this and how I came about to be here. I also answer many questions of all kinds (most of the time I can keep a straight face). Some of the more and least common go something like this:

-Do you ever cut yourself?
- Do you have any football players?
- Can you make me something that I have in mind?
- Isn't that nice that you can make some money from your little hobby?
- Your work reminds me of ---------- (your favorite unknown artist's name here)

- Oh look I used to do this in the fourth grade!
- Oh look I used to do this in the fifth grade!
- Oh look I used to do this in the sixth--you get the idea...
- Can you change the title of this piece for me?
- Will you deliver? (sure, with fries on the side)
- Can my kids stay here while I go buy some jewelry from that nice lady?
- Do you do ---------- (toads, clowns, Kinkade copies, tigers, owls, Michael Jordan...)
And my all time favorite:
- Look honey (talking to their child), this is what you do if you don't want to work for a living
....And so on!

Day 4: Neutral day

First day came and went without a hitch...and usually without many sales. But I never judge a 3-day show by the first day, or the second day, or at all. In fact, this business is much like legalized gambling, and I think that is one of the reasons so many artists get addicted. One year, any given show, you make $100, next year $4500; same show, same booth, same art, same weather... One weekend I sit and twiddle my thumbs, the next weekend, same city, I can't get any carving done and I actually have people waiting to pay standing in line. Someone told me once the good shows just spoil you and I tend to agree. I expect nothing and most of the time I leave pleasantly surprised.

Neutral Day is the only normal day. There is no set-up, no break-down, no early morning, no late night, no bruises, no backaches. Today feels like going to work at a gallery--MY gallery! Never mind that I was kept up last night by the lively disco music from some restaurant that doesn't know when to quit and is in dire need of new amplifiers. Never mind that in other cities I may have slept in the truck, campground or not. None of that matters because a rush of adrenaline seems to be permanently flowing during these adventures, which keeps me fresh and rested and ready for action.

Today is rest day, but I begin to think the strategy for tomorrow, because tear-down is messy. The logistics of where to park and when to sneak out and get the truck closer and how the dickens will I get everything back stuffed inside my poor tiny trailer all have to be well thought out in advanced. Then the time comes and all plans get tossed out the window. But those thoughts are some distance off for now, because I still must sit and smile pretty all day. I need to explain over and over how I make these woodcuts and convince them very subtly, that they really do want the one that caught their eye. I am really no saleswoman and admire those artists that feel completely at ease in the role, but nevertheless today I have to wear that sales-hat simply due to the fact that there is nobody else to do this.

And speaking of sales persons, that is only one of the hats. Any given show on any given weekend I transform myself from moving man to framer, truck driver and reservations clerk, stage builder, camper and auto-mechanic, sales clerk, handy-man, accountant, delivery person and...well, woodcut printmaker. Whining about having to do any of the above is pointless, as there is often nobody around to help. The expression "suck up my guts and go" comes to mind when people ask me what I do for a living. Add to that the utter unpredictability of the business and I begin to wonder why I do what I do!

Well, for one, I don't have to wear panty-hose and suits anymore, but I'm pretty sure that the love for the craft is what keeps me passionate and energized. There is no better way to make a living, I'm convinced of that.

Day 5: Moving out

Today can be described as hectic, long, stressful, busy, long —did I already mention hectic? For one thing, the last day of the festival is usually the busiest. Folks come back (we call them "be-backs") on the last day hoping for a good deal, maybe just couldn't sleep at night thinking of their empty wall space and that lovely woodcut print. Dealing with people who want deals is doubly stressful and a bit insulting; on the other hand, we all want to go home lighter than how we came—much lighter if we can. Every piece sold is another piece that doesn't have to be re-packed. On the other other hand, I don't want to give away the house or lose money on framed art or even give things away at "cost."

Figuring out "cost" is a bit flaky for an artist. How do you value creativity? What price to pay for an artist's mind? What is intellectual property worth? The Artist's Dilemma = Sure, I will mat and frame and even print for minimum wage and sit at my booth for free; but you want to buy my ideas for...how much?

Anyhow, philosophy aside, today's plan goes something like this:

A. Pack clothes and food and things and check out of the motel.
B. Leave all my valuable possessions wrapped in the car in some parking spot in the middle of some city.
C. Sit at the booth and sell much stuff.
D. At the sound of the bell, pack every piece of art.
E. Dismantle tiny gallery.
F. Shove everything gently and neatly back into tiny trailer.
G. Head off into the sunset.

That's the plan anyway, did I mention that artists packing up and leaving a show somewhat resemble a wildebeest stampede running from a pride of wild hungry lions and zigzagging frantically among galloping rhinos?

The good news is that tear-down doesn't take as long as set-up, about one to two hours if I am by myself. By this time it is way past sunset, usually dark, adrenaline is flowing through my veins and some times coming out of my ears from the physical tasks

of dismantling and packing but the body and mind are exhausted after yet another 16-hour day. Within about 15-20 minutes of driving, everything starts to shut down and the eyelids get heaaaavy. New bruises start to hurt, my back hasn't straightened out since setup day, I realized I never washed my hands and haven't had a thing to eat since noon, and in that sorry state the best thing to do is find a place to sleep and leave the drive back home for the morning.

Morning comes pretty early, the adrenaline is still trickling and I want to get HOME, like NOW. Fortunately I like driving and also fortunately, so far (knock on wood) all my outings have been successful. I hardly ever remember the trips back home, because I can't think and drive at the same time after the exhausting weekend. Auto-pilot takes over, the open lands of the desert renew my spirit and make me smile out loud-- and soon I have in my sights the lights of Las Vegas.

Post-Day 5: Re-covery

What, did I think I was done? Well, actually, once the wheels hit the driveway of my beloved home I consider myself done. The remaining tasks are a matter of resting, unpacking, updating the database with new customers and sales and such accounting things, re-inventorying, re-matting, re-framing and re-covering! All in all, this day is about recharging the batteries and not making any life decisions while exhausted. Some quick advice: don't plan anything for today. Give yourself the day to recap and recover physically and mentally. Rearrange your bookshelves if you must do something or watch the football game that your spouse taped yesterday. Smell the roses, even briefly. Pet the dogs, they missed you.

It's a hard fun life, in fact, this may be the "hardest happiest" thing I have ever done in my life. Usually in two or three days I'm ready to go again. I use the new flow of energy to apply for other shows, always trying new shows and repeating the good ones.

Sound like fun? Hopefully my experience will be useful to some, or just humorous. If the adventure peeked your interest, read on and find out all the details. In the course of the book, I am hoping to cover nearly all that is involved in being an art festival artist.

Chapter 1

The Nature of the Business

"Stay humble, stay hungry"
—Hakeem Olajuwon

Independently...Well, independent, anyway!

I was nearly set up for an indoor festival when the Fire Marshall came around and spoke to me about some extension cord I had tucked neatly under my carpet, insisting that the cord should be flat instead of round. His argument was that a customer with a high heel could pierce the insulation creating a short circuit which in turn would create a fire which would burn the entire convention center down...potentially. My neighbor also got the inspection lecture. Her offense was hanging frilly things placed near her lamp cords. After arguing with the gentleman for a few minutes, he left and she turned to me and said:

"What, does he think I'm going to let a million-dollar a year business burn down?"

I had to suppress a laugh (a very loud laugh), but the point is, there is money to be made in art festivals if you have talent and perseverance—how much money is entirely up to you. There is no standard because some painters are selling ten thousand dollar paintings and some craftspeople are selling six dollar ceiling-fan pulls. It follows that it is very likely that those two incomes from any and all festivals will differ greatly. Some folk do 45 shows a year and make a fine living, some do 20 and make a fine living; yet others do 10 and make a fine living. All depends on how big an investment in each show, both in terms of show type, time, experience, preparation...and, of course, the nature of the product. But we will talk product and numbers soon enough.

Incidentally, if the word "product" offends any artists out there, close this book and start rubbing elbows with gallery owners because art festivals are not for you. This book is about selling art, and art, by necessity, becomes your product. I don't mean you

shouldn't continue to put your soul into your art, but know that you are trying to reach an audience as an ultimate goal. Academic artists have their audience, as do the artists that become famous in the real art world. In art festivals, the audience for art is one of extreme heterogeneity. This eclectic audience has a much wider variety of art knowledge and income than the gallery crowd or the museum crowd, for one thing, but the important thing is that your audience, your very own particular audience, will eventually find you. Take care of them.

There are two people involved in this business of art festivals, the artist and the salesperson; since there is only one of you, you have to become both at times. Let the artist create art and let the salesperson sell the art and both of you will be immensely happy. This book is written for the salesperson in you, let your artist-side get back in the studio and make something beautiful.

Moving right along, you soon discover: You are your own boss! What a curse that can be... I found out I'm a real dictator, I don't leave myself alone for a minute and when I do have a rare respite in this hectic life, I make myself write a book. Being your own boss means many things, most of them good. For one, you can choose which 100 hours per week you want to work, no more silly schedules for sure. Okay, there are some late nights, even some completely sleepless nights...and long drives. There are some early mornings too, I recently received the "convenient" set up time of 3:00 a.m. But really other than that and the festival times you can choose your own schedule.

You can choose your income too, just like doing piecework. No more getting paid for doing nothing; if you work you get paid, if you stay home, your art collects dust. You can do 2 festivals a year or 50 festivals a year (how these folk do that many is beyond my comprehension). And none of that silly weekly paycheck either, you can be sure to make anywhere from $0 to an unknown amount that could be in the thousands in a single weekend. Ahhh, the thrill of the unknown...

Point is, you are in charge. You can work on your art or work in the yard. I like to do festivals during prime season and then take a couple of months off (except those summer festivals are soooo tempting sometimes). I need the *thinking* time, the time when my right brain is in charge and creates new ideas while my left brain decides in the background whether I should book the second weekend of November, between Sacramento and San Francisco. I absolutely need time to dedicate to my home and my neglected husband and animals. Absolutely in charge! Sort of. But the good news is that you could, if you weren't totally addicted to this life, stop and smell the roses—really!

Attitude: Haz bien y no mires a quien

Loosely translated that expression means: "Do well and don't mind what anyone else is doing." This is a fine credo to remember for all artists and craftspeople in the business. If there is a single key to success to this business, it is Attitude with a capital

"A." Fellow artists (the most important people you will meet) will appreciate a good attitude and promoters will invite you back to their shows and offer to feature you in next year's program. Most importantly, a bad attitude and complaining nature will get you banned from some shows and you will never really know why you aren't getting those applications any longer.

By "doing well" I mean many things. Be dedicated to your art, for one. I will talk more about your body of work and what it takes to "look" like a successful artist. Be a good sport at the festivals, park where you are supposed to, show up on time, pin up your sign if the promoter wants you to, and so on. Also be a good sport to your fellow artists (the most important people you will meet, I say again). Help them if you can when they need help because some day the wind will blow down *your* print racks and when you leave to get your car at tear-down, a watchful neighbor's eye is worth gold.

And by "don't mind anyone else" I mean two things. First, put your ego in your pocket for the time being, because your extremely high quality and unique wood carvings found nowhere else in the world will necessarily be wedged between tie-dye t-shirts and Andean flutes. Remember this: "there is nothing wrong with that." Repeat that to yourself as your nose starts to sneer at the frilly-hanguie-thinguie hanging and shining in the sun in the booth next door. Everyone is trying to make a living and you will soon see that the success of the art festival depends on a wide variety of arts and crafts. Ego will just get in the way. Ego will put such a scowl on your face that the customers and collectors will steer away from you as if you smelled. Ego will make you unhappy with every festival, it will make you get together with other egotistical artists and whine about everything. Ego will make your expectations too high and your results inevitably unsatisfying. Ego will seep into your art eventually. Grow a widely tolerant attitude and enjoy the show.

The second meaning of the "no mires a quien" is to not listen too much to too many people about what *they* think, or worse (much worse), don't listen to people when they tell you what *they* say. You know the type, they have no experience in the subject at hand but have heard that *they* say this and *they* say that and *they* don't think this will work and *they*...(seem to talk a lot, in my opinion).

On my way to becoming a successful artist I read many books about art marketing. So many strategies, so little time. I wanted to try everything, galleries, open studios, city halls, libraries, local shows, international shows...Well, eventually I tried many of these fine venues until art festivals won me over. But the one piece of advice that remained in my head after reading all those books was something a painter wrote: "Paint them, pack them, and peddle them."

There is a stigma that attaches itself as if by magic to the traveling artist. We automatically become lesser artists, gipsy artists, artists who couldn't "make" it in galleries or in New York. Don't listen to all that junk; it will clutter your brain. I have met many artists who *are* in galleries in New York and who still enjoy the direct contact with the art festival audience. I have pieces in museums and still covet the road and the thrill of watching a young man mesmerized by one of my pieces utter with enthusiasm: "I've got to have that!"

There will be those, there will *always* be those who try to take the wind out of your sails. They are easy to spot because they start their sentences with: "I hate to take the wind out of your sails BUT…" or "I hate to pop your bubble BUT…" Don't even give the sail-busters and bubble-poppers the time of day. In fact don't waste any time at all with negative people, they disguise themselves in "common sense" and "cautious" disguises (or much worse, wearing "proper" masks) and will take the fun and the thrill out of everything. A little secret: they are the ones in a bubble, a safe and boring bubble.

Set your sails and let go of the safe harbor, for there is no finer adventure out there for the artist than being a traveling artist and meeting your audience face to face. When you have done this long enough and keep catching those tail winds, you will know the highest high an artist can achieve. Those who stay behind will never know.

Highs: The thrill of victory

Wow! is the word I use most to describe the entire nature of the business, "the business" being: making a living as an art festival artist. There are absolutely wonderful friends to be made with people that love doing the same thing you love doing. There are beautiful towns and absolutely gorgeous scenery along even more amazing roads to see.

The ultimate thrill in this business is a booth full of folk that saw your art in the two seconds that it takes to scope out your entire booth, loved your art and now stand in line fighting with each other to buy your art. They look at you with respect and awe. They say things like: "you are so talented." They make predictions like: "you are going to be famous." They stroke you and beg you to keep them in your mailing list. They say a lot of things that will make you feel very good. Remember these little memory gems so you can use them, like safe and delicious "uppers," next time you have a flat tire between Nowhereton and Farfromhomeville.

Here is my favorite gem: I was in a local festival and a little girl came by with her friend and watched me carve. I usually smile but keep carving because I figure that is why people get close. They asked me a lot of little-girl questions and I did my best to answer. Later, one of them brought her mom near my booth and I overheard her say that she wanted to be an artist. Her mom was looking at some paintings across the aisle and said: "yes honey aren't these beautiful?" My little friend said: "No, mom! I want to be an artist like *her*!" She was pointing at me.

Lump in my throat and all, I gave her a little print I had been printing as a demo and smiled as she made a bigger deal out of the thing than it really was. It didn't end there. Next local festival, she came into my booth again and brought me a little drawing carefully folded in an envelope shape. Inside there was a note: "Thank you forever, Maria." That little drawing will hang on my wall forever.

Other than the compliments, you get freedom in this business, lots of freedom. You set your own schedule, apply only for the shows you want, see the states you want to see, arrange your schedule to accommodate your spouse's vacations. Other than when you are doing shows, you can get up early, stay up late, do your work when you please. It's a curse, I said that before and I will say it again. So why did I write this in the "thrill" section? Because it is a delicious curse.

You get to do what you always wanted to do for a living. A real living making art. Wow. After all these years I can't see retiring or quitting. Quit? It would be like quitting gardening or swimming in the summer or petting my dogs. You can adopt the attitude that this is work or you can adopt the attitude that this is the most wonderful way to spend your time. Art is what I would be doing in my free time if I had another job. It is work, no doubt about that, but work of the soul. And there is nothing like it in the world.

As for the cold monetary rewards, the first time I made over $5,000 in a single weekend I was high for two weeks. There are artists out there for whom that is an average take, best cozy up to them and see what they are doing right, while there are artists that never see that figure yet continue to enjoy the freedom and happiness of the life. That used to be half my yearly income when I worked at McDonald's back in the late 70's, struggling to put myself through college. And the best part about that is that I thought that was a great festival, but not the elusive "perfect festival." I should have had more large works on display, and perhaps the weather should have remained calm instead of windy…could have another matted bin on display and I ran out of mini-prints and business cards. The Perfect Festival will come yet, and it is that relentless coveting that drives me to tweak my approach, my booth display, my way of doing things. The Perfect Festival is a silent and ever present fantasy, but it drives me to try harder, to make better art, present better art, get into the Smithsonian Festival…

I have seen a painter make $30,000 in a weekend. Say that out loud several times because it is worth hearing. I personally don't carry that much inventory, but with more and more original carved blocks in my booth, who knows! The point is that the possibilities are endless in this business and victories are within the reach of everyone. Just don't define victory at $30K to start out or you will be disappointed for sure. Count the small victories, the steps to glory. Savor the first time you make the entry fee, the first time you sell a big piece, the first time you go over $1,000, the first set-up under two hours, the first time you sell more than one piece to one person, the first collector who

takes five pieces, the first gallery that actually turns out to want your work, the first festival where the wind didn't blow…Savor them all on your way to higher achievements.

Lows: The agony of the feet!

Gosh, literally, does this business hurt or what! I thought I was young and strong and nothing could hurt me mentally or physically. I was used to rejection, I walk every day, I have big dogs I wrestle with on a regular basis… This section is not only about how hard this life really is (the feet) but also about the down times (defeat). Let's take the feet first.

First year I did this I had flashbacks of the first few days of working at UPS (United Parcel Service). I started like everyone starts at UPS, as an unloader of big trucks. Then I *was* really young and strong and rode my bike everywhere for transportation and I was in great shape. Okay, so my boss decides to start me off in the Levi truck. Levi's as in Levi's Jeans; they come in big huge boxes weighing 35-50 lbs. each. A truck full. Truck as in tractor trailer, 26.5 feet by 14 feet by 12 feet full of boxes stacked from floor to ceiling, roughly 1200 boxes in every truck. I unloaded the whole thing under the watchful eye of Mr. Boss who had a smirk on his face the entire time. He asked me if I was tired and I said: "a little." I thought I would die that night and resigned myself to not ever being able to pet my cats again, but the pain was nothing compared to what I felt the next day. My shift didn't start until 6:00 PM so I figured I would be able to raise my arms above my waist just before then so I could comb my hair if I also lowered my head to meet my arms. No such luck, I showed up with messed up hair.

Mr. Boss asked me how I felt (smirk was huge today). I said: "a little sore." Thank God for massive doses of Ibuprofen, an unquenchable desire to prove myself, and a bit of a death wish. Back to the Levi's truck. Believe it or not, I made it again, this time faster. Long story short, by the end of two weeks (my probation period) I was unloading 3 Levi's trucks and helping out the next poor hapless rookie. Matter of pride, you see, the smirk was now on MY face.

Relevance, please! Oh yeah, a similar "I'm going to die" feeling came over me when I first started putting up my tent, unloading and hanging art, sitting outside in heat and cold for two days, tearing down the tent, unhanging art…pain and agony all over again. Twenty years after the Levi's experience, I knew if I just stuck it out it would get easier. It did. Really! But the point is that art festivals are hard on your body. The weekends of the festival are extremely intense, often starting out before the sun. The work is hard, loading, unloading, and building a tiny gallery within a time limit. Then there is the exposure to heat, wind, rain, cold, whatever the elements throw at you. I have sat in sandals spraying my face and head every hour with cold water and I have sat in full ski jacket gear with a blanket over my shoulders. There is no refuge.

You can add broken fingernails, pulled muscles, bruises in the most unthinkable places, sore necks, bad backs and twisted ankles to that equation. Long drives precede and follow the festival, many times alone. Motels aren't always the quietest resting places; neither are most campgrounds leading to an inevitable state of sleeplessness and weariness. Some times the best place to stay is the parking lot of the festival and comfort isn't exactly a feature of parking lots. Eating healthy can be a challenge, especially when the BBQ pork booth is cooking all day long about 20 feet from your booth. Even the most basic necessities like bathroom breaks can be a luxury. In short, it can be a tough life. I believe there is an unbreakable connection between physical and mental well-being and it is inevitable that you will ask yourself many times why you have chosen this as a lifestyle. Usually the question comes after you drop a set of tent-poles on your right big toe.

If I had any advice at all to summarize this section it would be to have a couple or three male offspring right around 16 years before starting art festivals as a way of life. They would sure come in handy. Anyhow, try not to make any major life decisions during set-up, or tear-down, or during a bad festival, or while changing a flat tire between Whowouldlivehereton and Ouchthathurtsville.

Dear Artist...

And speaking of a bad festival, let's talk about defeat. This is the mental part of unloading that Levi's truck. I am naturally loaded with a stubbornness that borders on recklessness. I will not be defeated. Better read that over and over again as a mantra.

First thing that comes to mind are the rejections. Before starting the art festival way of life, I had entered and succeeded in being accepted into gallery juried exhibits, museum juried competitions and all kinds of other peer or juror reviewed calls for entries. I knew all about rejection letters from a prior life in which I thought I was a freelance writer. When I started entering art festivals the rejection shock took me by surprise. I, after all, was already well seasoned as an artist and had won prizes and purchase awards in some very competitive exhibits. Art Festivals? Reject MOI???

Rejections came sometimes as fast as I can send new entries—Dear Artist, we don't want you. Try again. Just like opening a Power Bar or looking under the 7-Up cap and finding you didn't win the grand prize. Except this time, your work—your soul—is involved. Rejection hurts at first and I can't say you ever get used to the feeling in the pit of your stomach, the anger, disenchantment, second-guessing of your entire life as an artist, as you read those two words: "Dear Artist,"…

Never mind that I tried to get into the best shows right off the bat (hey, I think big!), or that my display looked amateurish at the time, or that my body of work was just barely ready to be shown…Incidentally, there is a chapter on all that stuff coming up. But back to the rejections, I always wanted to know WHY??? And of course you never really know WHY, you only know what they say in the letter, which is the same letter the jury

or promoter sent to *all* the artists that got rejected. But here are some possible reasons, real reasons, not the reasons you see on the letter. Hopefully these will help you swallow those "Dear Artist" pills:

- The best shows are very competitive, much more so than some calls for entries in galleries and museums. The game comes down to numbers, 3,000 applicants for 150 spots. Apply again, every year if necessary until you get in or lose interest in that show.
- Your work didn't fit the picture that the judge or jury had in mind. Simply a mismatch of work to reviewer. If you attend the show, peruse around and see what type of work the judge/jury liked and objectively decide if your work would match the show.
- Your slides or photos may not be as sharp as more experienced artists in your category. Always put your best foot forward, some competitive shows will negatively judge your display even if they like your work.
- Your application wasn't complete or you may have not followed all the instructions. Review your application procedure, make sure you follow instructions, decide if you really want to do the art festival in question. Some promoters are forgiving, some aren't. Always keep a copy of what you send.

So you got rejected, file the letter, make a note, and apply for other shows. There are hundreds of shows, thousands of possibilities. Look elsewhere, move forward, quit fretting already! Let's move on to the second type of defeat, the dreaded *slow-show*.

Call them busts, call them duds, slow-shows will take your spirit if you let them. Picture this: Late January, supposedly the beginning of the shopping season in Palm Springs and other fine Southwestern cities. Good weather although a bit on the cool side, sunny, no wind, expectations were high in this busy corner of a shopping center. The set up was on grass, which is always friendlier than the cold asphalt of a parking lot. So we set up and we waited. Since I carve a block during all my festivals to keep busy and demonstrate my craft (more on this later!), I carved and carved...first time I looked at my watch it read 2:00 PM and I had a serious neck pain form bending over my block. Not only had I not seen *anyone* in my booth, I don't recall seeing many people walking around at all. Ohmegosh! No worries, I am a seasoned multiple-year budding veteran and I know that you NEVER ever ever judge a show by the first few hours, or the first day for that matter. Many a late sales have saved previously dudsy shows.

So the afternoon goes by and the next morning and...I got a lot of carving done. I made 2 sales and tortured 4 people into signing my guestbook. I made my campground fee ($52) and gas—barely. Didn't happen, don't believe it, I am a good chooser of shows and this one was a potential winner! Much as I have had that experience, it still hurts,

like, a lot. A wasted weekend, wasted mileage on my poor GMC Jimmy and trailer, wasted energy setting up and tearing down—the experience can really bring you down quickly if you let it.

So when that happens, buy a new CD and play some happy tunes all the way home. Admire the landscape more than usual, stop to take photos for later reference more than usual, treat yourself to a sit-down meal…whatever it takes to bring yourself back up. Whatever else you do, avoid making any decision about being an artist until you feel like you are in a good mood again. Avoid changing your approach. Duds happen, to everyone. Let them go quickly and move on.

Okay, now that you are over the forgotten show, let's move on again. Incidentally, during the show in question I overheard the promoter say: "You know what they say, if you can't sell something three times, change your craft." In their defense, it was an unpredictably slow show and artists were nagging more than usual. But I was shocked because I do what I love and love what I do and can no more change what I do than change my height. And speaking of doing what you love, next chapter is about the stuff you do. But first…

Your peers: Love thy neighbor

Once I was all set up in a park show, ready for the crowds and talking leisurely with a fellow craftsman when I felt a cool sensation in my jeans, just below the knee. I glanced down casually and noticed in much more horror than I can express that the sprinkler system had come on and I had not one, not two, but four sprinkler heads showering my framed prints…ever so gently. Paralyzed for only a second, the only thing I could think of was to step on two of the heads and let the rest of my work be soaked. Out of nowhere, more experienced folk came into my booth with bags and indicated that putting bags over the sprinkler heads was more effective because shutting down one head just gave the rest of the system more pressure. I don't know who they were, I remember vaguely there were two of them and soon the four sprinkler heads had little bags tied with rubber bands and sprinkled away harmlessly inside the baggies and, more importantly, away from my works. Angels, I thought!

I have already mentioned that the absolute most important people in this business are your fellow artists and craftspeople. Love them all. What has amazed me most about art festivals is that the artists who do this for a living are as different as can be yet a lot alike. The vast majority of us are extremely nice people, more so than the crowd in a mall (for example). I think the tie that binds us is the life itself. We have chosen this way of living and that makes us a bit alike in personality. We also drive ourselves with no extrinsic incentives, get no regular paychecks, serve as our own bosses, suffer the same winds and most importantly: *we see each other all the time.* There are cranky artists too, but

I forget them quickly and remember the vast majority. It amazes me how many nice and kind people I have met.

We are a huge loosely organized family that comes together again and again. We take care of each other and cry when we hear someone gets in an accident and loses their business. We tell tales (some taller than others) about the time it hailed in Durango or the time the sand filled our booths for four days in La Quinta. When someone's booth starts to blow away during a Southwestern whirlwind, we run to catch it. When my small prints display blew down in a sudden gust there were two people in my booth in a second, helping me put the thing back up. When I saw that the newbie next to me didn't have weights, I tied her booth to mine.

Don't get me wrong, we aren't overly generous with parking spaces, especially at set-up and tear-down, but most of us are polite enough to move our vehicles a few inches when requested. Neither do we enjoy the occasional leachy artist who shows up without half the things he needs and borrows everything time and again. Most of the time I lend some stuff and occasionally I borrow some stuff, and both transactions are done effortlessly as when I borrow or lend a tool to a good neighbor. But we take care of each other because we are in this business together, it's a tough life despite all its advantages and we all know it. Without each other things could be much tougher.

In case my babble has already lost you, I will kindly summarize: it's a tough life. Being in business for yourself is tough, traveling is tough, setting up and breaking down a temporary gallery is tough, the uncertainty of the business is tough and the weather is tough. Having said that, it is also a fun life, traveling is fun too, talking to people about my art is fun, making my own schedule is fun, exchanging art for money is very fun. So if you can take the kicks, the life of being an art festival artist can be ultimately rewarding. Let's move on to how to get started.

Chapter 2

Do What You Love, Do It Well

"Let us, then, be up and doing.
With a heart for any fate;
Still achieving, still pursuing.
Learn to labor and to wait."
—**Henry Wadsworth Longfellow**

Your stuff

Let's talk about your stuff. What do you do? What do you call yourself? A painter? A sculptor? A craftsperson with a lot of skills? In order to sell something for a living you have to be either a great salesperson or do what you love and do it well. Some people are perfectly capable of selling anything and I envy their skill. The pure salesperson can create a need in the buyer, and then create that impulse to get the stuff NOW. I am not like that and, with a great many exceptions, many artists are not like that either. The alternative is to do something you love and do it well, then you can sell it because the stuff you come up with will be the best and you will love it and your customers will read that immediately upon glancing at your booth. You will be able to talk about it for days, how you make it, how you got into being an artist, how you live, how you love what you do, why they too should love what you do.

There are as many arts and variations as there are stars in the sky. What do you do? First reason for defining what you do has to do with the application form for your first festival. What box are you going to check? I am a printmaker and often there is no *printmaking* box, although one that looks like it reads *graphics/printmaking*. There is always the *Other* box, but it seems pompous to me to make a category for myself. You

have to define what you do because you will have to explain it to a promoter at one time or another.

The exercise of defining what you do is the first step in *seeing* what your booth display will look like. Let's say you have stashed a few paintings, a couple dozen etchings, some paper sculptures and a handful of wood-carvings and you say to yourself: "I will have a variety booth!" Surely it will attract people to have all kinds of different artsy productions in one single booth? Nah, wrong. Funny thing about this business, promoters want to see a cohesive booth because the public likes to see cohesive booths. Often if you have only two arts/crafts—like sculptures and paintings—you will have to apply for two different categories. There is a reason for that. Promoters of shows want to have variety, but they don't want their shows to look like a swap meet. Much more on the types of shows you might find out there in the next chapter. So what do you do? What do you call yourself? Think about those questions long and hard.

A body of work? You say...

A body of work is not just a compilation of your student work and some things you've been playing with. When I did my first art festival that is exactly what I had: several large charcoal drawings, some lithographs and a few ink drawings on gesso-board. I still have all but three of the pieces I took to that first learning experience. That show was also the first time I saw a *real* art festival professional.

His booth was white and shining, mine was a rented red and white striped tent. He had display racks and a little gallery *feel* to the entire set-up, complete with walls that enticed you to look inside (incidentally, I confess to have followed his lead and find that particular *gallery-feel* most successful for me). By comparison I felt like I just got off a truck and set down a couple of cases of used socket-sets on the sidewalk. But what impressed me the most was his body of work. It was different yet cohesive, all in the same style but not identical, all framed similarly but complementary. Wow.

First important quality about a body of work is having work that is sellable. There is a certain *polish* that is common in works of artists and craftspeople that have been doing their art for a while. This might be described as a finished look, or a professional look. The mistake you must not make is to think that anything less than your best work will sell *okay* because, after all, this is not a high-end gallery in Chelsea, in the heart of New York. Wrong and dangerous thinking probably will result in few sales if you manage to get passed the sharp eye of the promoter or jury at all. Art festivals are not swap meets where you can sell used and slightly worn art works in slightly dinged frames. Art festivals are a collection of shops, each shop being a specialized gallery of a certain type of art or craft. As in any type of shop, people expect to see quality, finished products, ready to use, hang, and give or show to their most discriminating friends. As in any type of shopping spree, customers will expect that what they buy is in perfect condition, but also hopefully unique and beautiful or useful beyond anything they can

find at any other shopping spree. If there is a generalization to be extracted from all this, it would be: the better your product, the better your sales. People can distinguish between production works and hand-crafted-with-love works and they will pay more for soul-full hand-crafted art. Art festivals are very special places; honor them well.

Second important quality about a body of work is that you have to have enough stuff to provide a variety. Heaven forbid that you sell a dozen paintings the first time out and you have booked a show for the weekend coming up (gosh, what a problem, huh?). Do you have anything left? Are you stuck with the three black sheep of paintings that you painted when you were 8? Too late to get a refund! How much stuff is enough? Here is an exercise, pick a 10 foot by 10 foot space, preferably a room with not too much furniture in it, stack some paintings or prints or sculptures inside until you run out of display space. How many does it take? If you are a painter of large paintings and also have some smaller works, between 10-20 will do probably. If you are a sculptor of huge stone and tile pieces a dozen will suffice. If you make watercolors and etchings in sizes 16 by 20 inches and smaller, you might need to take about 50+ works.

The loose guideline here is to have enough work to fill your booth display walls but not too full (I err on the side of way-the-heck-too-much just in case that awesome show is THIS weekend). If you have booked a three-day show you will need more than if the show is two days, but not necessarily. You can expect to make (another loose guideline) between 2-10 sales for very high priced items like paintings and large sculptures worth a thousand or more; perhaps 10-20 sales for mid priced items in the hundreds; lower priced items less than a hundred dollars might bring in 30-50 sales or many many more. As they say in the business, your mileage may vary. The range in arts and crafts is simply too great to try to come up with an accurate guide for everyone. You should bring more art than you can display but don't go crazy and have too many extra stock boxes sitting around your booth until you know what to expect. Stock boxes, no matter how beautiful, tend to look worse than product. After about two or three shows everyone comes up with their own guidelines on quantity.

Some artists swear by the "less is more" approach and show elegant bare display space with just five or six carefully chosen paintings. Some artists cover every bare piece of wall with a piece of art. Most of us are somewhere in between, choosing the elegant approach for high-end shows and the quantity approach for shows where the larger audience likes to browse. Ultimately, every artist does what pays off for them, a lesson learned after a few festivals.

So that's about it for the quality and quantity. Let's take on the more specific subjects of what you might consider in terms of having an edge in the business.

The unique and different: Skeletonized Leaves and Bug Jewelry?

Enough with the sneering. You are in business now and you better find out what it is that makes you *different and unique* from the next artist. Like it or not, you will have

to explain that several times each and every show, probably thousands of times by the time you hang up your trailer keys for the last time. So listen up and quit snickering. Oh, and a reminder: there are a variety of things that make a good show a *good show*, one of them is a variety of things. More on that confusing thought in an upcoming chapter.

So there I am on the edge of the world, well, really on the edge of the absolutely gorgeous California coast setting up my booth. Not a bad show, good promoter, good location, solid sales—really, I must do it again sometime. That's where I met skeletonized-leaves man. Natural assemblages of painted skeletonized leaves and other nature finds filled his simple and handsome booth. I asked and he gave me his pitch: "a two-step process to skeletonize the leaves...each assemblage an original design." He even had one set aside to let people touch it, because his nature works were beautifully displayed in elegant shadow boxes behind clean glass. A simple craft, in terms of concept, yet superbly executed, giving this artist the edge of uniqueness.

Now let's take the landscape painter. What is unique and different about YOUR Southwestern landscapes or New England idyllic townscapes or still-life pastels or metal sculptures or wood carvings for that matter? Uniqueness can be achieved in any medium with a developed style that comes either through years of developing a style or by purposely exploring an angle that suits you.

A different angle or unique approach doesn't have to be forced, you don't have to start painting with your toes or drawing on Plexiglas with laser-printer toner (been done). But the fact remains that selling a unique item will give that artist and edge over the artist who closely resembles many others. If your uniqueness isn't readily visible or apparent, be prepared to explain it to your prospective customers. Or take a step farther and make a poster about it and plop that baby right on the front wall of your booth so that people know what *you* do is different from what *they* do. There are two advantages with this approach; you save your breath and you entertain people *inside* your booth, a very important factor in the sale process.

And let's not get too cutesy here, there is another extreme. Let's take the artist who only paints aliens from outer space engaged in battle in blacks and blues because nobody else does that. Well, there *is* a reason nobody else does that. There is such a thing as too unique and different, bordering on the bizarre. The audience for such works is highly limited, much more in art festivals. Remember that people want to put what you do in their house or give it as a present. So maybe your Southwestern landscapes contain real sand in the oil paint, which gives them that special texture? Tell your customers about that. Maybe your still-life paintings are modeled after famous classics lost forever in the Nazi lootings? Explain how you are rescuing old forgotten works and honoring forgotten artists. Find what is special about what you do, exploit that uniqueness and tell your audience all about it.

Another case in point that caught my eye and I remember to this day: the bug jeweler. Other than uniqueness of design, the common denominator that she held with the skeletonized leaves guy, was quality. These jewels, all in the shape of or closely resembling insects, were superbly designed and executed, elegantly displayed and delightful to look at. The infinite variety in the insect world will give this jeweler unique ideas for several life-times. Think of the colors and the shapes and the variations on the insects. Some of the pieces were exact replicas of some delightful tiny bug, some merely represented the concept. And what an incredible idea!

What happens if too many artists start making skeletonized leaves art and bug jewelry? We are always afraid someone else will "steal" our ideas, but this is where style and originality come in. Making your art different than anyone else is not just a matter of finding something *no one* else does, heck, that would be near impossible! More than about finding a completely unheard music, uniqueness is about defining your own voice and playing your music in a way that catches the ear in a manner no other music can.

Everyone in the world can make woodcut prints, which is what I do, but I firmly believe that nobody else can make them look like I do. They could steal my designs and reproduce them and somewhere in the process their own style would make their woodcuts different from mine. Besides, artists are independent proud souls and copying is a dirty word for near everyone. And copies of other people's work look like copies of other people's work, soul-less and pathetic. I think as soon as someone picks up a wood chisel and a block of cherry wood and tries to replicate what I do, they will find out that woodcut printmaking is neither an easy craft nor exactly a get-rich-quick scheme. I have had people walk up to my booth and sneak a picture of some of my pieces, something that nearby artists quickly pointed out to me in a panic. I have had people print out my works from my website and framed the low-resolution works. Frankly, I'm flattered and I always hold the hope that those people are reporters or art critics and those pictures will end up in the New York Times or in Art In America.

A sculptor (who cracks me up) I know makes metal sculptures out of discarded farm machinery and other scrap metals. His work is unique, well executed and has the edge of humor. He often hears from passers-by the comment: "*I* could make *that*!" His reply? "Knock yourself out."

The last point in this little section is the question of whether you should shoot for a completely cohesive body of work or go for a variety. The booth that most comes to mind when I think of a cohesive body of work is that of an artist who does only white on white embossed works, all framed in black. His booth is beautiful, elegant but simple, everything pristine black and white. I feel like meditating in there and the works don't at all look boring or repetitive, but have a beckoning quality that invites you to look closer and admire.

On the opposite end of the spectrum there are two artists who show both watercolors and mixed media, or wood sculptures and paper works. The variety of sizes and colors are *held together* by their styles, and the cohesiveness results this time from the soul of the artist who obviously created a diverse array of pieces in different media.

A key concept to remember is that the work MUST be held together by something. A very similar body of work needs no further "visual glue." I display both figurative works and desert or road landscapes. My work is held together by my style, usually energetic and with a lot of the same line and shape used in both themes. The woodcut print also has a very distinctive and unique "voice," which binds the works visually close in look and feel.

Other than that, I feel a variety of sizes and offerings are an enhancement to a booth. I like when people come into my booth to see what else I have in there. I like it when kids rotate my hand-printed card racks to find one they like most. I enjoy it when people go behind my booth to look for more stuff and when they claim they can't make up their mind between two pieces that are marginally related, like a road landscape wood engraving and a figurative work of wood-people (figures with wood grain intertwined). Once more, you will find your own way after a few shows.

Presentation: Dress them up nice

Okay, if you have been paying attention you have seen various references to "well executed" and "elegantly displayed." When selling to the public, presentation is everything.

One fine art festival in San Francisco I met a couple of fellows that had the most well designed presentation. They also introduced me to the term "perceived value." Their works were laser-cut wooden ships, bridges and cable cars in low relief assemblages. Describing them doesn't begin to honor the intricacy and delicacy of these assembled masterpieces. Going one step farther, their display was elegant and simple, carpet panels with one model on each panel, a nice floor cover; their "floor models" hung well lit while the items for sale resided behind the booth all packed up in boxes. They got a pretty penny for their works and well deserved. And while the patterns are fed into a computer that operates a laser cutter (much assembly required after that!), the objects were of such detail and so well presented that their perceived value allowed these nice fellows to make a good profit. Well deserved.

Presentation of your masterpieces will increase their perceived value to the maximum the market can bear. When I first started my prints were "gallery framed" in plain white or off-white mats and simple metal frames. I would ask and get around $75 for a framed 16" x 20", which cost me around $15 to frame. After learning from the laser-wood-cutters and a hundred other artists I started framing better. I increased the cost of my materials just a bit to around $25, but now I get $195 for my 16" x 20"'s. Same print,

now brings me twice the revenue and all I really do differently is buy a better frame and cut an extra accent mat. The frames are still wholesale but more of a modern look in cherry, walnut or black. When before people used to actually say that they liked the piece but hated the frame, now I get compliments on my framing and I have been asked twice if I would frame someone else's work. My works look better when they are dressed up better, we all do! Oh, and I sell more of them, even at the higher price.

One key concept is "ready to hang," and I include all 3-D art as well so you can take ready to hang as an analogy for "ready to use." Nobody wants to buy a piece of art and think about reframing it or getting an expensive pedestal for it, before they can stand to put it in their lovely home. Another key concept is "embellishment" which is what your artwork is to someone's home. Think about your home and think about whether you would accept a terrible looking frame just because you liked what was in it. Annoying as it may be, we artists have to become interior decorators when it comes to the presentation of our works. Make the works look their best but also think about making someone's house look better for the sole fact of having your work hanging (or standing) in it. This requires nice framing without over-doing it or nice presentation for 3-D works, again, without overwhelming. Presentation is a delicate task and I have learned much from many pros in the business. Since I can't possibly give specific advice to all the different media out there, the best possible strategy might be to study the field.

Nicer galleries give the best possible presentations for all types of works. Even department stores and malls are good places to study during the presentation research. Notice whether art works are salient in their cases or frames, whether you notice the artwork first or how it is presented. Once you have gathered a few presentation possibilities, it is time to make the presentation scheme a practical one to carry around in the back of a trailer. Display supply warehouses and websites (check the Appendices for resources) are great sources for presentation ideas. Since I didn't like the prices at first, I made do with some good imitation display racks and less expensive framing, *at first*. As I became addicted to the business and started fine-tuning my display, I acquired more expensive and specialized display equipment.

Lastly, you want customers (with their hand on their wallet already) to know *exactly* what that piece will look like in a nice frame, on a nice pedestal, on their wrist, on their fireplace mantel, over their door, smack in the middle of their patio... Jewelers know that customers like to put the bracelet on their own wrist, a great advantage to their craft. If you display your works nicely framed on a neutral background you have just matched two thirds of the households of your audience. They "know" what the works look like in their house because they are looking at them now exactly as they will look after they finally lay down that credit card and take them home.

The rest of us are left trying to imitate what our audience's homes look like and trying to match everyone's décor. Since this turns out to be an impossible task, we conform ourselves with displaying our pieces in an absolutely neutral background and surroundings so that the prospective customer can *imagine* the piece inside their lovely homes without the distraction of highly colored display walls or cardboard boxes in the background. Embellish the works in order to bring out the best qualities in the piece, but do not overwhelm the display with your own preference of color and frame. I have to confess to this day I still display too much work in a more crowded atmosphere, but then, that's my style! Finding a style that both suits your work and you is important or you will feel completely out of place in your own booth.

On pricing... The wallet of the beholder

Pricing art work is about as personal as dressing, or at least some artists take it that personally, which leads me to place a disclaimer at the beginning of this section. What I will do is discuss the pricing issue from the public's perspective; after all, they are the ones with the wallets. Perhaps this can be taken as a guideline drawn from my experience with the public and by studying the price schemes of many artists in the business (both successful and not).

There are a few simple facts of life that may help decide on pricing your masterpieces. Pricing will also depend on the type of show that you attend; there will be much more on the types of shows and audiences each of those shows attract in a later section. The key concept in pricing is that you want to make money in every show, that is, you want to sell at a profit.

Within that wonderful array of beautiful works that you brought along to the festival, there should probably be a variety of price ranges and some choices, unless you are absolutely specialized. And by being specialized I mean selling very similar items of a narrow price range. Sculptures come to mind, or large paintings, or stained glass and mosaic doors. There is nothing wrong with being specialized, incidentally, I always say that there are two ways of becoming outrageously rich: sell sports stadiums to cities or sell light-switch covers to everyone in America. Either way works but the prospects and the selling approach for those items varies considerably.

The majority of art festival vendors, however, tend to try to stretch their offerings along a wider range. The reason is that customers like to look at big expensive stuff that is very attractive, but not everyone can afford the high-end item. I like to have larger works and original blocks highly visible to attract people; I just hate to limit my audience to the upper income buyers only (or maybe I don't yet have the guts to try!). What sells most in my booth, however, are mid size mid priced works, with higher priced and lower priced works tied for second. I like to do business that way, but I have seen many artists that have only high priced items and many more that count on making fifty or more lower priced sales per weekend in order to make the show profitable.

You will find your ideal booth after a few festivals and vary the booth from festival to festival. There are some shows where I know I probably won't sell high-end stuff and frankly, I'm not going to cart my best works and risk travel injuries to my frames just so people can shower me with aaaahhhh's. Other shows I know I will sell more mid-price stuff if I have fewer lower-end works. Yet others I won't take my hand-printed cards ($8.00 ea.) at all, either because a tower of cards (no matter how hand-printed they are) doesn't match the character of the show or because they are not allowed. Here is what I think is the ideal booth and please remember that this is only *my* idea of an ideal booth. Use as a rough guideline to start out if you have absolutely no clue, then refine your own scheme as you sell (or not).

- Several but few (depending on the audience of the show) show-stopping high-end works that will attract people. You have two to four seconds to attract someone walking an art festival to your booth. Price range of these should be such that one or two sales would make the show profitable ($1500-$3,000+).

- More of mid-range works that *must* resemble your high-end works in closely related format or theme. Some artists' body of work is very cohesive while some artists' offerings differ greatly. But you must not attract someone to your booth with abstract colorful stuff and then have only dull and drab mid-price range or your customers will feel "cheated" in some way. Mid-range is a wide term; let's say $100-$1000.

- Optional, some assorted low-end works for those who just LOVE your work but can't (or won't) afford anything over $50. For me these are 8" x 10" original prints and hand-printed (but not editioned) original mini-prints with envelopes. This is gas money and it counts, or as I like to say: 12 times $10 equals $120. I have through the years raised my lower limit to $25 and no longer sell cards. Instead, I place the same $8 card in a $2 wholesale frame and get $25-35.

Doing the math

Well, that's my story and I'm sticking to it! Here is how I came up with my prices after a few painful profitless adventures. I'm afraid I am a math person, so if I happen to lose you that's okay, there is always the easier strategy of going to a festival and seeing what's out there that vaguely resembles what you do, then pricing accordingly. Who wants to do that?!

First I priced my woodcut prints pretty much by the seat of my pants, sort of. I looked at a fair number of web sites with similar works and asked a fair number of printmakers how much they charged for their limited edition hand-pulled prints. What I

got back was a huge worthless range, anywhere from $50 per print to $700 per print, after compensating for size. Well, the next step was trying to narrow that silly range to something I felt comfortable and that at the same time allowed me to have some profit (so I can spend it on next year's entry fees!). Rather than boring everyone with the details of the cost of paper and ink at various suppliers, here are the general issues you might want to consider when starting to price your works:

- What is the *range of similar works* being sold at similar art festivals? If you don't know, better find out before the first one or you will waste an entire weekend. I can mentally deal with wasting entry fees much better than I can deal with wasting time.

- *How much stock* of the thing you are doing do you have? I'm a printmaker, so I make multiples of everything. However when I sell original carved blocks— one-of-a-kind blocks—my pricing scheme is much different. Also while you are mulling this point consider whether you can make similar "ideas" without cheating your audience, that is, are you painting unique landscapes or making several jewelry pieces that vary very little.

- Closely related point, *how many sales* do you expect to make? I know math is a horrible thing to some people, but if you are selling five-dollar items, can you make the thousand sales required for you to make $5,000 in a show? You might sell twenty dollars one hundred times, or $200 ten times or $2000 one time in a day to come up with the same total result. Thinking ahead about the audience, the show and your product is always a good idea. More on matching your product to the type of show in the next chapter.

- Absolutely consider the *materials* that go into the work of art. Gosh again I realize how lucky I am because wood, ink and paper are fairly cheap when compared to oil paints and canvas or marble or copper. But even I have to consider the cost of the frames and matting materials and get my money right back out. On the other hand, I can't justify doubling the price because although people will shake their heads at my explanation, they just won't pay twice as much for something the same size (unless they already know how much wood would a woodcutter cut to get a ten-color-woodcut-print).

- By all means pay yourself and figure out *how much time* goes into your work. A six-block print is going to be priced higher than a one-block black and white of the same size in my case. In your case, figure out how much your time is worth and then price accordingly. This is possibly the toughest issue to

consider because I basically do a lot of things for free, like sit at an art festival and drive. But in simple terms, if you spend a week on a hand-carved stone sculpture you should get for it what you want to make for a week's worth of work.

- Finally, is there **consistency** in your pricing? And not just consistency, but visible consistency. By this I mean that similar pieces should be priced similarly *unless* you can readily explain to your customer that, since this one is gold and that one is plastic, this one costs much much more. And remember that many prospective customers won't give you a chance to explain, so price tags with explanations of materials and such things are a very handy thing to hang by your art.

One last point worth mentioning is that it really doesn't matter what I think my art is worth because I am not the one buying it! The market always has and always will determine what something is worth. The purchasing buyer will let you know, by the simple act of opening their wallet, when you have priced your art just right.

Image IS everything

Lastly in this section is, again, the loose concept of *perceived value* in more detail. Fair or not, perceived value is the *thing* that allows stone sculptors to charge more than wood sculptors, oil paintings to be worth more than watercolors, polished gem jewelry to be more expensive than beaded jewelry, woodcut prints to be more valuable than reproductions. Perceived value isn't necessarily fair value, but it is there in the market and the audience has all the rules of perceived value memorized like a mantra. Just like in the kid's stone-paper-scissors game, oil beats water, stone beats metal, metal beats wood, wood beats plastic, canvas beats paper, color and shine beat dull and drab…

However unfair or reproachable or perhaps even ignorant perceived value may be, if the audience cannot see the value in something they will deem that work too expensive (or too cheap to be worthy!). Your mission, should you wish to accept it, is to convince the audience that what you charge is extremely fair, and further, that buying directly from the artist is the strategy of the intelligent collector. So should you under-price? Most pros in the business don't use low prices, they use high convincing explanations sometimes handsomely displayed right on the front wall of their booth.

Chances are you won't get the chance to talk to everyone that is looking at your beautiful works about how much time and honored tradition goes into every piece. Chances are, if your work doesn't YELL perceived value right on their face, they won't give your precious booth another look. By all means have your prices displayed by your pieces, most customers simply won't ask. The exception again would be very specialized and high-end items, which will attract the kind of audience that *will* ask.

One year I got really practical and figured out exactly the cost of every piece, categorized by size. The cumulative price of paper, ink, mat, and frame went into a spreadsheet. I even figured out how much my cards cost, envelopes, and clear bags. I was actually surprised that my profit margins were vastly different for different items, so I adjusted my prices accordingly to reflect the profit margin I want to make on each piece. It might be a while before you are able to do that since you don't know yet how many sales of what items you might expect on the *average festival* (gosh, does that animal really exist?), but after every season, when the wind storms calm down and your back quits hurting, it is a good idea to rethink your pricing until you are satisfied.

Last and very key concept on pricing is about satisfaction. Ask yourself whether you are content with what you get for your works. It took me a while to get over the feeling that I was giving my soul and, more importantly, my time away. Now I'm content. My customers are still satisfied that they are getting a good deal. I make sales in every show; in fact, sales continue to increase for me from year to year. Perhaps this is due to the tweaking and goal setting that I will talk about in a later chapter, but nevertheless, if sales are going consistently well, your pricing is probably just right.

Price tags on hand, let's find us some shows!

Chapter 3

Finding and Choosing Shows

"Give me six hours to chop down a tree
and I will spend the first four sharpening the axe."
—*Abraham Lincoln*

I live in Las Vegas, Nevada, which I characterize to my customers as the "cultural capital of the world". They laugh, invariably. When I first started doing art shows I didn't believe there would be any local art shows that were worth doing; later I found out even in Vegas money can be made and the art shows get better and better. It was here in the comfort of my own home that I learned that there are art shows and there are art shows.

I am not going to even attempt to classify or qualify the types of art shows, even though among fellow artists we often talk about "mall shows", "dinky shows", "parking lot shows", "easy shows" and a myriad of other classes of shows. We know what we're talking about, I think. And there is a wide variety of shows, which doesn't mean one is better than the other or money is a sure thing in some and a rarity in others. The main goal to be achieved by attempting to qualify and classify shows is simply to find a match for your particular type of offering. Fine-art-only shows may be the place for many painters, but jewelers seem to thrive there as well and sometimes the attendance at these exclusive shows is so poor that nobody sells anything. Huge mixed shows would seem a mismatch to high-end 2-D (wall-art, as we like to call it), but there is plenty of money to be made for everyone when 100,000 people show up in a buying mood.

One of the most important things to remember about art festivals is that there is a huge quantity and variety of shows to choose from. As artists and business persons, we owe it to ourselves to, not only research shows, but be picky about which shows we continue to support. But first, you have to have a choice, so let's take the first thing first

and chat about how to find shows. Then we can get into some tuning tips so that you find the best show suited to you.

Where are all these shows?

First year "in the circuit" I made the mistake of not seeking enough shows and not researching enough *about* shows. I guess that's two mistakes. The predictable result was a disaster year in which my total gross income was around $14,000. Well, I didn't even know if I wanted to do shows and I was doing them very part-time and this tough year taught me that I needed to do some serious research and dedicate some time to the fine art of planning.

Let's start with where to find shows. There are several trade publications around, some cover the entire US, Sunshine Artist, Craftmaster News and The Crafts Report to name just three. Out West we also have a regional guide or two and every region has its own websites and publications dedicated to festival listings. Obviously the country-wide publications will have a lot of extraneous information and listings if you are just looking to do shows in your state and surrounding areas. Another most important source is the web, but I have a whole chapter coming up about Loose Nuts and Bolts that covers the "nobody told meeee" stuff, with a section on the internet as a most valuable resource. Anyhow, just to whet your appetite, a search on the web for "art festivals" will yield several thousand results and if you are the surfing kind, you may not need a stinkin' magazine at all. Other internet resources covering the rare gem festivals such as those offered by small museums or art organizations are the Art Calendar listings and the Art Deadline web site. All these resources are online and are conveniently listed in the back of this handy book.

Time invested in researching all, not just some, of these sources will pay off tenfold, as there are shows that only list in some publications, shows that don't have websites, shows that are only advertise regionally and so on. Every promoter of an art festival, after a few years, knows just where to advertise their particular shows to get enough (but not too many) artists to apply. It follows that artists must do a bit of sleuthing to figure out how to find the right show in the right place at the right time.

Last but not least, attend the local shows you see in the newspaper or television. Asking artists attending a local show will usually yield a filtered list of a few shows in the area and will certainly get you the name of the promoter of that particular show. In the beginning, the local shows are the easiest to taste anyway.

What do you look for in a show listing magazine or web site? The same thing you look at when shopping for anything else: large selection, wide variety and features! You want as many shows as possible, of course, organized in some sort of calendar, and hopefully by city and state.

First thing you notice when you look at the June issue of one of the publications is that most of the June shows had deadlines last November and it is now too late to apply.

Research is something to be done well in advance. So you make a note of the shows that might suit you and apply next year. If you do this for long you will find yourself thinking about next February in July of this year. Next thing you notice is that there are way more shows than you can do in one lifetime, and that the listings don't have much information about the shows other than time, place, type of art accepted, sometimes estimated attendance (estimates are always debatable), and contact info for the promoter.

Send for information to shows that interest you and usually that gets you on their mailing list for a year or more. Keep in mind that many of the largest shows only keep you on the mailing list for one year (or even one mailing), so you have to call every year or dive right in and apply. Attending shows will also mysteriously result in more applications in your mail box, probably a result of that business card that you handed out so many times. After you get on enough mailing lists you may not need additional listings, but I feel it is good for business to keep trying new shows and even new areas, just to keep life interesting (and to try to find those *jewels*). So the next thing you need to know is what you are getting into.

How do you know which shows are good or at least well liked? Some of the listing magazines offer reviews, many sent in by artists, and some of the publications actually send foot soldiers to walk the shows and get first hand impressions. Read the reviews, will ya? If you are a photographer and you see a review sent by a photographer stating that the show was superb, you have the beginning of a guideline. Keep in mind, however, that middle-happy artists probably don't send reviews all that much and that reviews you read are often the commentary from a very happy camper or a very unhappy camper.

There are also publications and websites dedicated exclusively to reviews, one being published by Sunshine Artist Magazine, and several independent regional publications also compile reviews. Yet another worthy of mention is the Art Festival Source Book, an ambitious project that has categorized festivals for many years. The information learned there can be very valuable or it can be just plain wrong. Since the statistics are often derived from a relatively small sample of reviews, the numbers can sometimes be a bit skewed. Remember the happy/unhappy camper thing for future reference. Many of the comments are tainted by an artist's single experience, so the best publication is the one that has compiled reviews for many years and is able to calculate true average statistics on the shows. Also pay great attention to the 200-Best or the 100-Best or whatever your chosen publication happens to publish, as these are often chosen by attending artists. These are crème de la crème shows, the coveted ones that get ten times the number of applications as there are spaces. More on these later!

Additional valuable information to be found in a publication is some kind of idea of who made how much at what show. Again it is important to keep in mind that these

are usually artist's self-reported incomes for that show. At first I had no idea how much to expect to make in a show. Having a mid-range product and a few lower-end items, I simply didn't carry that much inventory so when I heard of people making 5 figure incomes I started thinking they might have sold their vehicles to some passerby in order to achieve such income. Later I observed the types of items that some painters, sculptors and specialty artists (e.g. stained glass doors, copper wall hangings) sold and I understood a bit better.

Yet other bits of information that are invaluable are things like how many jurors jury the show, whether you can set up the day before, parking situation, additional charges for stuff like booth sitters, and a myriad of other details that help the hapless artist choose. I hardly will do a show where the set up is only the morning of the show, just not worth the stress and exhaustion for me. Other artists, having "day jobs" to contend with, only do shows where set up is permitted the weekend morning. Everyone is different and the value of these publications and web sites is to help every artist make more informed decisions on what shows to do and what shows to avoid.

One thing about the published averages and statistics is that they are indeed averages. A baseball manager said of averages that if you stand with one foot in ice water and one foot in boiling water, the law of averages would suggest that you should be perfectly comfortable. You will always find 10% of the artists that thought a show was outstanding, 10% that will never set foot in that show again, and the rest…the rest are those who count in terms of the review of the show. That is because the average is the most accurate prediction of what you might expect. I have concluded that after reading all the ratings in the world, the real show experience by YOU is the best judge of the show. And make sure you give a show with good potential at least two solid tries before chucking it. Let's move on to those expectations, shall we?

The perfect show (A.K.A. "Last year's show")

The world of art festivals is as unpredictable as some business can get. I have already said that, I know, but it is worth repeating because from year to year, same show, same weather, same promoter, heck! same spot…may yield different results, leaving you baffled and confused and yearning for a salary job (NOT!). Whatever you do, don't believe all that you hear about *last year's show*, because often times our delicate artist memories are tainted by desire and unfavorable present circumstances. We tend to forget (repress?) 60-mile an hour winds and tend to remember multiple work sales to a single customer. This year's show (as opposed to the infamous *last year's show*) is invariably hotter, colder, windier, has less parking for customers, a tougher set-up, in a worse location, less advertised, and much much slower.

The criteria for categorizing shows is not to give each show points based on how much you liked the show or how many people you saw attending or even how much the average artist took in…on average. The main purpose of carefully observing shows is to

objectively match the show to your particular product. A secondary goal is to find the shows that you feel you can do year after year and to fine tune the criteria that you want to apply to a show.

Is there a "perfect show"? My fantasy perfect show would contain many of the items that I will point out in a minute. My perfect show is a small show that brings in tens of thousands of people, lasts four or five days, everyone knows what a woodcut is and appreciates the valiant way in which I am single handedly preserving the craft. In my perfect show, children, who tend to buzz to my work like bees to honey, would carry little tiny credit cards with great big spending limits. In my perfect show every "I love your work, it is beautiful" would instantly get me a $200 sale, all my "I'll be back's" would actually come back and all the folks that politely ask "do you have a card?" would subsequently buy a piece from my website. The weather would be in the mid seventies, calm as the doldrums and volunteers would bring me a turkey and tomato sandwich at lunch time and make several sales while I took a "rest" break.

Seriously, I have had a near perfect show. It was very near Las Vegas, this very spring. The weather was hot but not so much and all I remember is huge crowds mesmerized by my woodcuts, a line to pay, all my large works gone, a perfect location gift from a perfect promoter, an artist's oasis to rival all, beautiful music playing nearby. Sure, the wind blew during set-up but I don't remember that part. The thing is, that perfect show just happens suddenly and often times you will find yourself redefining *perfect*. Six years ago I made less than two-hundred bucks at the very same show. This time, the buying mood was perfect and crowds just kept coming. I was high for weeks after. Perfect shows happen, some times you might have to remember them as perfect and forget the little annoyances that really don't matter all that much in the long run. And as some wise artist pointed out, those perfect shows sometimes just make the rest a disappointment.

Your perfect show might be much different from my perfect show. Some artists like smaller shows, some like larger. Some insist upon an exclusive high-end mix and high-end audience while some (me included) enjoy the variety of a…variety! Let's pick the criteria apart first, then you can apply the learned criteria to your particular needs, likes and dislikes, and most importantly the match to your particular works of art.

Promoters: Magicians, gods and evil beings (oh my!)
I have some favorite promoters who produce vastly diverse types of shows. Some of their shows are a perfect match to my product, while others, either because of location, time of year or audience type, simply are not a match at all and I end up polishing my fingernails over and over again. There are artists who follow promoters wherever they go and that's just fine if they can make each of the shows a success. The promoter is arguably the most important person in the art festival business. I definitely have some

favorites, people I consider magicians of art festivals, who always seem to be there, treat everyone with respect, reward good sportsmanship and get tons of people to show up even when the weather is cold and windy; but I will let you find yours on your own. I have done terrible shows because I refused to let go of my favorite promoters. I have refused to enter wonderful shows because I couldn't swallow the promoter or their attitude or their practices. I have swallowed entire promoters (just kidding, of course). Point is, many artists inexplicably create an antagonistic relationship with promoters at first sight. The "us against them" attitude is more likely to create problems and we don't want problems, not with the very people who are going to be, this very weekend, our business partner.

That point is worth dwelling on for a bit: the promoter and the artist choose each other as business partners for a weekend business venture. When an artist applies to a show, that artist just chose the promoter of the show as their business partner. When a promoter accepts an artist to a show, the promoter chose that artist as one of many business partners for that weekend business venture. Without the artists, the promoter will fail miserably at the weekend business venture, possibly lose money and it will be difficult if not impossible to repeat that business venture in that particular weekend again. Without the promoter, the artists have no festival to go to, plain and simple.

There are others involved in the venture, such as the city/county/merchants association, major sponsors of the event, and, of course, all other artists, food and entertainment vendors, etc. With so many people involved, really, it's a miracle that a festival gets organized and comes to fruition at all and many a festival has seen a horrible and sudden death when one or more of those partners refuses to act as such or, worse yet, begins acting solely in their own interest.

With all that in mind, it is to the advantage of the artist to keep in mind the partnership frame of mind when dealing with promoters. Once this happens more and more, success is more likely, as business partners tend to respect each other, listen to each other's suggestions and overall make the (temporary and always risky) business venture more likely to benefit all.

Getting to know promoters is therefore a priority for the art festival artist. You don't have to take a promoter to breakfast to get to know them. Just look at the application package and you know much about them. I don't do shows with more than six pages of rules and regulations, I simply get tired of reading and I start thinking of the promoter as a fuddy-duddy old woman who sits on a throne and yells: "off with their heads!" a lot. Conversely, I tend to instantly like promoters who offer things like suggested places to stay, maps to and from the site and city of the festival, tips for selling, stats on past shows, opportunities to choose location of booth, prizes with rewards like preferential placement in future shows, artists oases during the shows, and such little

things that make artists happy campers. One of the most charming touches I have ever seen at a show came in the form of a Saint Bernard, who walked the show in the mornings loaded with coffee and bagels, offering artists a bit of unusual entertainment and a welcomed breakfast after an early morning set-up.

Attend a show and observe whether rules are being enforced (a pet peeve of mine since I tend to follow rules), whether the promoter or a deputy is visible and willing to help artists during set-up, break-down and also during the show. I don't mean by this that I expect several burly young men to load my stuff out of my trailer.............

.............(sorry for the pause, I was dwelling on that thought for a moment), but merely that the attitude of a promoter can make or break a show for me, regardless of whether I make money or not. I also like well organized shows, which can mean many things to many people. The point here is that the promoter is vastly in control of the show, and a magician promoter is *very* good to find. Keep them when you find them and work on your own marketing and salesmanship to make the show a success.

A last note about promoters, whining about the weather won't help the clouds go away. After the show by all means, send them a thoughtful letter telling them how you didn't appreciate being shoved in a corner behind an oak tree, or how the six people that showed up to your booth in an entire morning just happened to pass by and nobody else in the city seem to know about the show. But during? I consider it to be bad sportsmanship to burden a promoter with a lot of empty whining about the speed of the wind.

Remember again for better or worse, there are far more shows and promoters than you can possibly do in a lifetime. Simply decide what is most important to you in a promoter and then go with the gods and leave the evil beings to wonder why they can never get enough good artists to fill their show. Oh, and there are promoters I have never met, but their shows are so good that I consider that fact a reflection of the "boss" in charge and continue to apply and enjoy.

Massive or cozy? Easy vs. hard shows

After reading the 200-best shows as rated by Sunshine Artist Magazine, I started applying to the nearest ones to me, which roughly limited the choices to those West of the Rockies (only fifteen West of the Rockies by the way, a terrible thing!). I even got into some of them and will continue to apply for the tougher ones, since I am the stubborn type. Once I got into a couple, I understood the expression "easy show." These massive productions were definitely NOT easy.

First of all, large and popular shows are competitive and expensive to enter. You might get "wait listed" which might mean that you wait until the last week before the show to receive a phone call to tell you to pack up in a day and rush over to the show. Some artists even go as far as showing up the morning of the show and hoping for late

cancellations; shudder at the thought, but to each their own. I got wait listed for the same show twice in a row and decided to dump it; I hate limbos. Then there is the matter of dishing out somewhere in the neighborhood of $500-$1200 for the entry fee, which puts undue pressure on an artist selling an average ticket of $100. Of course you count on a superb show but sometimes superb shows can be struck by sixty-mile per hour winds and sand storms and…well, they turn out to be not so superb after all.

Another feature of the massive show is that set-up and tear-down are often—how shall I describe the experience—horrible! That's how they are. Parking is conveniently located *over there* somewhere; often you have to pay extra fees to park within the confines of the show. Set-up times can be as convenient as 3:00 a.m. Tear-down consists of 500 artists and their oversized vehicles elbowing for space just next to their booth. While many artists have tandems and one rushes to the convenient parking lot *over there* while the other starts to tear down, many of us are all by ourselves and are therefore stuck with the handy hand-cart and a vehicle *over there*. Good exercise, anyway…I guess. And while the majority of the artists are nice, considerate people, everyone is pretty much thinking about themselves at this point (and rightfully so). Needless to say the process can be messy.

So why do we attend the hard shows, these massive horrible experiences? Because easy shows don't usually bring in 100,000 people who, with a wallet full of money and empty walls, have waited all year to come to the Most Massive Art Festival of Them All. That's why. Because easy shows can be cozy affairs where, lacking any customers to lure into your booth, you get to know your fellow artists all too well.

However, easy shows are much more charming and often times working a show year after year will make an easy show very profitable. Did I mention they are easy? The marketing chapter later in the book explains how to *work a show*. An easy show usually has no frills, few (and logical) rules, returning artists that behave for the most part, a good promoter that makes the show comfy for everyone. Perhaps there is easy set-up as well, where you drive up to your space and nobody bothers you while you set up your wares, sometimes set up is the day before so you can even have the luxury of a night's sleep and a shower prior to putting on your sales hat. Tear-down, since easy shows tend to be smaller, is also painless and you can dismantle everything in peace and drive again right by your space to load up. Breakfast is served, bathrooms are close by and perhaps you can even expand your space with a couple of print racks just outside your booth.

Some artists, not surprisingly, just do cozy shows after a few horrible experiences in the massive kind. So why not restrict our attendance to only easy shows? Two reasons come to mind. Easy shows tend to be more unpredictable in terms of audience attendance and readiness to buy (read $$$). Easy shows tend to be the kind of show that repeats a bit too often and you will get asked a lot if you will be "here next weekend too."

My particular preference is to do easy shows that bring me a lot of income (yeah, then I woke up). We call these "gems", "sleepers" or "jewels." These are easy on the outside but have massive hearts inside and the audience comes to the tiny park and buys up your entire booth. Promoters are wonderful and everyone is happy. As you can imagine there aren't many of these. They are tough to find and usually hide among many trial and error "dinky" shows, where everything is friendly and nothing ever happens. And, again, easy cozy fun shows are simply not as consistent as the widely advertised yearly massive events that are sure to bring in thousands of potential customers.

Through rain and sleet and torrid sun...: Indoor vs. Outdoor

After a particularly rough year where the weather seemed to turn ugly just as I set up my tent and buffet my face with wind, rain or both, I made the mistake (yes, another one) of briefly falling in love with indoor shows. Two pieces of advice: never invoke El Niño weather just before a show and never fall in love...with a show, that is. There I was in the comfort of an inside set-up, happily exchanging a bit more distance to carry everything for the pleasure of setting up my poles (no canopy top required) in the air-conditioned and shaded environment of a convention center. There I was hanging my art knowing that the treacherous wind gusts would howl outside while I enjoyed a glorious calm and dry weekend. Then, the very next day, there I was wondering why everyone was spending $5 a hundred times on diverse crafty shiny colorful things while complaining that $100 was too much to pay for a finely crafted woodcut. I sat and twiddled heartily. Surely it was a fluke, the audience was there...

There are many things I have come to understand about art festivals, but I still don't know why outdoor festivals tend to be, with some notable exceptions, a consistently better venue for fine art while indoor festivals tend to attract crafters and their audience. This is not to say that fine art doesn't sell indoors and there are many specialized art festivals that are exclusively indoors. And this also is not a matter of quality because some of the finest craft festivals are held indoors. But it seems as though, for the most part, art sells outside, even expensive art.

As convention centers and such places are very expensive to book, so the entry fees are passed on to the artist. Expect to pay upward from $500 at indoor shows, more for corners, more for facing the entrance in some cases. Expect huge crowds who have paid a gate fee for the privilege of shopping. Expect to carry your set-up and product into the convention center from a parking lot far far away. A good hand cart and patience are essential. On the positive, expect no wind or weather, which means that you have more options for fancy displaying and delicate placement of art and craft. Also on the positive, usually indoor festivals give you the *entire* previous day to set up, which means you can take your time and sweat less.

Conversely, outdoor shows seem to have a wide variety of entry fees ($50-$1200+), ease of set up, time of set up, and gate fees, although mainly due to the logistics of fencing off several city blocks, many more outdoor affairs are free. Much as promoters try to choose just the right time of the year, the weather is likely to be variable too, with unbearable heat, gusty winds, rain, snow and hail ruining many a fine show. But all in all, many outdoor festivals are held in times of balmy weather like spring and fall. Winter shows in the desert climates are wonderful as are summers in the cooler or mountain states. Why is weather such a big deal? Your product has to be protected; if you happen to do batiks on silk, water can ruin thousands of dollars of good art.

I've set up in 40 mile per hour gusty winds and packed up in pouring rain. It is an absolutely miserable experience and everything gets soaked and some things get just damaged enough to have to be replaced. You get home and you have to dry out the tent, the poles get rusty, mat board gets wavy, frames come apart, every single piece of everything has to be checked for damage. After a particularly windy show I found sand inside all my framed works, despite nice dust covers on the back. I spent a week taking all my framed works apart, cleaning the glass inside and out, brushing off the sand and putting everything back together. Usually after such experiences I start looking for good indoor shows again!

Being prepared for the weather is a must. The internet is a valuable resource when it comes to checking the weather prior to a show. Good weights and a solid tent will lessen the impact of windy conditions. During a Southwestern dust-devil I have seen unweighted tents go up in the air twenty feet and come back down skewering a neighbor tent and several large paintings, poles twisted like pretzels. I have come back to a festival blasted by 70 mile-per-hour winds during the night where some of the tents were simply gone (yeah—with the wind, I didn't want to say it!).

Under rainy conditions it is good to have awnings and bring down the tent walls that are getting hit by the rain. I bought transparent walls that can be zipped under the standard white walls so that viewers can continue to view my art while the rain soaks someone else. And incidentally, people continue to buy through rain and wind in some cases, which is why most of us sit there seemingly like fools braving the elements. Usually customers came out with the intent to get something and they know the unpredictable nature of the local weather. If they come at all, they will withstand the weather just like you and carry on business as usual. But no need to fear, I have also been to perfect outdoor shows, where the weather was sunny and cool and thousands came out to enjoy the good weather and great art. Good weather at an outdoor show puts people in a very good buying mood.

That is more or less my impression of the outdoor versus indoor issue. A good mix of indoor and outdoor shows I think is healthy for most artists. There are many more

outdoor shows for choosing but indoor shows can be a welcomed relief during a bad weather season, in the hot summer months or the cold chill of winter.

Home field advantage?

To travel or not to travel, that is the question! There are a few factors at work in this issue to be considered before making a conscious decision. If you are like me, unconscious decisions are much more fun, but since you are only young once and soon wasting time on a back road ceases to be charming, perhaps it is best to give the traveling issue some deep thought.

First, your home market can be limited or you can easily saturate an area; in any case, I find it best to limit my appearances in any one area of my home city so that repeat customers are forced to attend one or two shows at most thus maximizing sales and minimizing effort. Second, you need the opportunity and/or equipment to travel, which can be quite an investment and initially expensive. Third, the best rated shows are spread all over the country and, if you are goal oriented, you want to go onward and upward and eventually climb the upper rungs of the ladder of art festival success.

The first point may seem a bit elusive at first, but let's say you do this art festival thing for a few years in your mid-size hometown. You now have a nice mailing list of customers who come back again and again. Then you notice that many of them want to chat with you and show up to all your festivals with the sole purpose of "just seeing what else you've done since I last saw you." Their walls are full, literally and figuratively speaking. There is only so much of your art that they will stuff in their house. No problem, right? After all it is a fast growing community and there are plenty of new customers to go around...Then you notice that even new and seemingly inexperienced customers begin to ask the dreaded question: "Are you going to be at the so-and-so show next weekend?" You want to lie at that point and say that this is the only weekend *ever* that they will be able to buy your art. But you dutifully say yes, and at the other one after that and here is a card with my schedule. Now they have several to choose from, they postpone their next visit to the next art festival and you never see them again.

In addition to that, in your many years in that particular area, you have been approached by and gained entry to several area galleries. Another dreadful question comes up often: "Do you show locally?" NO!, you scream in your mind, the ONLY way to get my art is to get it NOW while I'm out here and tired and sore from setting up in the wind...but you, again, dutifully say yes, of course and hand them your gallery cards. Now they have yet another excuse to leave your booth without buying something *that day*.

Once I was next to some wonderful artists in an art festival in my hometown and had (not one, not two...but) four customers who actually told me they would buy from my neighbors this time since they were from out of town and I was local. They could

contact me any time. They didn't and they won't. I got the drift: move around; make your product just available enough and just scarce enough to encourage good sales every time *especially* in your hometown.

The other side of the coin is that people like to see you a few times before they trust you, but I think the scarcity principle rules over the trust principle. How many "going out of business" sales do you get the itch to go to? How many "one time only" offers do you respond to? Those strategies work well! Marketing is also a fine art and people respond to wise marketing strategies.

But to end the discussion of hometown shows on a positive note, there is such a thing as working a show and becoming a fixture that people expect to see in their neighborhood. You develop a following; people like to study art many times before purchasing. I now have several hundred names of actual customers that come to see what I've done on a regular basis. Some will travel across town when I miss the shows in their area. I do about two or three shows at home per season just to keep my collectors happy; I know many of them by name and like to surprise them by remembering what they bought (I can match artwork to faces a lot easier than names). That is called "working a show" and I will describe it in detail in the marketing chapter. Some customers actually ask for me by name in festivals I don't attend and the promoters let me know. If I hear that enough times, I hear a bell ringing and telling me perhaps it might be worth my while to add that show to my busy schedule!

And finally, many artists are perfectly happy doing only their hometown shows and bringing in a decent part-time income. Most of us for whom art festivals constitute the sole form of income, however, find that a nice mix of home-games and away-games is a key to continued and consistent growth and success.

Setting off into the sunset

One of the limitations that prevent people from traveling even regionally is the seemingly unlimited number of gadgets needed to take your show on the road. First thing to consider are the many barriers to whisking off the family vehicle loaded with stuff on a weekly basis. Many artists first trying out the art festival life have a *day job*, which effectively prevents them from getting the extended free weekends required to participate in an out of town festival. And it may be just fine and tolerable to do one festival or two per season, but the prospect of spending your well earned weekends setting up, braving the elements, tearing down with two drives (to and fro) on each end, can be daunting if not exhausting.

Added to the time investment is the equipment needed. While the family mini-van may be just enough to transport all your wares to the park across town, it may not like a 300 mile trip across the desert fully loaded, and the vehicle will be tied up and not available to other drivers in the family. I started out in the circuit by putting my faithful

1978 Datsun (yes, that would be the long-ago predecessor of Nissan) Galavan to work. This is a mini-pick-up truck that had been modified with a self-contained mini-camper. All four cylinders of it had well over 250,000 miles on them and while the brave little old soldier made it across town just fine happily loaded with art and display, I couldn't possibly force it to climb its way out of our valley and over some mountains to go to a festival out of town. I even did a festival by loading up the (much newer) SUV with display racks and tent tied to the roof rack and artwork stuffed in the back. It was a good trick to pull off one time, but I learned quickly that if I wanted to continue to travel out of town, I would need either a large van or a trailer to haul all my stuff in a reasonable manner. I opted for the latter.

Many artists make do with hatch-backs, mini-vans or pick-ups, so the necessity varies with product. Jewelers and artists who make smaller works don't need all that much room for their product, although there is still some display walls or tables and tent to worry about. Many pros have huge motor homes and travel from show to show with their entire product and their home too! If I were to break it down to the bare essentials, I would suggest a reliable larger van or a truck/SUV/van-trailer combination. For a few shows almost any vehicle will make do, once the commitment is made to do this for a living, a reliable vehicle that can comfortably carry product and set-up is a welcomed asset. A vehicle that combines the above and camping/sleeping ability is a plus.

Other than a vehicle, good maps and a willingness to organize your life a bit prior to the trip is all that is needed. Many festivals offer free stay within the parking areas of the festival, which can be an excellent money saving strategy. For motels and campgrounds, early reservations are often recommended. Again, I tend to combine camping, parking lot camping, and motel stays just so I don't get sick and tired of any of the above. I enjoy camping in campgrounds but for the bigger festivals I tend to find a motel so that I will be well rested throughout.

Needless to say traveling is a bit more complex and tiring than staying home. Somehow the dud shows at home are easier to take because you can cry on your spouse's shoulder, sleep in your bed and pet your cats in the morning before departing. But like everything else, the seemingly complex and numerous obstacles of traveling to a distant art festival soon become routine with a little practice. Every show is a learning experience and many of us have learned to make frequent traveling a series of adventures to be enjoyed.

Lastly, the *good shows* always seem to be out of town. I envy those who live within 100 miles of several dozen good shows (Florida, California and New York come to mind). I have made it a firm policy to only travel 500 miles or less; a firm policy which I break a few times per year. I like to try out shows that get great consistent reviews and I like to

push myself to try the best shows, those that receive 1000 applications and where sales are consistently great for most artists.

The simple reason that these aren't all conveniently concentrated near your hometown is that these shows bring in thousands and thousands (up to 300,000+ buyers!) of people. Any city, no matter how large, can support very few shows that are that well attended. Some of the best shows have become "the only game in town" through the year. Here in the Las Vegas area, we have one show in nearby Boulder City that ranks among the best attended. Folks from all over the valley wait all year for this show. A promoter would be foolish to try to establish a competing festival in this small area (less than 2 million people) at around the same time. There are other shows that are beginning to make a reputation and are starting to bring in some impressive attendance, but in any limited area there can only be so many like that.

Another reason to try to do big shows besides the fact that they bring in the numbers is what I just mentioned about the Boulder City show. Some art buyers in the West wait all year to go to Cherry Creek in the Colorado summer, Sausalito in California in the fall, La Quinta in Palm Springs area in the spring…you can fill in the name of your favorite big shows in there. These huge events have a long and reputable history and folks in the area have become faithful attendees.

In any case, these massive first-rate affairs are well worth applying for year after year and traveling well out of your desired range in order to attend. I visited one of these while I was still doing the smaller shows and had just begun to test the waters out of town. Wow! I was impressed and intimidated all at once. It seemed like all the canopies were shining white and the displays perfect and luxurious. I knew at the time I was not ready to stand my closet racks and cable ties against the "big boys" of art festivals. Later all that changed and, as I got more experienced and polished, I also got a hunger pang for the big time. Some artists jump right in and travel right off the bat, entering and getting into the big shows and enjoying a much larger "circle" of collectors.

All in all, there are quite a number of things to consider when you are deciding to travel or not to travel. Soon you will find out what shows in what areas are good to you and what shows are not worth traveling for and when it is best to stay in the comfort of your hometown or a small travel radius.

Product emphasis: Is variety the spice of life?

I don't know if you've been paying attention, but I keep mentioning the word "mix." Mix your shows, mix indoors and outdoors, mix hometown and travel, and so on. I happen to enjoy a mix of everything and despite careful reviews by similar artists, the only way to find out what a show will do for your product is to do the show. One way to limit disasters is to find shows that emphasize the products they sell.

Take these two fine shows: "Fine Art and Wine Tasting" and "The Great Craft Festival" Notice anything right off the bat? Chances are these shows will be vastly different in their product offerings because of a myriad of factors. Advertising the "Fine Art and Wine Tasting" show is unlikely to bring in many families to spend the day entertaining the kids and thus children oriented toy crafts probably will not sell very well. Conversely, in "The Great Craft Festival" you are unlikely to find many collectors of fine paintings walking around. The difference is not a matter of quality or which is a *better* show; the difference will reside simply in matching your product to the show's product emphasis.

How do you know in advanced that the promoter will stick to their guns and, if a show advertises fine art only, limit the art to fine art only? Trust thy promoter! They may be your best friends after your fellow artists. Get to know promoter and their shows by reading reviews, attending the shows if at all possible and, most of all, asking your fellow artists. I have avoided many shows that looked good *on paper* by asking veteran friends, a) if they had done the show before, and, b) what type of wares they saw for sale there. A very good friend of mine is a jeweler and, although I trust her dearly, her experience with some of these shows may be much different than mine. Having said that, most savvy veterans are very keen observers, and they can probably give you good clues as to whether the show in question is going to be a potential match for your product.

My particular preference? A mix, of course! I enjoy the large shows that bring in gazillions of people, families, old, young, retired, kids.... I do well in a variety of shows because I have a wide range of prices and sizes of offerings (a mix?). But on the point of the product mix of the show, that is, what types of things are being sold, I enjoy (read: *sell well at*) shows that have a very wide variety of arts and crafts.

I firmly believe that a wide variety of all types of arts and crafts make a better show, including very high-end specialized arts like sculpture and 2-D works, and all the way to smaller items that people can purchase on impulse like hand-crafted light switch covers and other functional items. I firmly believe that because a show with a varied mix creates that wonderful event that we call "the buying frenzy." Just like a shark feeding frenzy, when people start to open their wallets and buy stuff, they find it easier to open them again and buy more stuff. At this point, it doesn't matter what the *stuff* is, as long as they are walking around and seeing other people carrying bags of *stuff*, they want *stuff* too. And since people are naturally of a competitive nature, if they see someone eyeing and lauding a large painting, they will start looking over the shoulder of the prospective buyer to see what the big deal is about. A keen salesperson can make two sales right then and there. Buying frenzies will be fully described in the marketing/sales chapter, and you will learn how to do your very best to create one of those whirlwind successes right in your booth.

Besides mixed shows, other shows I've found to be a match to my product are select fine art shows such as museum shows and shows that attract a younger crowd or baby-boomer families. The audiences tend to be smaller at those shows and therefore competition for their money is a bit sharper. In any case, consider the mix of the show and take a good walk around to study the products in the shows where you are most successful. A bit of pre-planning and discriminating and you will have the product factor on your side on the road to the perfect show.

Audience emphasis: Who loves you, baby?

If you are a careful observer, it won't take many shows to figure out who are your most frequent buyers. Once you figure out what type of audience likes your art or craft, find the shows that bring out those buyers that like your product in order to maximize the number of people that will spend money in your booth rather than in someone else's booth. Sounds simple enough, doesn't it? Who loves your product? Who is *your* audience?

A painter next to me in one of those massive shows would walk around her booth and talk to me during those rare lulls. Her work was very unique, with a surreal style and beautifully rendered. She displayed a few original paintings and quality reproductions that she sold framed and unframed. Sometimes people would enter her booth and she would completely ignore them. In other instances she would spot someone about to enter her booth and interrupt our conversation to hurriedly introduce herself to a passerby who was only glancing in. After a while I figured out what she was doing and who she was picking as potential *and more likely* prey, er, potential buyer. She confirmed my thoughts when she glanced at an older couple and turned back to me saying: "I never sell anything to anyone over 60."

I know, we all hate categorizing and being categorized and despise profiling and being profiled, but forget all that for now because you are absolutely going to need to profile your audience. Very soon into the art festival life you, a new brilliantly observant you, notice with great curiosity that retirees seem to really like your work. Further, and more importantly, you notice that retirees seem to buy your mid-range work on a consistent basis and mature folk (the ones just prior to retiring) seem to love and buy your high-end work. You tuck that little gem in the back of your mind and begin reading the reviews of upcoming shows.

Lo and behold! Right there in black and white that show that you have wanted to try gets a review. Described as the audience most likely to attend plain as day it says that this very show attracts retirees and older residents from nearby affluent areas. What are you waiting for now? A bolt of lighting? Thunder? A voice from the heavens above to tell you? APPLY NOW!!!

Well, okay, the process isn't at all that clear cut and clean for many of us. But if you pay careful attention to those who make up your buying public, you will notice patterns. My audience seems to be young and the folks right next to young. I flunk out at retiree shows, whereas many other artists do very well. People my own age (early twent—I mean, mid-forties), especially couples, tend to buy my larger works. Younger males especially, but the whole college-age crowd tends to buy my mid-range work and yes, they do carry credit cards in those tattered blue jeans. Anyone and everyone buys the lower priced works, but it's difficult for me to make a show worthwhile when I'm only selling lower priced works. I seek young shows in young towns or massive shows where a large portion of the audience will be *my* audience. As I tend to do some surrealistic figurative stuff, the finer art crowd also enjoys and purchases my larger works, especially. Tough to get those folks out to an art festival, but there are some very select festivals that attract them. You bet I apply to those! As I have tweaked my inventory to match a more diverse audience (by offering more higher-end and lower-end works than when I first started), I tend to do okay at most shows and very well at almost most shows. And that's about as predictable as the business gets.

What if you don't notice any pattern? What if you consistently get a random mix of people that buy a random mix of your art? I've seen that happen, although not often. Then you are looking for those massive affairs that will have a fine assortment of 100,000 people walking by your booth. There truly is a show for everyone, artist and audience alike. How to get the people who love your product (but don't know it yet) to stop in and drop bucks in your pocket is a subject for a later chapter.

The perfect show? Or the perfect mix!

So is there a perfect show? After taking into consideration all the factors above, can you expect in 10 years to be doing 10K per show every show? Right? …And then you woke up! Don't get me wrong, it is perfectly possible to make ten thousand and much more in a single show but the joyous event isn't something to be expected in *every single* show. There are some people that do make that much on a consistent basis and my hat is off and I bow before them.

The perfect show takes on the disguise of a perfect—or near perfect—season. A good mix of shows that work for you I think is essential to enduring this life. Ask any old timer and they will mention some shows they do from time to time, some they do every year, and some that they used to do, tried a couple of times and found them not a match to them for one reason or another. Another strategy is to decide on an area (a state or two) with several shows that fit your needs and plan a fun circuit for a limited time like a month or a summer. Forget the duds, which eventually will happen to you less and less, and remember the good ones.

By all means if you consistently do very well at some show, repeat the procedure to eternity. Furthermore, seek other shows by that promoter or even other shows that have many of the same qualities (we talked about these just now, remember? audience,

product mix, at home or away, indoor/outdoor, big/small, and promoter). Once you have figured out the *type of show* that works for you on a most consistent basis, you are one step closer to predicting the future—a luxury in this business! And by all means continue to shoot for the stars and apply to the best shows even when you get those rejections. The best shows in the nation aren't just the prettiest; they have earned those ratings by consistently bringing artists the audiences that make artists successful.

Finally, find the shows you can live with. Many artists seem perfectly happy staying in or near their hometown and doing a half-dozen shows a season or a year. Yet others will amazingly book all the big ones and go from massive show to massive show with hundreds of miles of travel in between. Many of us have *sacred* months when we don't book any shows, just work in the studio to recharge the batteries and let the artist create. I tend to bunch my shows in two yearly bunches, spring and fall; I take a long break in the summer and another early winter straddling the change of year. Although many artists and crafters have grown accustomed to doing work here and there, I need long stretches in the studio to come up with new works, carve uninterrupted and print my beloved woodcuts. Sometimes I insert a lowly show in August and January; actually, I always insert a show in August because I like to get out of the heat of Las Vegas and there is an awesome jewel in...hey! I'm not telling you...

This strategy and schedule works well for me. Ultimately, only you can find out what works for you. Now let's take that fresh list of great festivals and step into the dressing room to spruce up your art.

Chapter 4

Presentation—Your Best Foot Forward, Please

"Ask a toad: what is beauty? ...a female with two great round eyes coming out of her little head, a large flat mouth, a yellow belly and a brown, warty back."
—Voltaire

When I first started playing this art festival game, I had a chip on my shoulder. I was already a seasoned "submitter" of applications for all kinds of things. Some of the skills I learned in the art of submission (notice the interesting dual meaning of the word?) applied to art festivals as well. Initially, I failed to see the challenge in applying for art festivals—I mean, we're talking art festivals, not international museum exhibits! So in the back of my head I was thinking that I already was a widely exhibited artist, have been shown extensively, and have become part of permanent collections, in museums and other very reputable galleries up to and including international venues. I knew how to send slides and knew what a good slide was and...darn it! And how am I supposed to have a slide of my booth when I don't even have a booth yet?

Fact is, I was all green when it came to fine tuning my application skills when targeting *art festivals*. I knew how to apply, yes, but I didn't realize these juries and promoters were just as picky and discriminating and many times just as knowledgeable as any of the museum exhibits I had previously sought. Perhaps I didn't try hard enough or perhaps I didn't send a consistent body of work or my best slides. These were art festivals! Notwithstanding my incredible experience with the application process, ahem, I immediately received a nice batch of humbling rejection letters.

Not being one to dwell much on my mistakes and failures, I quickly had the chip on my shoulder surgically removed, improved my attention to detail and learned to better apply to art festivals and consequently now attend pretty much the shows of my

choosing. Here is how I maximized my chances of squeezing in right through the front door.

Best work, right work

Yes, of course, your work is perfect and everyone likes all of it. Mine too. Now! Let's get serious about a bit of self-critique and objectivism. Look at your work and have someone else look at your work. Funny thing, when I first started I didn't really know what piece would be a hit and what would sit on my display walls forever more. I listened to what people said and, much more importantly, I took note of what people bought. If a work produced the "what-the-heck-is-that" glance from more than one passer-by, I took a hard look at that work and made some decisions about whether the artwork in particular was suitable for this audience. If a work consistently made folks scramble for their credit cards upon first glance, I took note also.

Note also that I said "suitable for this audience" and not "good or bad." This is very important because whether the art festival audience responds positively to a type of work may or may not have any relation to how good or bad the artwork is as a work of art. Remember that you are now selling art and the focus is to find out what the art festival audience wants to buy, and not so much to elicit favorable critiques from museum curators.

How on earth do you know if a particular festival will be responsive to your work? Now it just so happens that promoters for most shows are a reflection of the show's audience. If a festival offers a variety of arts and crafts and low-end woks sell very well, you can expect that the promoter will know that. Consequently the promoter is very attuned to the festival's theme and focus and to the general types of works that will sell. I had a tough time getting into a festival and finally decided, since I still stubbornly wanted to attend, that perhaps I should go scout incognito and see for myself what types of work were being favored with an acceptance letter. Surprise surprise, absolutely everything in the festival had a strong Southwestern theme, be it landscape or cowboy or native or flora—*all of it* was on the extreme of the thematic scale. My decision was to drop the festivals, rather than change my entire body of work to match one festival.

My mistake was to not have checked out the festival first, or at least talked to someone who had done the festival. I wasted precious entry fees and disrupted my scheduling plan due to my lack of research. I felt rejected needlessly because I had sent my very best work, the same work that had granted me entry in some of the most competitive festivals in the region. Live and learn.

And speaking of best work, most artists instinctively know what that is and know how to choose the best of the best. Don't ever make the mistake of thinking that just because you ran out of slides of your very best work, that those second rate paintings or dark and out of focus slides will slide through because the festival isn't all that

competitive. You just never know when someone is going to be watching very closely and in the midst of a pile of sharp applications, yours may just be left out of the running. One of the lessons I learned was from a rejection letter, carefully worded like this: "Your competition is very keen..." Remember that.

Have your artwork say: "cheese!"

At a recent festival I had the great opportunity to see a slide show of the best of category and best of show winners. Not only did I learn about the works that "make it" into the big leagues, but also about slide taking and presentation of works and enjoyed the same view that is displayed to the discriminating eyes of the jury.

Some of the publications that I recommended in the Finding Shows chapter also periodically publish articles on how to take slides of your work. I bought an entire book on the subject, appropriately named "Photographing Your Artwork". The slides in the festival slide show followed all the rules and also presented the works in a professional manner; they presented the work in the best possible light.

Eventually you may want a professional photographer to shoot your work. They know best how to avoid glare, get colors true to life, frame your image in a black border and so many more tricks. Professional photographers tend to charge a premium for their services, so it is best to approach them with several works ready to shoot. Once you have a great slide of a work, have duplicates made and send those around, keeping your original slides for posterity. To begin with and in the interest of economy, having a professional photography studio produce your slides is an investment that you may or not want to make. Although getting into the best shows of the country would almost require professional slides, to get started in your first few festivals you may choose to shoot your own slides.

Taking the digital world as an example, when I put my works on the web I first take a digital picture of the work. Then I open that digital image in Photoshop, an image manipulation and creation software program, and I proceed to make that picture of my work represent the real thing in the best possible way. I crop out the background, enhance the lighting so that the work is well lit, tune the colors as true to life as I can, sharpen if needed and, if the work looks a bit naked after all that, I place it on a contrasting background to bring out the best. If I feel like it, sometimes I even take a detail slide so that web viewers can click on part of the image and appreciate the detail of certain areas.

Well, I only know of one or two festivals so far that accept digital images with their applications (thank you!), so for the rest of them, we are for now stuck to slides and photographs. As I revise this section, I see more and more festivals now taking either CD or web digital submissions, which I believe will make the process of applying just that much easier for the artists. Learning how to take and manipulate digital images is

something I would put at the top of my list if I were an artist that did not have those skills already.

The points I just mentioned, though, remain the same; it takes some practice to get your slides to look professional. If you have the money and/or a photographer friend, by all means have them take shots of your work for you, but unfortunately most of us for one reason or another are stuck with the delightful task of recording our works on film. I guess first I will cover the WHAT your slides should look like, and then briefly attempt the HOW, although for that task you are highly encouraged to seek better sources.

Picture perfect

Some applications and a handful of promoters will give you hints on what they expect to see in a slide. A great guideline can be found in the previous year's festival catalog, where the best slides of the best works are shown. With the far reach of the internet, previewing slides from previous shows at a promoter's website can also give great suggestions on taking good slides and, more importantly, what a winning slide looks like. Really the recommendations that are mentioned in the application are common sense, but I have seen some pretty bad slides or photos even from artists that should know better. Basically, your work should be centered, sharp, lit properly and standing alone. Slide and photo will be used interchangeably from this point on.

1. First and foremost, work should be centered in the slide. If it isn't and the presentation is indeed a slide, use slide masking aluminum tape to get even margins around the work. For 2-D work, if the background is showing behind one edge of the work but the other is cropped, crop the offending background. Sometimes the safest thing to do and required in many competitions is that the work fills the entire slide with no background showing at all. Since most cameras tend to be slightly off-center from view to print (because the view finder is off to the side), filling the view finder with the work is often the safest thing to do anyway. For 3-D work, just be sure that the piece is centered against a neutral or enhancing background.

2. Sharp slides are a must, trust your camera's cross-hairs or distance settings and be sure to keep the camera still while shooting. As I will mention a bit later, two indispensable additions to your growing equipment arsenal are a tripod and a cable release. Lacking those items, be sure to support the camera and take multiple shots of the work to increase the chances of getting a good slide out of the bunch. 3-D work requires more depth of field in order to show the entire piece in focus so adjust the settings accordingly.

3. Lighting the work so that the color is represented faithfully is very important, as important as making sure there is enough light. Dark slides will project dreadfully. Check slides on a light table before sending them (most photo developing houses have them) or view them with a magnifier lighted slide viewer. If you can afford the money and space for a projector, by all means pop those fresh slides in the carrousel and view them as the judges will.

4. Make your work stand alone. This means no background for 2-D work or an even border all around. Remember the principle: enhance but not overpower. Borders and/or backgrounds should be neutral both for 2-D and 3-D works. Black or white (or off-white) are the preferred, and often required, colors for backgrounds according to judges. In the case of 2-D work, always read the application and if they ask that the work fill the slide, have the work fill the slide.

5. One last point here and that is the all important and sometimes absolutely essential *detail* slide. If the application does not discourage detail slides, you might want to consider sending what a painter called: "the painting within the painting." While the overall look of your works and the entire composition or shape of the work is the most important thing in judging that work, sometimes we artists tend to reward the viewer as they come closer with a delightful detail or two. If details are your game, show them off in a detail slide or two. I wouldn't necessarily send a detail slide with every slide, thus doubling the number of slides in your packet, but you might include a detail or two of your most important work just to enhance your overall presentation and impress some judge with your fine workmanship.

Lights, camera, action!

Alright, now I will try very hard to explain HOW to take slides of your work. Or perhaps better said, how I take slides of my work after reading two books and a few articles on how to take slides of my work. I tried several strategies and this seems to give me the most consistent results. Please note that I am just breezing through the very basics, be sure to consult some of the resources in the back of the book for much more detailed and knowledgeable information.

Basically the simple steps involved are to place your work steady in good lighting conditions and against the proper background, line up the camera with the work, focus, set the proper speed and exposure and click click click…My approach might be deemed the "poor man's" or "beginner's" approach to photographing work, although I own good equipment and some gadgets that make the whole process painless. The whole procedure does take some practice to get it all right.

As far as equipment, an SLR (single lens reflex) 35mm camera with a zoom lens is essential for 2-D work, a wide-angle or standard lens for 3-D work, preferably one with manual exposure and speed settings although good results are obtained with the

automatic settings. Again as I revise this I realize an entire year has gone by, enough to make vast improvements both in technology and affordability of outstanding digital photography equipment. Add that the fact that you can get good slides made from digital files and I have just complicated the whole issue of slide taking. Sorry about that. Although I now own and use an awesome digital camera, I still take slides with my old faithful SLR.

1. Whether 2-D or 3-D the work must be well lit. 3-D work is best photographed in controlled indoor settings where lighting can be manipulated to obtain the most dramatic effect from light and shadow. 2-D work, however, has the advantage that it can be more easily photographed outside on a good sunny day. In either case, obviously the film chosen has to match the setting so be sure to consult a good source and get indoor film for indoor shots and outdoor film for outdoor shots.

 I use the convenience of outdoor lighting with added advantage of the ease of availability of outdoor film for all weather conditions. My preferred background is a sheet of mat board, either black or off-white, which I clip with bull dog clips to a 4' x 4' piece of wood I keep handy for this and many other purposes. I then clip the artwork to the mat with the same clips. If it is windy outside, I use artist's removable tape on the back of my works to steady the prints and remove the clips from the shot. All my work is on paper or wood. For 3-D work you will need a pedestal and background covered with a neutral, black or white cloth.

2. Lining up the camera to the (2-D) work probably makes the most difference in how professional the slides or photographs look to a judge. The trick is to have the work and the camera tilt at the same exact angle or be perfectly straight with the world. Otherwise, the sides of the work will converge and give you away as an amateur photographer. The easiest way to accomplish this feat is with a multiple adjustment tripod. It takes a while to get that first adjustment right, but once accomplished all the work will be lined up correctly. Letting the work fill the entire view finder works well to correct any angle discrepancies, but then your work will be slightly distorted. It is best to spend some time setting up the tripod and work so that the sides of the work correspond with the square of the view finder.

3. Once work and camera are lined up, get out the gray card (18% gray) and read the proper exposure. I do a lot of high contrast work and it is almost impossible to get exposure right without the use of a gray card, available at your photo supply shop. Even after setting the correct exposure, it is a good idea to "bracket" several shots, shooting some at the correct exposure, some at the next aperture and some

at the previous aperture. Be sure to set the camera for the right film speed and set the shutter speed to a high setting to flatten 2-D work and avoid blurring. 3-D work should be shot at a slower speed to allow for more depth of field. Any time where detail is crucial, a slower shutter speed can also be used. If all this is complete Greek to you, get help or read through the basics of photography in your camera's manual. Although some of the more modern auto-everything cameras do a fine job at getting good slides or photos from your work, once you see more professionally taken slides you will appreciate the art of photographing art.

Focusing may seem like a step that you would not forget, but I have seen other artist's slides and could not believe how a little bit out of focus can make a great piece of art seem…not so great. This is especially important for 3-D work, where the depth of the object has to be in focus. Put your trust in your camera's cross hair system and even take the time to measure the distance between camera and art to obtain the best possible results.

4. Time to click click click, and I mean that literally. Don't just take one slide that you think is going to be perfect. Take a dozen or so of each piece of work, hopefully you saved up three or four works to all be shot at once so that you can "fill" a roll or two of film. Two items made my life much easier at this point; one is an inexpensive cable release for pressing the shutter release remotely so that you don't disturb the camera's positioning. The second is an auto-advance motor, again to prevent disturbing the camera as you advance from frame to frame. Even so, check the positioning of the camera to the work every three shots or so because gremlins crawl in your tripod from time to time and disturb the entire alignment.

Once you have spent an entire morning cursing at the wind and other foreign objects flying into the view finder, don't take your film to the nearest grocery store. Instead use a photo lab that you can talk to in case the speed of the film was not set properly and you need the film pushed and other exciting things like that. An additional advantage of the photo lab is that they can take your slides and magically give you prints and digital photos on CD from a single roll of slide film. Until all the art festival promoters of the world get together and decide to accept a single format for accepting works, the three formats will come in handy to meet any requirement.

5. I forgot the most important step. Once you get your slides/photos back, CHECK THEM before sending them. If you don't have a projector or at least a light table, a great source of white light is the computer monitor, otherwise hold them up to a bright light AND get an inexpensive magnifying viewer so that you can assess the

quality of your slides. Do not send dark, out of focus, poorly aligned, crooked or otherwise imperfect slides. Just tighten your patience belt and do it again until you get it right; I guarantee that poor slides will be a waste of your time and entry fee.

All that work may seem overkill but the important thing to remember is that your slides, photos or digital files are the only representation of your work the judges will see. You can't invite judges to your website and you can't have them over for coffee in your gallery. Those three or four valuable slides, photos or digital files are the only way for you to show the judges that you are worthy of their show; more worthy than the other hundred applicants in your category.

All those words, all those pages...

You must must must must read all those pages on that twelve-page application, every danged one of them. Read all the instructions, read all the fine print, the check-lists, the important dates summary, the release, especially the lines above the signature line that begin with...I, the undersigned artist, agree to whatever was written in this long application and swear I will never call the promoter to whine about anything. Once I received a 26 page application, no kidding, which I read thoroughly and proceeded to chuck in the trash. I mean, really...Some applications are half a page long, lean and mean, those scare me a little too I think because it tells me the promoter doesn't have many rules and perhaps the show will not be overly organized or advertised. Gosh, I don't know, give me a nice two to four page ap printed on 11 x 17 paper folded in the middle. Those are my favorites.

Oh, okay, seriously, read the entire application cover to cover. If you don't like some of the rules, don't apply for the show. I like to see as much information as possible right up front. I don't enjoy applying for a 3-day show and finding out when I get my acceptance packet that we set up the morning of the first day or that there is no available parking within miles of the show. I want to know in advance and I don't particularly enjoy bothering promoters with phone calls so I like to read applications and the more information they provide about the show, the more likely I am to apply.

And if you do apply, what is most important is that you apply correctly. It is tough, I know, all those words...READ THEM!!! Read all the instructions, send whatever the promoter asks for and do not send whatever the promoter does not ask for or specifically tells you not to send. Read all about how to label your slides properly, sign where it says to sign, send the correct number of slides, meet the deadline, do not call if it says no phone calls, and so on. My recommendation is to sneak in under the radar with such a perfect application and such good images represented by such perfect slides that there will be no excuse for that promoter to judge your application on the basis of anything other than your work.

Keep in mind that many of the better shows are very competitive, which means the promoter is looking for a way to make their selections manageable, i.e., an excuse to reject your application. The instructions stated send everything in a #10 envelope but you thought you'd send a full size 9 x 12 flat package to make you stand out? Bye bye! Instructions said nothing extra but you thought you would impress with your accomplished 5-page resume? See ya... By all means use the "best foot forward" adage and if (and only if) there is no instruction that says send only the specified number of slides, you may sneak in a detail slide or two showing off your craftsmanship.

Most of the time, though, read carefully and do exactly as you are told. Many applications will be received and many applications might be rejected because the artist did not follow instructions to the letter. What's the harm in doing it right? Let your art and your images be the decisive factor in whether you get into a show or get rejected, not the wrong size envelope or a missing stamp in the return slides envelope. Read everything, be thorough. Yes, some of the rules seem a bit silly some times but I just don't consider it my job to judge the judges. Follow instructions to the letter; label your slides as they are shown in the diagram even if you have to remount them every single time. Place that red dot wherever the promoter wants it even though you have your own ideas where it should go.

The purpose of this exercise, filling out the application, is not to get you noticed (except by your images) and not to stand out in the pile of applications (except with your images) and definitely not to call attention to the judging committee that you are already going to be the type of artist that will ask needless questions before during and after the show. Many questions are answered in the application and the check-in packet and, frankly, I get tired of telling fellow artists where the bathrooms are located and directions to the proper artist parking; it's in the application in black and white. So do yourself and everyone else around you a favor and read everything you are given. If questions arise after reading, by all means pick up the phone or send an email to clarify points unclear.

Scout the show, apply early, apply often

First spring out in the circuit, I applied for one of the biggest shows in the West. I called and received the application around two weeks before the deadline, dutifully sent in my best figurative works and dotted all my i's and crossed all my t's and...received a rejection letter faster than the speed of light. Undaunted, I repeated the process in the fall, this time sending the application a bit earlier and...received a wait list. Could it be that so many printmakers in the West were producing better work than moi? I asked my fellow artists about this incredible phenomenon (yes, I'm kidding) and they promptly told me that to get into that particular show, the main criteria was to apply early. Impossible, I said, so I traveled to the show and found indeed that my work was at par with the two other printmakers that were selling in the show, that there were more than 500 artists scattered across several downtown streets, that the quality and offerings varied as much

as any show with 500 artists can possibly vary, and that nearly everyone I asked had rushed their application to the mail box the day they received it. Next time I did the same and I have attended that show ever since.

Sometimes your best foot just does not seem to propel you forward, and then it is time to dig deeper and find out why the particular show that would fill that calendar hole so delightfully continues to send you a rejection letter, or worse, a wait list notice. In the example above, the quality of my works was appropriate; I found that out by walking the show. I just wasn't getting the application out early enough. These days, I apply for that show at the time of the previous show, which is also when accepted artists receive an early version of the application for future shows. These days, I get in every time.

I have walked other shows and found that it wasn't really the quality of my work that was inappropriate, it was the theme. Although the promoter did not specify what types of work they accept in their application (tch, tch) it was evidently clear that a Southwestern theme was the *only theme* in the show. I met the promoter and suggested that perhaps this should be stated in the application, received a look in response that resembled my cat's leer when I tickle his feet during a nap. But at this point, I felt it was dishonest of a promoter to continually rake in the entry fees from artists whom they had no intention to ever allow into their shows. Word gets around anyhow, so listen to your fellow artists…most of them.

Other than the general look-and-feel of the show, when you visit a show try to talk to the people that attend year after year. I learned that many shows, especially the very competitive and highly coveted shows, date/time stamp the applications as they are received. This means that if batik artist 103 and batik artist 107 have about the same quality work, 103 will beat 107 for no other reason that they ran to the mail box a little harder. Many promoters disclose this fact, some don't. This little helpful fact might be in the application, read it again!

Another trick I learned that is not always disclosed in the applications is that many promoters invite the same artists back year after year. They do this by sending applications pre-juried, waving jury fees, or actually inviting artists to come back because they were award winners or for whatever reason. All these are fair practices; it is the promoter's show as far as I'm concerned, as long as the promoter discloses such practices that directly affect applicants. I would always like to know if I am applying for one of 200 spots or if 120 of those spots are already compromised and the odds are less favorable.

One way to get into the tougher shows is to continue to apply year after year. Committees change, and one year the jury might like my work. Or committees don't change and one year they will give me the persistence award and let me in. Artists die and maybe I will just outlast everyone in my category. Seriously, juries may look favorably upon you if you send new works and a perfect application year after year;

maybe one time a competing artist will get lazy and send the same slides they sent the previous year. Whatever the reason, I continue to apply to the best shows in the country and receive the eventual reward of an acceptance letter.

Sportsmanship awards

So! Finally finally finally!!! You made it into the show of your dreams after years of trying and you run over to the promoter and tell them they should have let you in a long time ago because their show isn't really as good as you thought. You proceed to park in the wrong place, close early and complain loudly about the attendance and the wind. NO, of course you wouldn't do such a thing. I have seen an artist pull up an hour before set-up officially started with a long truck and trailer. He blocked several spaces and proceeded to the check-in area. When nobody was there to help him for another hour, he took it upon himself to drive through the grass, trailer and all, and unloaded his sculptures on several other artists' spaces. At check-in he found out that his space had been changed and argued rather loudly with the promoter. Finally he was allowed to keep the space at the expense of three other artists who had to move. Lucky me I discovered my booth location would be within earshot of the gentleman so I was able to *enjoy* his company throughout the show. During the show he was boisterous and complained about everything, he was asked to move his vehicle both days of the festival due to improper parking across five customer spaces. He began tearing down about two hours before closing boasting that he had made enough money. The promoter quietly commented as she walked away, "last time."

Really it is a privilege to be admitted into some of the competitive shows, nobody likes to admit it. I love to finally get into a show I have been applying for. I smile at everyone; I shake hands with the promoter and tell them what a nice show they put together. I make it a point to park in the right place, close at the right time, open early, go to the artist's dinner (why would you turn down a free dinner?), give the category winners a big applause and generally try to be the best show-citizen I can possibly be. When people call me teacher's pet, I just bark back at them.

Mostly, and more importantly, I tend to follow the rules. It's easy: first you read the rules, and then you do what the rules tell you to do. If there is a rule that starts out with Don't--- then I Don't. Rules are meant to keep law and order in a business where everyone is their own boss and has their own ideas about what they want to do and about what they want other people to do.

Rules about parking in artists' parking were made because some insensitive folk (insensitive to good business practices) parked right behind their booth thus preventing customers from parking behind their booth. Rules about not breaking down early were made because some insensitive folk started to tear down when their sales went cold and thus, by showing customers the show was over, prevented everyone else in the show from staying open until the last minute. Rules prohibiting representatives were made to

protect us all from unfair competition by the cheap labor mass produced trinkets that anyone can find at Wal-Mart. Think just a little about why that particular rule might have been put in place and chances are you will find a logical reason. Think just a little about being a promoter for a minute; I personally don't want the job of trying to enforce law and order on 300+ free-living and free-thinking artists, no matter how well behaved they might be. Be a good sport as much of the time as you can be. That's all anyone can ask.

There are no sportsmanship awards, incidentally. There is really only the clear fact that if everyone mostly behaves most of the time, things will go more smoothly for everyone and that includes you and me.

Like a dog with a bone...

Following my own advice still didn't get me into some of the shows I wanted to get into. Even more puzzling, sometimes I got into a fairly competitive show, and then just when I thought I was "in" I received a rejection letter the following year. Then I got in again...puzzling! When I get puzzled by something, I figure I'm missing some key ingredient in the recipe for success and, being of stubborn nature and curious as a dead cat, I investigated deeper. There in the depths of the promoter's bag of tricks, I discovered that elusive concept called "tenure."

Tenure, as well known in University systems, simply means you have earned your stripes and are now a permanent member of the show. Tenure, whether officially or unofficially, is given to artists that consistently receive good audience reviews, have good sales, follow rules, or simply get to know the promoter after a few years. Unfortunately, tenure is not defined in any book, whether by the promoter or a higher power, so many promoters embrace "tenure" as a way to keep their cadre of artists without having to explain to anyone how those artists can get in year after year or how another hapless untenured artist may someday through some magical spell, obtain and retain tenure.

But promoters aren't audience ignorant, in fact many know their audiences better than the artists, and so they understand that a fresh new look for their yearly festival is essential to that festival's survival. No promoter wants their faithful attendees to take a fast look at the festival and turn around saying: "same as last year."

So now you have a show of 200 booths, 120 tenured artists, 12 or so returning invited award winners, about 60 spaces reserved for fresh look artists...and little room for much else—oh, and 800 applications. Keeping the show high quality and problem-free yet varied enough to hold the interest of the audience is a big task for promoters; perhaps presenting a bigger dilemma for artists that really want to get into that show but get initially rejected. In any case, just learning about what might be going on behind the scenes makes it easier to swallow that rejection pill year after year. What to do?

Be persistent, doggedly so—but be ready to let go of that bone when all the meat is gone. There are a lot of shows out there and sending $20-30 dollars year after year to a

show that never accepts you is just silly. Find out as much as you can about the "system" that the particular promoter uses to accept and reject artists. Don't ask other artists, they will fill your head with urban myths and dubious rumors—either ask the promoter very politely, someone close to them, or just observe and find out what's going on.

Who's behind the two-way mirror?

One very important factor that deserves special mention and comment is the jury process. Some of the better shows kindly and perhaps candidly disclose their jurying process in excruciating detail; the vast majority of promoters do not. Promoters are certainly under no obligation to do so, legally or even ethically. Putting myself in the shoes of the promoter, I don't know if I would either. Artists can be cranky people; keeping one artist satisfied most of the time can be difficult, keeping all artists satisfied all the time is impossible. But it is always to an artist's advantage to discover who is looking at our precious slides.

More and more of the important shows have blind jury procedures, whereby the name of the artist is withheld from the jury's eyes and the art is judged solely on its artistic, creative and professional merits. Although this is usually the most desirable jury, every show has different procedures for showing slides, reviewing photos or projecting digital files. Knowing the type of jury and the jurying procedures helps us artists fine tune our applications for the various shows and, more often than not, the better application has the better chance for acceptance.

Roughly there are three types of juries, the single promoter, a recurrent jury committee and an independent non-recurring jury. Some shows mix jurors, keeping a person or more as a permanent juror and adding different juries for a fresh look year after year. Yet others invite the top award winning artists to jury for the subsequent year.

One set of eyes

First and foremost, a single promoter (or a single promoter and his/her closest associates) reviews the work and decides single handedly, often as they receive your materials, whether you are in or out. If you are in, everything is honky dory and you can enjoy acceptance into that show every time you apply unless you do something stupid to ruin the relationship. If you are out, however, you have a problem. The reason for rejection might be that your slides weren't up to standards or that you simply didn't put your best foot forward, followed directions or something of the like. But the reason may also be that there were too many applicants in your category or another perfectly reasonable explanation. Unless it says specifically NOT to in the application, it might even be worth calling the promoter to find out what they are looking for if you can manage a reasonable conversation with someone who just rejected your work.

However, with single promoters it may well be that the promoter simply doesn't like your work. Probably in this case the promoter won't tell you that straight out. There could also be other reasons, for example they have already unofficially tenured artists in

your same category that apply to the show year after year; or the promoter doesn't feel your work matches the audience; or your price range doesn't match the audience.

Point is, it will be very difficult if not impossible to get into that show as long as that promoter is in charge of that show. If the location and the show are so appealing to you, a face to face meeting might be the solution, or at least the resolution of the problem. Also watch for a change in promoters, sometimes they simply hand the reins to someone else but the show…well, the show goes on! That might be a time to squeeze in "under the radar". If all else fails, move on. There are tons of shows and tons of reasonable promoters, let go of the one that doesn't fit with your work and look at it as a simple mismatch of your work to the promoter.

Group-think

Committee jury shows might be more forgiving than single jury shows, but the fact remains that the same people every year have the same taste in art every year. More important for the artist attempting to get in, is to attempt to find out who the committee members are; many times they will walk the show and it is advisable to stay in good terms with such nice people.

An advantage of a committee jury over a single promoter jury is that you and your art may find an advocate among the members who can convince the rest of the jury that your work is worthy of the show. A huge disadvantage is what is known in business as "group-think," where a leading member may declare something about your work that nobody else wants to dispute. In groups, often a leader can sway the entire group to think one way, or a strong member can keep other members from speaking out.

What this all means for the artist is that even though a committee may be a good thing because of the variety of opinions, it may also be a bad thing because of a tendency to think like an individual. In any case, committees many times have a point system that makes things much more equitable for the artists than a single jury. Often it is difficult to get the entire committee together and as a consequence committees judge artists independently, award a certain number of points for pre-defined categories (such as creativity, technical merit, display appeal, etc.) and once all the points are tallied, artists can be ranked and accepted or rejected as the case may be. This system is widely used as an impartial system that is not influenced by other jury members.

Finally, committees often use invited jurors to participate in the process, so in addition to the permanent members of the jury, new fresh eyes are added yearly. This addition of new jurors keeps the festival offerings fresh and gives artists a fairer chance to get into the competition.

Wandering eyes

In an effort to be completely impartial and attain the best choice of quality art possible, the hired jury was invented. By "hired" I don't really mean paid because more often than not, jurors are asked and volunteer to serve in the festival's jury. This type of jury always employs a point system or rating system of some type, has strict jurying rules, which together serve to give artists of quality the best chance of getting in for the first time and thereafter. But who are these jurors?

Again, some of the better festivals simply post their juror's names on the web or send artists a list of jurors right along with the application or acceptance or both. A not so quick glance at past and current juries for various festivals reveals the identities of these folk as award winning artists (participating in the festival itself or not), local or national gallery owners, museum curators, university professors, and art educators. There are many others such as present and past art organization members or officials and a wide variety of generally knowledgeable art people who have graciously volunteered to look over thousands of slides and fill out hundreds of forms, tally points, give some slides a second look, tally more points, devise tie-breakers, and finally…FINALLY!, come up with the ideal mix of artists that will give a show and its artists maximum success. Remind me never to volunteer to be a juror!

Taken all into account, I actually prefer the hired jury, especially one that varies from year to year, in my opinion this being the closest possible approximation to the elusive *impartial jury* that we all seek. A different jury ever year means a better chance for a varied festival from year to year, and a better chance to get in for artists who continue to apply to these festivals. The primary disadvantage of the hired jury is that entry into one year's festival does not necessarily mean you can count on that festival next time since a fresh set of eyes also means different preferences.

Breaking up is hard to do

So you try year after year to get into this wonderful festival where everyone makes a bucket of money and you receive letter after letter of rejection. What to do next?

Take it on the chin and let it go. Tough words, I know, but really at some point we all have to quit buying $20 letters of rejection. If you miss them that much, write yourself one for free! I know of an artist who wrote a letter to promoters who rejected him that went something like this:

> *"Dear promoter/gallery owner:*
> *Although every effort is made to accommodate every rejection letter received, we are afraid your letter of rejection could not be accepted this year. Letters of rejection are received every day and it is difficult to make such*

decisions. Your competition is keen, please review the points below to improve
your rejection letters so that you may gain acceptance in the future.
 -Be sure your rejection letter is concise and to the point
 -State in your rejection letter exactly why the rejection was sent
 -Try to make your rejection deadlines earlier
 -Personalize your rejections; they will be better received by artists
We encourage you to keep rejections coming and thank you for your interest."

Humorous! The point is, rejections come for many reasons which may or may not apply to you. I recently gained acceptance into a festival that had puzzled me by rejections year after year. The rejection was puzzling because the quality of the work shown at the festival varied widely. I applied earlier; in fact, I applied the day the application came out on the web, about two weeks before they were mailed…presto! I've been in ever since.

There are shows, however, that simply don't match my work, or single jurors that simply don't like my work. I now have let those go and save myself the entry fee and the nail biting. There are just too many good shows out there to be fretting over a single show. I have learned over the years to simply ignore application packets coming from shows that don't match my work. I actually enjoy having the promoter spend .78c every year and use their applications as cushion for my recycling bin. Small victories…

What does it all mean?

I currently live in Vegas, so the term "legalized gambling" is very familiar to me. Understanding the jury system in art festivals is one thing, being able to "beat it" is another. In the end, find out as much as you can about the juror or jury system for the shows you want to enter. Sometimes your favorite show only has one juror and it happens to be someone you despise or someone who just can't stand the type of work you do. Let it go and seek the shows and promoters that jury and treat you fairly.

Me? I love to roll the dice! I apply for the best shows every year, up to three years in a row. Then I figure that my current work is not a match to those shows, cut my losses and try something else. Shows are shows and there are tons of them. The best shows are good because year after year they give their artists great results ($ales). But this does not mean you can't make very decent sales at other shows if you find and work your audience and stubbornly pursue the right strategies for success.

If my back and truck hold up through the years, I also assume that my work will improve and my presentation skills will improve with time, since I am not one to stand still for very long. So maybe I will try again in three more years. Entering shows can be a bit like gambling, but if you put your best foot forward then you can be assured that at least you gave it your best try. Success will come in time.

Let's get the show on the road, shall we?

Chapter 5

Starting Out (Be Prepared...Be VERY Prepared)

"Following the sun, we left the old world"
—Inscription on one of Columbus' caravels

Commitment: "I do!"

When I first started out, I talked to a bunch of people about this business, picking their brains about the whole complicated life of being a gipsy artist. I remember to this day everyone's advice and the diverse attitudes that people had about their chosen way of life. I talked to many people who had tried their luck in art festivals once or twice and they just didn't work out for them. I talked to many artists who do an art festival or two per season.

But what I remember most was the degree of commitment that the full time artists showed. Art festivals were their chosen life now, there was no day job, no alternate income, nothing to fall back on except more art festivals and hopefully better weather and a better economy next time. To this day, the committed artists' advice was the best advice I received because once we commit "for real" we are not playing around with art festivals, we are making a living solely with art festivals.

So does this mean that an artist can't just try a few festivals and see how they work out? Well, not exactly, but in this crazy business, the degree of commitment is directly proportional to the degree of success. A half-hearted Costco shade canopy with five borrowed easels holding paintings is going to give vastly different sales results than

a professional canopy with display walls and thirty or so works hanging proudly around a well designed booth.

Commitment does not mean that a new artist needs to run out and buy all of the best equipment to do their first festival, we all started with the bare minimum and grew as our businesses grew. But a bare minimum is necessary and a nicely put together display is necessary and, most importantly, a good dose of "committed attitude" is absolutely necessary. If an artist is not willing to give art festivals a good year or (better!) two and willing to learn the ropes and willing to take the hard knocks, there is no sense in trying. One or two art festivals simply will not give anyone enough experience in the business to give minimally satisfactory results. Face it, you're getting married! This is no "living together" trial; dive in and give it your all, pack up a smile and about a hundred pounds of good attitude, come'on along and we ol' timers might even give you a hand now and then...otherwise, stay home and avoid the broken fingernails. Seriously, you owe yourself the most honest and energetic attempt you can muster.

Equipment: "All that?"

Being of meticulous nature, I went to a few art festivals before I started and looked at a variety of displays before embarking on my first...YEAH RIGHT! What I meant to write was: Being of impulsive and reckless nature, I just signed up for a local art festival and then started thinking, now what? How do I show my stuff? What if it rains?

My first display consisted of a rented tent (you will find these are particularly ugly and often dirty...did I mention dark and with NO walls?)...where was I? Oh yeah! A rented tent, four easels that I hastily made—oh, alright, my husband and I hastily made two days before the show, an office supply store receipt book and a stool to sit on. I think I had a pencil too, and the second day I remembered to bring a hat, sunglasses and a cooler full of Gatorade. The easels were about 6 foot by 4 foot, legs had to be screwed on site and taken apart after the show to fit in my poor over-abused twenty-year old mini-motor home. My prints simply leaned against the easels. Clever, I thought, but had it been windy, I would have been in deep doo-doo (art festival terminology, glossary in the back of the book).

Thanks to my dear husband, who showed up a couple of times to see how I was doing, I was able to walk around the festival a little bit. This particular festival was very small and not many experienced artists were present, which meant my booth wasn't the worst looking...just nearly so. Anyhow, I spotted a small gallery—wait! It was just a booth! But oh my oh my, beautifully arranged in a gallery like manner. The "gallery" was composed of a white shining canopy with white shining walls, carpeted walls arranged in a clever **L** so that work was visible from every angle, a "back room" where the artist sat quietly behind a tall carpeted desk conducting business. I asked a lot of questions, I'm sure I sounded stupid but got some good advice. I want to find that man and show him my display today but one thing you learn in this business is that people come and people

go and someone helping you is to be savored that moment because you often don't get a second conversation.

Needless to say you can also start the same way, but if I had to do it again, I would have investigated the issue a bit more prior to signing up for my first festival and would have given my first try a more honest effort. The experience was not very pleasant since every moment I felt that I could (and should) have prepared much better. So let's get to the business of enumerating the seemingly overwhelming lot of "minimal" equipment that is needed to embark on this ship.

Weather-proof

Like a ship at sea, prepare yourself for the ravages of the weather, and stay prepared even when the forecast says otherwise. Just this year I was soaked by an early spring shower in Scottsdale, Arizona (famous for its arid weather and an ongoing 7-year drought), whipped by 50 mile per hour gusts in my own home town and drizzled and buffeted by freezing rain in the (otherwise) beautiful Rocky Mountains. You and your artwork have to be protected and protected well, both while you are present during selling hours and in the not-so-still of the night (when the wind "really" blows).

First thing's first, you need a canopy. Most people starting out and unsure of their art festival future buy a pop-up type (e.g. E-Z Up, Caravan). These have the advantage of being inexpensive, easy to set up and compact to carry and the disadvantage of being light and easily whipped by the winds. Properly secured, they are still a bit too flimsy for my taste but the majority of art festival pros use them and swear by them. The walls are attached with Velcro straps to the frame and only some models have zippers so the walls can be secured to each other. The peaked tops look great and very festive, but tend to act like a sail in the wind, gather water in the rain and have been known to collapse under the weight of the water or snow (hey! I said BE READY for weather!). If I sound less than enthusiastic about these is because I have had one land on top of my own canopy during a particularly nasty windy night. I had to tear down my booth to lower my own canopy enough to retrieve the rascal safely and never even received an apology from its owner.

The other general type of canopies is the non-pop-up type, composed of a set of break-down poles and a tent-like top (e.g. Trimline, LightDome, Show-off). These take longer to set up, are heavier to carry, take up more space to transport and can make you curse when you catch your fingers in the snap fixtures. They are also more expensive than the pop-up types. Advantages include complete zippered walls which also attach by zipper to the top making a tighter enclosure for more security. Some included or optional features are vents and skylights in some models, sturdy construction that withstands windstorms better than the pop-ups, optional awnings and half-walls and rounded roofs for better wind and water shedding. I consider these a bit more versatile, sturdier and even better looking, as the dome inside gives more apparent space than the visible awkward framework of the pop-ups.

All in all, the decision to invest in a sturdier model or to purchase a pop-up depends on what is important to each artist. My first tent was (and is) a Trimline, still going strong after twelve years. My works on paper framed behind glass demanded good protection from the wind and rain and I live in the Southwest, often subjected to sudden gusting winds. I don't particularly mind the longer set-up and can now set up my tent in about 20 minutes longer than it takes to put up a pop-up. I confess that in some fair weather two-day shows, I wish I had a pop-up, but I've invested in awnings and other amenities for my Trimline, so I don't think about it too often. I enjoy the versatility of being able to set up a 10 x 10, 10 x 15 or even a 10 x 20 by expanding my awnings. I purchased clear walls for rainy weather and like not having to hang on to my tent during the wind. But it is considerably bulkier, heavier to carry and does take longer to set up and break down.

Display like a peacock

I have talked about my first wooden display easels, now chopped up for firewood and assorted home projects, including a handsome dog house. My second display set-up consisted of those white grid metal closet shelves you can buy at a home improvement center. These worked very well for a long time, I stood them up vertically and tied them to each other with plastic cable ties, making a grid wall that allowed me versatility in hanging and much display room. The only problem I had was that I had no flexibility of display, the walls formed a 10 x 10 three sided display with a table in the middle. Progress costs money, so soon I started surfing the net in search of a professional solution. I saw the carpet panels, but the price! At that time, I just could not justify 10 panels at $120 each! Also at that time, the manufacturers charged more for colors other than a medium gray and I just don't dig gray as a background for my work.

So, next I purchased a set of display grid panels, lightweight and much more professional looking than my closet shelves. They also set up much more efficiently than my grids, so my set-up time was considerably reduced as was the weight that I had to carry when my booth wasn't exactly near artist parking. This constituted a vast improvement and a setup I kept for several years.

With more progress (read: made some money!) I eventually invested in the carpet gallery panels with adjustable legs and of a nice buff color. I hated them at first because they caught the wind during set-up, which didn't happen with my grids. But they do look much better, I admit, and have the advantage of making solid walls I can hide behind when I am feeling shy. Seriously, my work shows off much better and sales, as all the pros pointed out before, have increased since I invested in a better display.

So what's the moral of the story? Well there are as many display solutions as there are art media, and even within the medium some artists choose vastly different approaches to their display. All I can summarize is some general points on how to find out what type of display an artist might need. Here are some quick guidelines that should work for all:

- Peek at some art festivals before you invest. If you sell pottery, look at potters' displays and try to find out where they got or how they made their display.

- Make a note of your display needs (walls for paintings, shelves for pottery, boxes or bins for prints, pedestals for sculpture, etc.) and search real live art festivals and the web for display solutions.

- Read art festival magazines and trade publications and search the ads for appropriate displays and maybe even some great deals on used equipment.

- Invest in the best possible display equipment you can afford. Better displays aren't just prettier; they actually will bring more sales.

- Get what you can, make what you can, but promise yourself to progress as sales improve until you are absolutely comfortable with the thought that your display is not the factor that is making all those customers pass up your booth.

- Be creative. As with accessorizing a plain dress, there are many ways you can dress up a less expensive display to make your work look its very best.

Later in the Great Adventure chapter I will throw in some "neatness" pointers that may seem obvious but sometimes I pass by people's booths and shudder at the display. Oh no, that sounded snobbish, didn't mean it that way, but appearances are everything and a sloppy display or cardboard boxes showing under the table just aren't conducive to attracting sales. You will find out in a later chapter that you have about two short seconds to attract the attention of passersby, so spread out your plumes like a peacock and proudly display what you have. But for now we're just talking about what kind of stuff you need, not how to set it up. There's so much to know!

Please step into my office

I joke around with my customers all the time, asking them to "step back to the office" so we can take care of business after a purchase. Truth is, I have pared down "the office" to a single carry-on size rolling bag that holds everything I need to conduct business. The clever little thing was designed for business travelers and has a back that becomes a fold-out table. I love dropping people's jaws when I unfold it and pull out my receipt book and credit card processor right out of the case and place them on the "table."

Business? You say, "But I just want to peddle some paintings…" Well, like it or not, you're in business and, whether you declare yourself an official business or a hobby, you at least need to conduct yourself like a business. Think of an art festival as a series of shops in a gigantic outdoor mall. Customers expect to walk into a shop, buy something,

pay for it however they like, and have their item wrapped up and ready to go. Sometimes they even want their purchases delivered, shipped, or carried to their car. And the keen business person needs to be ready to fulfill every customer's need or risk them going as far as the booth next door.

The back of your booth becomes office and warehouse alike, where business is conducted, receipts are written and tallied, repairs are made to broken frames or nicked sculptures, and extra stock is kept for that lovely moment when you need to fill a void in your display, left by a freshly purchased item. These "backs of the booth" are often a bit messy, after all a 10-foot booth doesn't leave much room for neat stacks, but try to keep yours as neat as possible because customers will sneak in there and promoters might object to a messy back office. Besides, you want to conduct business efficiently and that is only possible in a neatly organized and efficient establishment.

Here is a list of essentials for the traveling "office":

- Business cards will be your most popular item. I made just that clever comment at a recent festival and a woman responded wittily: "well, the price is right." Funny. Fact is, you will give out many business cards and it's good to do so even if you know for a fact they will end up in the trash. Never know when someone might travel to your website after the show is over (you ARE going to have a website aren't you? More on this later!). A post card with your upcoming shows or galleries is also nice to have handy, but I'm getting ahead of myself and into the marketing chapter.

- Receipts not only show you are serious about your business, but they become yet another piece of paper stamped with your name, address, contact information and catchy logo that the customer receives and looks at for at least a second or two. Receipts also, of course, are meant to keep accurate track of sales, taxes, and inventory. Got a calculator or two handy?

- Bags or boxes or blankets or tissue or craft paper or whatever you must use to "wrap" the valuable item you just sold. Most of us have used trash bags for light items, the kind with the handles look nice enough for shopping bags, but bulk colorful shopping bags are cheaper in the long run if bought in quantity. I have seen artists hand a naked item to their customer and turn around, leaving the customer to wonder how they will get their nifty little something home safely. Many artists think of themselves as traveling gypsies without much room for niceties; customers always think of you as a full fledged business store and every self-respecting business gives bags or boxes for purchased items.

- Take credit cards? You will need your trusty credit card swiper, radio, cellular or good old fashioned manual imprinter (*knuckle buster* to the trade) and the all important credit card slips. Also a cell phone for those huge purchases that have to be pre-approved or for those rare times when reception is lost to a nearby mountain. Keep your calculator handy for figuring taxes and discounts.

- You will need something to put cash into, depending on how much cash business you do. I highly recommend carrying a fanny pack or small tasteful purse or big pockets to carry your cash on your body. I have heard terrible things about cashboxes walking away. I sling a cutesy purse across my shoulder in the nicer shows and opt for the fanny pack in the blue-jean shows.

- Needless to say, have your common office supplies handy, staples, and pens, scissors and screw drivers and knives, paper clips and glue, mints and bungee cords and a hundred other things that will continue to accumulate in your portable office—just in case! These little things will become obvious once you need them, and I promise in three or four years you will NOT have to stop at Office Depot after the first day of the show to stock up on price tags (did I mention price tags?).

- Another essential is a small tool bag or a large tool bag or a huge tool bag with— tools, of course! Depending on what you do you might need a few framing supplies, a few booth fixing implements, a couple of screw-drivers, a hammer, some spikes for grass and nails for asphalt (shhhhhhhhhh) to secure your booth in case of high winds, bungee cords, more bungee cords, assorted spring clamps, trash bags and duct tape. Six or seven years down the line you should have everything you need and I promise you won't have to rush to the nearest Home Depot to get rope so you can tie your booth to a tree during a windy night.

- A chair for you to sit on during the show is essential, of course, and a small table to conduct your business is a nice touch. Everything should fold or stack or double as something else so buy things with that efficiency concept in mind. For example, an upside down art container covered with nice cloth makes a nice office table.

- Don't forget to be able to fix or customize whatever you sell. For example, I sell prints and I always carry a few framing touch up supplies and the proper tools for those delightful moments when a customer wants THAT print but in that OTHER frame. We aim to please.

I will finish with a last word about all these little "necessities." You certainly don't have to be ready for everything, and so at first you really won't need to carry all that stuff. You simply won't know what you need until you need it. And, it's probably okay to borrow something sometimes, but don't become a chronic borrower because the word will get around and people will shun you like the plague. I personally love it when someone asks me for something I have because it makes me feel vindicated and gives me justification to throw yet another gadget in my already overflowing and oversized tool bag. But when the same person asks me for three or four "essential" items during a show, or for batteries and other things that cost me money, I put my foot down.

And a covered wagon!

First festival that took me out of town I was faced with the mountain of STUFF that constituted my tent, display, product, office and peripherals. Having worked at UPS before, I knew how to neatly pack a mountain of square boxes into a small space, but all this stuff was irregularly shaped, non-foldable, non-stackable and there was simply way too much bulk to fit into anything short of a bus. Immediately, my old 1978 Datsun Galavan, a mini-motor home on a mini-truck frame, filed an abuse law suit. While the law suit was going on, I had no choice but to resort to the GMC Jimmy, who snickered the entire time I grunted and shoved, shoved and grunted. Eventually, I bought a trailer. The abuse law suit now includes the Jimmy, who blew a crankcase gasket pulling the trailer over the mountain pass between here and California and is now collecting permanent disability.

Seriously, the point is, even if you don't travel out of your town you will need a trailer or a van or a large enough vehicle to carry all the nifty panels and large paintings or sculptures…and that huge tool bag! Here are some options for toting wares to far away places, without bias to one or the other. I think in this case, like in many others in this business, everyone chooses what suits them best.

Many people make do with the family mini-van or SUV or even a regular ol' car. This is good for smaller displays like for jewelers or potters or small sculptures or other works that don't need display walls or multi-level shelves. Usually this type of vehicle can comfortably accommodate a pop-up tent and a couple of tables, chair, and so on. A major advantage to using your current vehicle is that you don't have to invest in another vehicle. A disadvantage is that the vehicle has to be completely unloaded after every show and the supplies and equipment stored somewhere in your lovely dwelling.

Pick-up trucks, uncovered or with a camper shell are a good solution to carrying full size panels, or a pole type tent, or larger products such as some sculpture or paintings. Obviously uncovered trucks have to be covered by a tarp once loaded unless everything is water proof, but the advantage of a pick-up truck is that it was made to haul stuff and loading and unloading them is easier than, for example, a station wagon.

A larger van or a dedicated mini-van is a great solution for many people and those non-descript white cargo vans are probably the most common vehicle in shows. Advantages include large cargo and weight capacity, single vehicle parking and maneuverability, and in most cases, the ability to leave at least some equipment stored inside between festivals.

Probably the second most popular solution is the truck/SUV/van-and-trailer tandem. Trailers come in many sizes, the smaller trailers are probably the most common solution for the medium and larger product artist (sculpture, painting, glass, pottery, wall hangings, metal, wood, etc.) and the larger trailers for the very large product artists such as life size sculptures. Advantages of a trailer include the larger capacity, ability to store between shows, and the ability to drop trailer on site and have a smaller vehicle to get around. There are occasional maneuverability problems in some shows where streets are narrow or space is limited, and trailer owners soon get used to carting our stuff a bit longer stretches or waiting for the vans to leave and spaces to open. You never quite forget the first few experiences at backing between booths and vehicles, or having to manage a u-turn with inches to spare in a small parking lot in San Francisco under the watchful eye of the parking lot security guard (not that it ever happened to me).

Fewer artists have box vans, very large capacity trucks (like moving trucks) or live in motor homes and travel show to show. Disadvantages of very large vehicles are parking and maneuverability, and these artists are resigned in many cases to carting their entire display and product very long ways. On the other hand, they don't pay for motels and are always in the comfort of their own home. Something to be said for that!

I opted for the smallish trailer SUV tandem, which allows us to have a "normal" vehicle to get around but with enough power to pull the trailer for my trips. Once I unload the trailer, I try to drop it on site and lock it up tight (including a nose lock and hitch lock). I am then free to move about until the last day of the show. In some cases I magically transform my utility trailer into a camper with the aid of selected camping gear and I even installed a sun-roof and an inside lock so I can enjoy fresh air and the stars wherever I sleep. Works for me!

Other than the commitment and the equipment, I know I have mentioned this before but it is worth repeating, attitude is the most important ingredient in this trial. Many artists engage in negative self-fulfilling prophecies and even comment aloud that they are just "trying this for a couple of festivals to see if it works out." I have news for them; IT isn't going to do anything! IT just sits there just like the artists sit there with a scowl on their faces waiting for money to fall magically from the sky.

There is no IT, there is YOU and your newly acquired positive attitude. Other key ingredients requiring commitment are being prepared and doing vast amounts of work

over and over again. You are pretty much alone in the quest to make this life succeed or not. And you won't have much time to try to make much awaited first sale...read on.

Chapter 6

You've got 2 seconds! Marketing and Sales

"Hell, there are no rules here - we're trying to accomplish something."
—Thomas A. Edison

"The door of opportunity won't open unless you do some serious pushing."
—Anonymous

Ready for your first show? Let's—hold on a minute! What exactly are you going to do when someone walks into your booth? Are people going to walk into your booth? Think you can talk them into buying a $500 art-do-hickey? Who are you and why should they? Would you walk into an outdoor festival and drop $1000 on a gipsy artist's lap for a sculpture on any given weekend? Know someone that would? Fact is, if you build it they will come...and look at it, but getting them to *buy* something at any price requires yet more work on your part.

I will approach this first from the salesmanship, then the marketing angles; yes, I know the title of the chapter says marketing first and then sales, it just rings better that way. They are different concepts, both absolutely essential to the consistent success of any artist. Woah! Did you see that word? CONSISTENT? Yep, I saw it, that's the key to succeeding in this crazy business, building some kind of consistency in sales over the long run, not just having a good show now and then. Here we go.

"The theory of compressed air"

Bear with me, this is only a theory, but I have seen it with my own eyes so many times that I am close to absolute proof, declaring it a physical certainty along the lines of the law of gravity and centrifugal force. I am sitting at my booth, dutifully demonstrating the art of the woodcut by carving on a piece of cherry wood. Children

flock to me, as they are exempt from the theory of compressed air, and I explain to them how to do woodcuts (if they only had teeny-tiny credit cards in their tiny pockets…sigh…I would be a rich woman today). Sales come and sales go all morning but my booth is now empty despite a healthy crowd just outside.

Those empty "time bubbles" usually signify it is time for a break, and so I head toward the row of portable restrooms…unknowingly followed by a stream of compressed air! I don't notice this right away, but were I to look over my shoulder at this precise moment, I would see my booth fill with people. And they are not just passing by, these people will look carefully at my art, browse through my bins and read every sign. I've snuck up and watched them do it. In fact, I have challenged the theory and entered my booth at this moment, hopeful in making a sale to one of these obviously very interested parties…only to have my stream of compressed air push them away just as I enter the booth and greet them heartily.

Is this possible? I test the theory again and again and it works! I leave, they come in as if sucked by the vacuum I just created, I come back, they leave as if pushed by an unknown force—Eureka! I've discovered a new physical law! Wait a minute… In all seriousness, salesmanship doesn't just happen. Many artists sit in the back of their booth and let folks browse at leisure, then greet them politely and strike some sort of a conversation with the prospective customer. Some are more insistent than others, some simply wait until the customer is ready, yet others push harder and make an open offer. Salesmanship is a matter of style. I have read many books and articles on salesmanship and rather cut off my right arm than employ some of their tactics, even if I could possibly pull them off. I have improved over the years, mostly by reading and practicing and educating myself a little and carefully watching those sales pros pull off sale after sale. Among all the tactics and tricks, I found my own way, one that suits my personality and I feel more or less comfortable with. Salesmanship is as personal as your art, and if you aren't comfortable with your own sales tactics, failure is imminent no matter how successful the tactic.

But as usual in this business, there are some things everyone can do to maximize their sales success. Some of these I have seen and some I have done. Everyone will find their own style in nabbing those sales, but the thing that does not work is doing nothing and expecting the customer to grab your stuff off the wall and pull out their wallet. *That,* I guarantee, does not happen…very often. So it's up to you again.

The Theory of Compressed Air shows us that there is a fine mix of unknown elements and some ethereal components in the art of making a sale. But there are also some known elements and controllable components and those are the ones that we need to learn and sharpen and hone carefully and constantly.

Salesmanship: You've got 2 seconds!

Watch people at an art festival. They walk and talk and glance at the booths in passing. The bigger the festival, the faster they walk and talk and glance at the booths in passing...some times the pace of the festival is so fast it makes me want to install a drive-thru window! They want to "do" the whole show! Never mind that I spent four hours last night setting up a delightful gallery with ins and outs. and never mind that I spent two hours this morning straightening out frames and washing glass and never mind that it takes me forty hours of carving to make just one large woodcut...I, like everyone else in the show, have about two seconds to attract the attention of customers passing by. Really! Look at them go by, some of them miss your entire booth and glance only at every other booth while carrying on a hearty conversation with their shopping buddy! How dare they?!

You need to become a little of a people watcher because the mood of a festival is fickle and jumpy as a hummingbird in a flower garden. Immediately after a show begins, start people-watching and see if you can figure out the mood. Is it going to be a "wait and see" show? A "jump on them" show? A "grabbing it off the walls" show? A "pulling teeth" show? Is the audience in a shopping mood already or are they walking around looking for lemonade and hot-dogs? Are they looking for presents for everyone they know, just bought a new house and need new stuff, or are they walking aimlessly, happened upon an art festival and stopped to enjoy the sounds and sights? You need to figure it out fast and be flexible enough in your strategy to accommodate THEIR mood. And you need to stand out, to make them drop their cell phones and their conversations and attract their attention at all cost.

What you need is a way to make them look at YOU for two seconds: a colorful banner, an inflatable Gumby doll, a clown with a sign, a set of road spikes, anything!!! We call those show stoppers, and you do absolutely need one.

Show stoppers

To choose your own version of the show stopper, you need to remember that two-second rule. Test this if you want, pick a festival and walk around and try hard to walk slowly enough to get a good glimpse at every booth you pass by...on both sides of the row—impossible! Show stoppers are all about TELLING the passing audience who you are and what you do in less than two seconds. Think of fish swimming hurriedly in the vast ocean and toss in your loaded lure among 200-plus other loaded lures...what wiggly, colorful, tasty thing are you going to dangle in front of the fish so that they land in your, rather than your neighbor's basket?

Needless to say show stoppers can't be road spikes or Gumby dolls, but do include colorful banners, some are sort of gaudy and some are very tasteful. Some fly out into the wind and some are firmly attached to the fronts of the booth. Simple rules for

picking a banner would include making it tasteful, large enough to attract attention but so that it stays within the confines of your booth space, colorful is a definite plus, large letters and catchy slogans that make people STOP and read; example: "Alice in Wonderland: Watercolors by Alice Wonder" versus "Alice's Watercolors". Yeah, corny, but effective! In the world of sales and marketing, all is fair.

Other signage that is very effective is a sign that matches the art. I have seen a full façade of wood in front of a wood turner's booth, a leather skin with burned lettering in front of a leather artist's booth, a metal sculpture holding a sign in front of a metal sculptor's booth, and so on. These are probably the most effective show stoppers because they tell the passing audience in a single glance who you are and what you do.

Signs and banners are not the only show stoppers, size works too. Larger than life sculptures or paintings also work very well. Even if most of your sales are medium range and small pieces, having a larger than life work even if priced in the multi-thousand dollar range, will make people take a second look at your booth and that is half the battle. And imagine your delight if it sells! Jewelers and artists who sell smaller items solve the show stopper problem by posting very large posters of their work easily visible from outside the booth. And small size works too, by the way, because people are instantly intrigued by little things they can't quite see from the outside of the booth and when they see a whole bunch of little "somethings" deep inside the display case, they just have to come in and investigate what those little things are.

Color and sparkle are obvious show stoppers and I really envy painters and metal artists who shine with their color and sparkle leaving the classic woodcut artist to compete with contrast and detail.

Whatever the show stopper, have one. Bring that piece that you don't intend to sell but that everyone you have ever shown it to says: "oh my GAWD!!!" Everyone has them and this is the time to plant that thing right in the front of your booth.

One caution about show stoppers is that they should be used with good sportsmanship in mind. The fluttering banner I spoke about at the beginning of this section fluttered right in front of one of my panels, completely obliterating one of my pieces. I asked the offending owner of the banner politely—twice. After the second half-hearted attempt on his part to prevent the fluttering, I simply gathered it and tied it to its pole with a cable tie. Next morning the banner was loose and aflutter again and within the next hour, having an unlimited supply of cable ties, I tied it again. My neighbors called me rude, I called them insensitive.

Your show stoppers should attract attention without interfering with your neighbor's display, disrupting the flow of traffic, or otherwise infringing upon another artist's right to make their sale. Be a good sport and keep your show stoppers inside or

above your booth, not out in the traffic's path lest the promoter is the one big fish that gives you a second look. Music is usually not allowed, neither are megaphones, large SALE signs or anything tacky and unsightly. Read the show's rules and pick your show stoppers carefully and they will work to get the fish to the lure...now all you have to do is make them bite!

...And people stoppers

I was dutifully carving my block at a festival when a heavily pierced and tattooed person of the female persuasion came in and screamed: "oh my God! You just opened my third eye!" The conversation evolved (or deteriorated, depending on whose head your ears were located) into a nonsensical babble of third eyes and alter egos and ultra lives and other things I dare not mention.

In another woeful occasion I was verbally assaulted by an overenthusiastic gentleman who "saw my suffering" and it was his suffering too and how coincidentally wonderful that we should meet in this life and have a chance to suffer together for a few miserable moments. Eeeeek, dude!

Why would you want to stop people from coming into your booth? Well, aside from the two examples above, you don't! But these humorous instances may come in handy when you are tired and the wrong kind of folk comes into your booth to do some crazy thing, in this life or another. Consciously or not, I see many artists engage in behaviors that are obvious people stoppers. The funny thing about people stoppers is that you will never know what happened or that anything happened for that matter. You simply will not get any healthy traffic flowing through your booth and sales will be few and forced and you might be left wondering why.

The most common people stopper is the artist. As a general guideline, it is appropriate to be visible and available without interfering with either traffic flow into the booth or browsing space. This approach allows the artist to wait for the right moment, politely offer help, talk to customers and answer their questions, or just sit back and wait for that wallet to peek out of the purse.

Especially obvious as a people stopper is the artist who stand or sit smack in front of their booth (or partially into their neighbor's booth!), blocking the path of people to come in and browse. Understanding personal space, a 10 x 10 foot booth is a very small space for shopping and anything blocking the entrance will deter folks from going in to have a better look at your precious gems. If the booth is set up like a jeweler's or some smaller items sellers with a counter type of set-up, the artist faces the customers and gives them that familiar small shop feeling while standing behind their precious gems.

I have seen artists sit on a tall chair or stand in front of their booth, arms crossed, dark sunglasses on and staring out into the crowd like the bodyguard of some Hollywood star. I, for one, am too scared to go in there! I recently saw a group of five artists standing in front of their booth yapping and laughing away, leaving little room for

anyone to walk between them and their own booth. I have seen couples set up a chair on each side of their booth and sit like two stone gargoyles in front of a mansion's gate. Let your customers have a look at your booth without your (undoubtedly) handsome face in the way. Your booth should be like an inviting and happy open house with attractive artwork enticing customers to come in, without doormen or lions at the gate.

Best placement for the artist seems to be somewhere aside (space permitting) or toward the back of the booth, semi-camouflaged by your own priced products so that people notice the art first, then the artist, and so that they can easily browse at leisure before feeling pressured to buy. If space permits, place yourself aside your booth, where you can be easily seen but your booth front is completely unobstructed. My favorite place is completely behind my booth but with a good view of my booth's contents. This allows me to completely ignore the people with third eyes yet promptly hop to the sales task when a young couple (my most common customer) waltzes in and starts drooling over my art.

Many booth setups allow the counter approach, where the display itself is a barrier between the salesperson and the customer. This arrangement works very well because it is very familiar to the shopper and also allows the salesperson to watch over their goods without interfering. I admire artists who adopt this type of setup, jewelers especially, because they face the public constantly and there is little time and room to fix their hair between customers. These artists tend to be masters at the craft of salesmanship, they talk to the public constantly and reap heavy sales; it is well worth everyone's time to watch them and learn.

Another kind of people stopper is the artist's behavior. Generally, artists and their helpers should conduct themselves as if they were employees at a gallery or gift shop. How many times do we walk into J C Penney's and find the employees gathered around a table eating lunch? Sure we all have to eat sometime, but laying out a slab of bar-b-q ribs at high noon on your office table is going to do very little to keep the customers that venture into your booth. Another little secret: lunch time is usually a very busy time during most outdoor festivals, so eat early or late. Discreetly keep your food hidden from view and take bites here and there. Otherwise, just get out of the booth altogether, eat your ribs where you won't disturb the crowd and then come back in when you are done.

Boisterous talking with fellow artists or long-lost friends is another people stopper. I know it's really nice to see each other and catch up once in a while, but do it behind the booth or out of the way of traffic to your own booth and to your neighbor's booth. And speaking of your neighbor's booth, standing in front, even by a single inch, of anyone else's booth is really bad behavior. Bad enough customers do this all the time, but when fellow artists block my display from view, I cringe and very firmly ask them to

move. Everyone is in the festival for the few precious hours of a single weekend to do serious business, I would hope, so leave the socializing for the time after the canopy walls come down. Needless to say keep children and pets out of the public's way, no matter how cute and lovable they are to you.

Lastly, the display layout can invite or reject people in a subtle way. If everything can be seen from the outside, nobody will come in for a closer look. If walls are placed closing the booth's front except for a little opening, few people will venture into the "cave" to see what else is in it. Study your layout and see if the display invites people in or forms an impeding barrier. Place large items toward the back so they attract people inside. Don't block the path into the booth with print bins or a single chronic bin-browser will impede traffic into your booth for a long stretch of time.

In summary, think like a shopper when setting up your booth. At this point of the festival, the display should not be about the comfort of the artist but the comfort of the shopper. I confess I take a long time to set up my panels each and every show because each and every show is different in terms of traffic flow, light into my booth, width of shopping alleys and neighboring artists. I ask myself if I would notice my booth among the others, if I would notice anything in my booth that would attract me to go inside and if, once inside, the layout is conducive to browsing. It's not about me and my comfort, at this point, it is all about the prospective customer and I want to make sure their shopping experience is best inside MY booth.

Someone's in my booth! Someone's in my booth!

Scary, huh? Here's a real "live one" and now you have buck fever, don't know what to do, don't know what to say, you crack a stupid joke and the prospective customer gives you "that look" (oh my gawd, IT TALKS!) and walks out like a rattle snake just bit'em. Oh, don't worry, that happens even after ten years in the art festival business. Point is, what do you do now?

Well, you got past the two-second look thing and now you have 20 to 40 additional seconds to talk this precious human being into pulling out some money out of their wallet. Think about what it takes for you to pull some money out of your wallet and you can begin to see the difficulty of the delicate task at hand. Generally speaking, you need to explain (in twenty seconds or less) WHAT it is that you do, WHO you are, and WHY they should purchase one of those whatsies, right NOW.

Before I get into particulars, I confess I am a huge fan of demonstrating art at the booth if at all possible. This accomplishes all of the tasks related to sales problems and I don't have to say a word. In fact, there are ways to tell the customer all about who you are and what you do without saying a word. I call this the interactive approach and many customers appreciate the gesture of being left alone to look and feel and explore on their own. Other customers like to ask questions and to be spoon fed, but they are easy

enough to please; just answer these busy beavers and, like your mother taught you, speak only when spoken to. But I'm getting ahead of myself and salesmanship is best broken down into the three easy to swallow aforementioned pieces: What, Who and Why. Let's begin with the What.

WHAT is this thing?

I have actually been asked that very question, which didn't make me feel overly competent about my signage—but maybe this person had never seen a woodcut print before they walked into my booth, which happens often. If your art is as obvious as painting or watercolor or stone sculpture then half the battle is won because the customer is now feeling very comfortable with your products and knows exactly what they are looking at. If, however, someone walks into your booth full of embossed and hand-made paper collages and says, "nice pictures" you've got some work to do.

First you have to explain what it is that the customer is looking at. This can be accomplished with a simple sign explaining the process, a sequence of "work in progress" stages, a tastefully framed newspaper article about your craft, a well made step-by-step poster, or by your carefully worded spiel that elaborates on all your mysterious methods and secret processes. I guarantee you will get tired of telling folks what you do and you will begin sounding a lot like a National Park guide leading a tour. And be prepared for a variety of reactions because, much as your process fascinates you and your family, some customers will simply develop a horrible scowl on their face and walk away in a panic when they don't readily recognize what it is they are looking at; they won't even give you a chance to explain. This is why I highly recommend the silent approach first, a nice poster, sign or a live demonstration. After the customer is intrigued by all this wonder, then chime in with a few words to illustrate the process.

I have even seen a clever ceramics artist play a video on a small TV screen in the corner of her booth. Talk about grabbing people's attention! A brilliant idea because everyone is extremely familiar with watching TV, and as a consequence she had a constant flow of folks who stopped and watched the video; then once their attention span for passive entertainment elapsed, they started browsing her offerings, knowing all the effort and time that was involved into making one of the pieces. This is a key point so I'm going to repeat it: make sure your sign, demonstration, video, poster or dancing clown, clearly and concisely show how much work, patience and specialized skill goes into making whatever you make. Oh! And make sure that having demo videos or dancing clowns is allowed at the festival.

Another very important point to emphasize in these attention-getters and explanatory tools is the uniqueness of your work. I touched on the uniqueness quality a little in the chapter about defining what it is that you do; this is the time and place to emphasize it, rather loudly. What is different about your work? Even if the customer

thinks they know exactly what you do (oil on canvas), tell them that you put real crushed pearl in your whites and real sandstone dust in your skin tones. Tell them you make your own brushes from your own pet squirrels because that's the way you learned it in Italy, where you studied as a child just across from Michelangelo's old studio. Tell them something memorable, something that makes them say "oh, wow!"

Other approaches that work are simple brochures or even post-cards placed conspicuously where they pretty much jump into the hands of the customer. These should again, concisely but clearly explain what you do and what differentiates your work from the other thirty painters in the show. And these handouts should be about as nice as you can afford. For one thing it's tougher for anyone to throw away a nicely printed full color brochure on cardstock paper with shiny coating, and for another, this is your business now and the more professional approach you apply to the business, the better results. Customers want to deal with serious business people; and serious business people don't hand out bad copies on cheap white paper.

Does all this mean you can't talk if you love talking? Oh gosh, no by all means talk to the customers if you are a born people-person. Everyone should find the approach that works best for them, and if your comfort zone includes talking to hundreds of people every day and engaging them in conversation, then more power to you. But the signage and information brochures will still come in handy when that customer steps out and says those dreadful words: "I'll be back" Then your only recourse is to shove the literature into their hands to help them remember what it was that attracted them to your booth in the first place. Many brochures will end up in the trash, granted, but many will also end up being read and if there's a website clearly printed at the bottom, perhaps something else might develop.

If right now you don't know exactly what to put on a brochure or a poster and there haven't yet written about your work in the local newspaper, listen! Listen to your customer's questions; listen to fellow artist's questions. Develop a set of Frequently Asked Questions (FAQ's) and you will know exactly what most people want to know about you and your art. Undoubtedly the same questions will come up again and again and it will save you and your customers a lot of time to jot down the answers and let them read at leisure…while you take care of this other customer!

My approach includes about all of the above, except I don't use posters or newspaper articles. Being a woodcut printmaker, I carved a woodblock sign with the woodcut process and made a print of it. Turned out to be a wonderful show stopper too, people stop and read about how to make woodcuts and at the same time get suckered into my booth to look. When passersby see a crowd forming in front of my booth, they peek in to see what the big deal is all about—why didn't I think of it sooner?

Once I get them inside the booth, I jump in right away and let them know I'm carving in the back or ask them if they have questions, or, if I'm nervous enough, crack a bad joke. Once their curiosity has been peeked by my sign, their questions tend to be more focused and they already know what they are looking at aren't "peechures" but woodblock prints, and the darned things take time to make and are sort of a unique art. And with all those little battles won, the war—I mean, the sale is closer to becoming reality. If they leave, I make sure they remember me and give them a handout that has a ditty about The Art of the Woodcut on one side and a ditty About the Artist Maria Arango, on the other. Let's talk about the About the Artist thing.

And WHO are you anyway?

Yep, you guessed it, I have also been asked that very question. I answered: "I am The Great Maria, Last Keeper of the Woodcut Art." I got a chuckle from the customer and also a sale a bit later. Couldn't really help it, I get awful nervous when asked to talk about myself and humor is my natural defense. I think many artists feel the same way.

But the fact is the people buying your art are going to want to know something about you, especially when purchasing the more expensive fare. How do most artists get over the hurdle of self disclosure? I have seen many approaches, some more tasteful than others.

First and foremost is the brochure I mentioned in the previous section. Talking or writing about your art is a lot easier than talking about yourself, which is why in this case the newspaper article comes in really handy. Regardless of the size of the publication, a nice article about you written by a professional writer is a huge plus because it accomplishes two purposes: the article tells the customer who you are and makes you look important enough to have been published. Lacking this gem, have someone write about you or write about yourself in the third person, as if you were a reporter. An added presentation bonus is if the brochure you make up is in the familiar format of a two column newspaper or magazine article.

Once more, the brochure should be at least neatly printed on subtly colored paper, at best full color in good quality brochure paper. And the write up should again emphasize your uniqueness as an individual; as a reported once said, everybody has a story. Don't just merely talk about your artistic career as if writing a boring resume, a lively biography including some personal data gives your prospective collectors a sense that they got to know you a little bit. And believe me, people who buy or will buy your art want to know you!

I was lucky enough to have been born in Cuba and raised in Spain, something unusual, and I start my About the Artist handout with those exact words. That factoid about my life is interesting and serves well to draw people into reading more. I don't dwell on that too much, moving right along to how I happened to become a full-time

artist at mid-life and touch upon why I do what I do hopefully without getting overly mushy. I love what I do and I want to make sure the people who read three paragraphs about me know that. Remember you are selling yourself in a few sentences, what do you want people to know most about you? Answer that and you have your brochure.

Of all the signs I have in my booth, about my art, about my process, and about me, the latter is the one that people read most and with most interest. Go figure.

Needless to say boasting excessively is in poor taste and also transparent to the keen public eye. World renowned artists don't do street art festivals. I guess I should mention here that one newspaper article and perhaps one or two ribbons from prior festivals are probably in good taste. But taking the concept to what we call the "brag wall" is unnecessary and reeks of excessive self-importance. I have seen artists fill an entire wall section with articles, prizes, certificates and ribbons, leaving the customer to wonder where the art is. We all have the ribbons, strutting them excessively is not exactly considered good sportsmanship. And frankly, in a 10 x 10 booth, your walls should be full of your art. But neither be overly shy or secretive, the buying public wants to get to know you a little, especially when making an investment in your artwork.

WHY and why now? Buying frenzies and a recipe to cook one

Well, now you have the customer in your booth, have explained your process, they got to know all about you and they are as good as a fish in the basket, hook, line and—"do you have a card?" *Aw naw,* dreadful words to hear from a customer's mouth. Do-you-have-a-card does not mean that they will contact you necessarily or that they love your work necessarily, although it might. Do-you-have-a-card usually means, but not always, that they are leaving now and they will shove your card along with many other cards and you will never hear from this person again, perhaps.

An artist had a business card printed with only one word on it: "NOW." I am sure customers didn't appreciate the touch of humor, but the artist had a point! Now! Buy my stuff NOW!!! It's starting to drizzle, I'm 500 miles away from home, I set this stuff up for you in the raging winds, I'm sore, you like it, face it, you love it...buy it NOW!!!

Well, we can't very well say all those things, but something you do at this point will make the difference between a sale and a "be back" or a "do-you-have-a-card?" How do you create the need to buy your stuff and buy it right now? How do you push that customer teetering on the edge to that final wonderful event called "I'll take it!"?

It is time to observe the crowd again. It is time to observe that particular event often seen at smaller item arts and crafts booths: the buying frenzy. Buying frenzies just seem to happen unexpectedly, usually (remember the compressed air theory?) one begins just after you return to your booth from a well earned rest. Buying frenzies happen when two or more people are in your booth, they browse casually...which attracts other casual browsers...now when three people are in there, other people begin

to wonder what the fuss is all about…rubbernecking into the booth, they await…Now someone actually grabs something out of a bin or a shelf, and someone else looks over their shoulder thinking, wait! Did I want that? They begin eyeing each other and if something attracts them, they make sure they add it to the stash in their hand lest that other person gets it…oh the joy…

As your eyeballs try to follow the entire event, like trying to follow all the fish in an aquarium, you begin to perspire and your right knee might start shaking uncontrollably, but you confidently wait patiently and casually, very inconspicuously step back slooooowly and warm up the credit card swiper so it won't pull a muscle during the inevitable incoming rush of sales. Then, suddenly, the first customer comes at you and you dutifully and quickly ring up the sale, then the next, two more are sighing sort of still browsing but really "in line." How did this happen? How can you make it happen all the time?

Well, all the time would be wonderful, but a spoonful of psychology, a half cup of salesology, and a pinch of luckology…and you too can create a buying frenzy that even piranhas will envy. First, you have to have people in your booth, usually two, three is better, more than five is chaotic. Hopefully you have been reading and you did all the things needed to get people into the booth. Once you have your tiny hapless crowd, browsing your work, reading your signs…come on out of your back room and start talking, not just to one but to at least two at a time. Make sure that you address at least two "competing" costumers at once because this way you create competing interest for a particular item. Point out something about that item, a curious story, something unique, how long it took you to make it, the curious character of the material, the dream that gave you the idea…then! Move on, quickly, to a related item that is similar but has something different about it and talk about that with as much enthusiasm and zeal. We artists tend to work in series or within a particular style, and it is good to point that out to your victims—I mean, your customers, right at this moment, because you want them thinking about several items at once.

See what you've done!? You have given them the WHY they should buy your stuff. Neither customer knows exactly what they want but their interest is tickled and now they are wondering which precious piece of art the other is thinking about buying. What if I decide to buy Blue Boy and SHE wants it? What if SHE gets Red Cat but later I decide that's the one for me? They're nervous…you've started the soup, let it simmer, move on to the next customer, hopefully still browsing and leave the first two alone for a second but keep an eye on them; tell them you will be right back. Browse with the third or fourth customer, talking about those pieces or about your art in general, but watch carefully! And as soon as one of the original customers makes a move, a sigh, a glance towards you, say some magic words that will precipitate the blessed event: "Are you

ready?" "Taking that one home?" "I see you decided on the best one!" "I really enjoyed making that one."

Most of the time, a nervous glance follows, these are serious shoppers and they don't like to be rushed BUT! YOU have just created a NEED to buy NOW. Oh delightful delights, you will hopefully spend the next 20 minutes to half hour taking care of two, three or more sales. The time when this worked the best I actually made four sales worth around $4500 within an hour's time, and I sold a large framed print twice, since one customer took one with them and another wanted the same. I suggested quickly that they could purchase it and I would deliver the next day—and they did!

Even if only dealing with one customer at a time, this sales strategy works well. First, create an interest in your work and give the customer a reason to buy from you. Each customer will be different, so make sure that you watch and listen as much as you talk, or more. You have to find out what particular obstacles are preventing this person from buying right now, this very moment and then try to address their objection with a solution. A bit more on this later, but the main thing right now is to listen and watch, pounce when appropriate and back off when the signs aren't there.

Some customers will let you know with body language that they already know what they want, just need to choose between the last two. Leave them alone, your work is done and any interference by you at this point may blow the sale or prompt them to walk away to "think about it." Still more customers, without telling you, are trying to decide between your art and someone else's, so be prepared for them to simply walk away. But while you have them in your tiny booth, give them every reason to purchase from you.

However, once they have chosen you, still the task remains of creating the impulse to buy now, before they leave the booth and see other things, before they remember that other metal worker at the other end of the show, before it starts raining, they fill their belly with food—now! Delicately infer that this is a popular item and sells almost every festival; or hint that you will be happy to hold the *purchased* item for them until they are done walking the festival; offer them a break in the price *now only* if they are really resisting, usually the sweet smell of a good deal pushes most people over the edge. Think of something that will precipitate the sale, anything! Or sometimes, when they are being particularly difficult, pretend you've lost interest and walk away politely, saying something like: "Feel free to think about it, just let me know when you are ready." Ready? They will exclaim! I was born ready! Wrap it up, now!!!

Closing the sale

Well, or not. Be well prepared to work a customer with all your charm and salesmanship and have them walk away to "think about it." It's what professional shoppers do. You will learn other tricks by watching good sales people but don't discount the artists that approach sales with their booth in lieu of their mouth. The quiet

sellers sell with their art and with carefully and cleverly posted signs. They leave very little room for questions and give customers the control to browse at their leisure and purchase when ready.

Closing the sale is a huge delicate subject but it all boils down to removing as many obstacles as your customer imposes until there is nothing but a gentle downhill slope to the final step: the amicable exchange between money and art. Any time you make a business decision, think of the customers and their mental and physical obstacles. Take credit cards? Take checks? Do you ship worldwide? Do you have that in a smaller size? Can I look at your website? Will you do any other shows in this area? Will you be back next year? Can you pad my purchase for my travels? Do you have change? Can I take a picture with my cell phone to show my wife? Will you be here after closing time so I can show my husband? Can you come early tomorrow? Say yes to most of those and, obstacles removed, you will be closing sales right and left.

Granted you will not be able to tailor your business entirely to everyone that walks into your booth, but when the customer is finally ready to buy the slope to the sale is very very gentle and easily reversed. Be delicate at that point and just shove them enough to get them to open their wallet. Push too hard and watch them retreat back up the slope to the "do you have a card" stage. But do make sure you at least nudge them a little, because without any pressure at all they will find it easier to retreat to the "maybe-stage" and pat themselves on the back for not having spent any money. Listen to the customer, remove obstacles, and then gently close the sale. "Are you ready?" "Would you like to pay for that now and pick it up after you are done with the show?" "Should I ship this for you?"

In the end, you will do what is comfortable and that is the only way it will be natural enough to work for you. Customers are as unique and different from each other as pebbles on the beach, and a single approach will not work with everyone. Learn to say the right things and the clever sales tricks, but more importantly, learn to listen, and learn to wait.

The Art of Marketing: Back for more

Alright! Not a bad festival, sales were good and salesmanship is in the bag. Later you casually walk over to the next booth to tell them the story of your piranhas and you see that this other artist is calling her customers by name. Not only that, they have her calendar in their hand and promise to be back again for more next time? Wow…more learning to do. How does she know them?

Welcome to marketing! The brother of sales, marketing is the single most powerful tool that I have surprisingly found missing in the arsenal of many artists. While sales may depend on handing a customer a card with the word NOW on it, marketing is the patient sibling and hands the customer a card with a scribbled 10% OFF written on the

back. The front of the card has my name, email and website. My scribbled initials by the 10% OFF, tells this customer they are special: I took the time to offer *them* a discount and a personal invitation to come back.

Marketing includes working the audience and working the shows. Marketing is the single most important tool that will assure consistent and continued success. Like watering and feeding a delicate plant, marketing cannot be done just one time. Like watering and feeding a delicate plant, marketing has to be adjusted and tweaked and results have to be carefully observed and measured in order to assure the health and longevity of the business. Like watering and feeding a delicate plant, if marketing stops, the plant's health is in severe jeopardy. Rain may fall on the plant saving its life, but in order to assure consistent and continued success, you cannot count on occasional rainfall to water the plant, and nutrients, well, they just don't fall from the sky. Enough with the botanical analogy, let's get real.

Feeding the hand that feeds you

I've talked in previous chapters about how to find the specific audience that is a match to your specific artwork; marketing is more about feeding that audience. Funny thing is, many artists I talk to think the general public is generally stupid and the way to get *them* to buy from *us* is to trick them with some gimmick. There is definitely a prevailing attitude of *us against them* that I don't really think helps any artist sell. I love my audience. I love when they come back for more; I love when they look for new stuff, when they respond to emails, when they come into my booth with the postcard that I just sent them and yell: "Hi Maria!"

Let's study the fishing hole analogy again; you are on your first fishing trip. You don't really know what type of fish you will find, what time they feed, what weather they like, what bait to put out except for some general acquired knowledge of fishing and fishing holes. So you fish and you try some things and you make some mistakes and you learn something and you go home with a decent but fair catch. Next time, you know a bit more about these fish, you get up earlier and you bring the right kind of bait, wait for the clouds to come in, toss the bait in the right hole just next to the shore where you saw them feed last time and lo and behold, you go home with a much bigger catch.

Art festivals are a little like that, you have to get to know your holes and your fish! After a few years in the circuit, I feel a bit apprehensive when attending a new show because I have no prior knowledge of that particular location or audience. I am counting on first time buyers, people that have never seen me or my art before, and I am hoping that someone that has never seen me or my art before is willing to give me a few hundred bucks for my art. Tough task!

Getting and keeping collectors is not easy. There is a lot of competition out there and most people like to collect from different artists, but if you persist long enough, you find that collectors take pride in their collections. This means that you need to feed them

new and exciting things every time they come. But I'm ahead of myself again, because retaining collectors comes after acquiring collectors. The game is all about rewarding your audience so that they become your collectors; it is all about giving them something so you can eventually get something back. Getting your audience to turn into collectors really is about feeding the hand that feeds you.

Getting and keeping collectors: Your bread and butter

The first and easiest tool for getting collectors is a guestbook with the purpose of getting names in your mailing list. Two easy ways of gathering names are to have an actual guestbook where people can readily sign name and address or a business card bucket where they can drop in their card. Since many professional shoppers don't carry business cards, I prefer the guestbook approach. I also prefer that they write the name and address themselves, because this way I avoid the feeling that I coerced them to give their address and plan on sending them junk-mail. If they sign, they remember they did and that usually means they really want to be in your mailing list. Why is this important?

When I first started out I asked everyone that came into my booth to sign my guestbook, quickly resulting in a list of names of folks who were very obliging but had not intention of ever buying my art. At .39c a mailing (it was then only .29c), this free-for-all strategy quickly got very expensive. Now I wait for people to voluntarily sign the guestbook without saying a word (these are the best kind of prospects because *they* sought *you*). Alternatively, when someone obviously likes my art or stays in my booth longer than the average thirty seconds, I ask them if they would like to be in *my* mailing list. Make sure you specify that it is your mailing list because many people believe that artists in an art festival are like a troupe of circus entertainers, that is, we all travel together, belong to the promoter and we'll remind them when the art festival is in town again. Another good strategy is to tell them that you will only mail them once in a while with a calendar of your shows. Nobody likes junk mail.

With the advent of email, I now also keep an email list. The advantage is that it is much cheaper, but the main disadvantage is that it is very easy to delete an email, whereas a postcard with my calendar sometimes can reside behind a magnet on the fridge door for quite a while. But for quick, "I'm coming to your town next week!" reminders, email has become the cheapest and most immediate way to contact your prospects.

With this wondrous mailing list tool in hand, you now can send postcard reminders, kindly provided free by most promoters. Frankly, I don't understand artists that don't take advantage of this free resource. Timed correctly, about a week to two before the festival, a postcard reminder can make the difference between a great show and a mediocre show. Your collectors will come to see YOU at the festival because YOU sent them a postcard. They pretty much feel good about that and they will probably

reward your gesture with a sale. I have had many shows where the majority of my sales came from my repeat customers. Had I not sent out a mailing I would have not been able to make a profit at all with just the new business that came to the show.

Yet another easy way to pamper your collectors is to send them a Thank You card right after the show. In addition to collecting addresses in my guestbook, I routinely collect the address of everyone that makes a purchase from me. This little morsel costs very little and I can't count the number of comments that I have received in return. When I didn't have many collectors, I also sent them all hand printed Christmas cards, but that soon turned into a huge chore!

Along the lines of keeping your collectors informed and interested, a newsletter is a great tool to assure keeping them interested in you. Remember that your audience collects your art, but they really want to get to know you, the artist and the person. I don't know why this works and I'm not sure I like it all that much because I tend to be a private person when I am not in my booth. But the truth of selling art is that tradition dictates that the artist becomes a part of the art and people love people-stories.

A very successful artist living in Japan publishes a newsletter that pretty much reads like a life-long diary. The professionally printed piece comes to my mailbox every three months or so and tells all about what he's been up to, who he is hanging with, what progress he has made on his latest series and even a corner reserved for his family's stories. Collectors LOVE this! They love getting to know you and, even if you make up a persona just for this purpose, it is really a very cost effective way to keep them interested in you and your art. Everybody has a story and it is up to you to make your story interesting to your collectors. They love it, really they do.

Personally, I send a newsletter twice per year. I haven't quite polished it as much as my artist friend, but I will get there. Obviously along with that fascinating tidbit about printmaking and my dog's latest trick, I make sure I include a schedule of my shows! I also hint about my latest piece and my latest series and usually add something about what the future holds for me, leading my readers to await the next one. I make sure I give them something for free, whether that is something about the history of the woodcut, facts about paper, story of a famous printmaker, and so on. Really anything interesting that they probably don't know and they probably can only get from my little publication. It's fun for me too!

Magic seven?

They say it takes seven times of seeing a product before the buying-center of the brain gets activated. *They* also say it never rains in Arizona either, and me and my works got soaked to the bone one fine spring weekend...But *they* in marketing know about marketing and it does take some recognition and comfort before people will buy from

you, the more expensive the item, the more times you have to "hit" a prospective customer with a reminder.

I have already spoken about newsletters and schedules of shows on postcards and sneaky discounts on the back of a business card. In my humble opinion, the cheapest and most effective way to remind a customer who you are, what you sell and when you will be in town next, is the World Wide Web. In every one of those email reminders I talked about, I send a customer my website. Many artists think that having a website is the kiss of death and, in fact, the other question that can kill a sale (remember the dreaded: "do you have a card"?) is "do you have a website?" This means the customer is between the hot dog and the kettle corn and they don' have no stinkin' time to be lookin' at your art at the moment. But they might browse your website someday in between their music downloading and online shopping.

Glass-half-empty folk say they never will seek you out again. I say it's the electronic age and everyone can now easily browse my website on their cell phone or PDA as they sip Starbucks coffee these days. And they might, and they do and they buy things from me online, especially after a festival and especially after they have seen the actual work "live and in person."

So here is the MAGIC SEVEN of Marketing: IF, and that's a big IF, it does indeed take seven "hits" for someone to make a large purchase decision, the web allows that person to view my works an infinite amount of times for free and at little cost to me. IF that customer is too busy on that weekend to (ONE) browse my booth and IF they actually kept my card and they type the magic letters www.1000woodcuts.com, (TWO) they can browse my work at their leisure any time they want to for as long as they want to without the wind blowing and the heat beating on them. As an artist, especially a new artist, you want to be found. You want to give people the opportunity to find you by entering your name in their favorite search engine, the choice to browse your work in their pajamas, to read your story to their spouse, to get to know you and your art and your dogs and how you started and where you came from and whatever else you want to share with them. Then, by the very nature of the internet, they forget about you and head off into Yahoo to look at the weather forecast and discount Jamaican cruises.

But! A few days or weeks later (THREE) they get a postcard in the mail with your name on it about a festival a couple of weeks from now ten blocks away from their house. Wow…where was that website again? Your email reminder (FOUR) comes in during the week prior to the show, with your neat www.igotyoulookingagain.com right in the signature line. Now (FIVE) they go to the web again and look at your stuff some more to see if they can find the one piece they saw last festival and they laugh at the latest pictures of your dog chasing a lizard. They may or may not go to the festival but if they do, they (SIX) will look you up in the catalog just to see where your booth is, no ifs about it this time. And finally, belly full of hot dog and still munching on the kettle corn,

(SEVEN) they stroll into your booth and now the rest of the magic is up to you. They will greet you by name; do yourself a favor and pretend you know them and have been waiting for them all your life but you are "bad with names." Works every time...I give my customers the feeling that I know them all personally but I'm a flaky artist that can't remember names. After all, they put up with my email reminders and newsletter jokes...and I am a flaky artist.

Sound a bit like a fairy tale? Marketing is actually based on sound science. People forget where they heard about you, they just know they have seen you a lot lately. Marketing works and perseverance has made many a sale with people that walked into my booth and tell me that they have been following me for the last two years and finally they have the money to make a purchase. Maybe seven isn't exactly magic, but the important point is that keeping after customers (the ones that actually buy something) sinks your name deep into their psyche and when they are faced with 400 booths at the next show and they see your banner they will readily recognize your name. Marketing is not only about making your prospective customers familiar with you and your work, but making them comfortable with purchasing something from you, versus purchasing something from someone they know nothing about.

Needless to say, all these little marketing tidbits need to show professionalism and consistency. You don't want to radically change your entire image between the time someone picks up your business card and goes to your website. They will lose the recognition link and you will have to start over with that customer. Professionalism and consistency give customers the same comfort they feel when they go to the mall and spot a Gucci purse, Nike sports shoes, Channel fragrances, Levi jeans; they know those brands, they recognize them, they buy them.

The next section explains how to "work a show," an elusive but related concept that makes you a comfortable, permanent fixture rather than a passing gipsy. If this marketing stuff is making you want to retire to a tiny cabin in the woods and whittle flutes in seclusion, join the crowd! Marketing and sales rate near the bottom of things I thought I'd be doing when I decided to take the plunge into "arthood." But nevertheless, after a few years under my belt I can tell you that selling art is better than not selling art and collecting collectors can be a fun sport—and a very lucrative one.

Working shows

Back to one of my first big shows...There I was sitting in the hot sun, a poorly educated rookie with barely a couple of small local shows under my belt. My location within the show was less than desirable, but I did not know that at the time. My booth display and selection of artwork was less than desirable for the audience at hand, but I did not know that at the time. I showed up to set-up at exactly the same time everyone around me, left no back room for stock ignoring a neat alley between booths, and sat

with my back wall completely zipped in 100 degree weather making my booth seem more like a small baking oven than a small gallery (if only I'd had cookie mix…). After three days of that, I netted around $140.45 but I won a prize in my category.

Had it not been for that prize, and not knowing the principles of working a show, I might have not done the show again. But that prize granted me a free choice of location for the following year and I suspected that I might do better after a year of experience. So I applied again. The second year I chose a great location, according to the experienced artists, and a bit of shade in my much larger back room. I also had a better display, more work framed more professionally, a better attitude, the sense to open my back wall to let the air flow through and probably a million other details that escaped even my very observant eye. Truth is, just as when you go to school for a long time or do the same job for a long time, just by doing you pick up little tips and tricks that make all the difference. After three days in my sweet corner spot I netted around $3500.

But the learning didn't stop there, I'm one to always look for improvements and I decided for the third year to try to catch an even better spot and increase my display to a double booth. After all, I was at home and hauling and setting up more work just doesn't take all that much more effort. In fact, this last irrefutable truth has stopped me from doing many a dinky show: it takes the same effort to do a dinky show than it does to do a large show. But I digress…third year running, with the perfect location secured, an easy early set up, a back room with shade and wind shelter, the perfect selection of varied works for the audience I knew well and last but not least, a bit of pre-show marketing, I netted around $7400. That's probably not tops for that particular show, but it is a very good show for me. So what did I learn? A thousand things! Among them:

Hit me again, please

First thing is that a show with good potential deserves a second chance. Number one principle of working a show is to give the show a chance if the show deserves one. How do you know a deserving show?

First, the audience has to be aplenty and also be of the buying kind. This is easy enough to spot, many happy shoppers walking around with things under their arms. This year the things may not be your things, but if the audience is there and they are buying, this show deserves a second try. Often a poorly attended show is due to lack of advertising and/or competing shows or other events in the same area. Investigate the audience angle first by asking some of the show-goers politely how they heard about the show. Too many "I live around the corner and didn't even know the show was here" responses and a bad feeling starts to creep in. If however you see the show advertised on television and on the newspapers, maybe poor attendance or poor sales were a fluke. If the weather is not cooperating and it is unusually cold or hot, take that into consideration when evaluating attendance. The same applies when world events of the uncontrollable kind happen the day before the festival.

Second, the general "feel" of the show must be good. Is the show in a good location in the city? Are the grounds beautiful and likely to be well attended? Is the show layout good? Were setting up and breaking down relatively easy? Were there amenities for artists? Prizes? This second factor is really a non-scientific personal gut feeling. Did you drive home angry and disappointed or did you catch yourself thinking the show had possibilities but nothing happened for you *this time*? Let your gut guide you a little and simply try to get a feel for your comfort level. If you liked the show despite poor sales, maybe it's worth doing again.

Third, the history of the show deserves a second look. This is fairly simple to figure out. First, second, third year shows are likely to be less well attended than the 30th Annual Megafestival of the Arts. Shows that have changed location recently, changed promoters recently, changed layout recently, and so on, are less likely to attract large audiences who are ready to buy. Audiences need a history. Artists need a history. A baby show needs another chance; a bad show that is already all grown up may simply have gone stale and may not necessarily deserve your investment of time and money.

Lastly there is the other people factor, namely your fellow artisans and the promoter. Rude artists tend to turn me off to doing a show a second time, although I'm beginning to get better at ignoring rude behavior. A show is just nicer if everyone makes an attempt to behave in a reasonable manner. We all expect a bit of chaos during set up and break down, but the more near polite artists are, the better for all. Once in a smaller show, a loud artisan parked a thirty-foot motor home within the small confines of the only parking lot. At lunch time, the generator came on, the barbeque came out and yelling and drinking could be overheard throughout the show. Funny thing was, nobody told these folks a thing. The promoter nowhere to be seen, most of us stunned. The show died the following year. Word gets around in our small world of festivals.

While such incidents are rare, the behavior of artisans tells a lot about a promoter, which is the other people factor. Artists behave better when promoters make them, whether it is by overt and immediate rule enforcement (the MEGAPHONE!), by not inviting rule-breakers and other trolls back to the next year's show, or both. In my humble opinion, a promoter who enforces rules rather tightly is a blessing. I tend to abide by the posted rules and if everyone did the same, shows would go much smoother for everyone.

When the people factor is a positive one, the show may be worth a second try. And nice people are always helpful when learning your show didn't go so well, so it may also be worth talking to some of them about how to improve your future. Always remember that there are plenty of shows to choose from and there is really no pressure to keep any one show on your schedule if the experience is overly negative or otherwise unpalatable.

Location!

Not only is a favorable location of the show in the city a factor, but, while you are sitting there doing nothing but envying the booth down the road that is getting all the attention, perhaps analyzing why that booth is getting the attention is worth your time…or will be next year.

Location within the show is one of the most debated issues among artists. Some swear by corner spots while others think it is a waste of money; some prefer the midst of the action while others thrive in the fringes of the show; some double up their space when possible, others stick to the basic in-line 10x10. Whatever your location, it is worthy to note that the *More Traffic Over There* mirage is as much of a metaphysical uncertainty as the *Law of Compressed Air*. Try this experiment: count the number of people walking around in front of those booths "over there" and jot down the number. Now walk away from your booth and count the number of people walking around in front of your booth. I guarantee the numbers will be very close.

Having said that, do note that some festival layouts are more favorable to traffic flow than others. For example, if the audience has to walk side streets or walk toward a dead end, chances are the flow will be better in the main drag and in streets that go to some other part of the show. This does not mean that the main drag is necessarily a better location; just that it will probably get more traffic flow. Most, but not all, artists do better with more traffic flow.

One way to know for sure that sales are better in one location versus another is to ask your fellow artists (try to pick artists you have gotten to know and trust, as tall tales are an integral part of the business). Answers will be mixed and tainted, no doubt, but you will eventually get the feel for one part of the show or another. Another way is to look at the application and see what location the promoter is charging more for. If the main drag consistently brings artists better sales, artists will request the main drag, the promoter will notice and often, but not always, they will make it more competitive to secure a space on the main drag (read: charge more). After all, art festival promotion is a business just like any other.

Back to the point of repeating a show, if your location within the show was less than desirable, maybe a second try in a better spot is the recipe for success. Remember that the show must otherwise have potential, otherwise paying more for a corner or a double space in the most visited part of the show may not bring the desired result in another try or ten more. Also remember that sometimes show rookies get poorly placed on the first year and promoters reward their repeat vendors just like any other business would. Maybe next year you will get that favorable placement.

Good locations are desirable but it is important to remember that the best location in a lousy show will not change the show by itself. Location is only a factor and, although

good locations are desirable, other factors are of equal importance. One last point, a good location for you may not be necessarily so for another artist. Locations at the exit of a show are best for impulse shopping but most shoppers tend to slow down their pace toward the middle of the show and so those might be best if your artwork takes a long time to browse, or for larger works. As with everything else, make sure the location fits your particular needs, rather than become obsessed with always being in the middle of the show as a matter of habit.

Did you remember the bait?

Ah yes, the fishing hole again…Well? Did you remember the bait? Was it the right bait? Do your humble offerings match the pocketbook of the audience? Are you selling lobster at a baseball game or pop-corn at the opera? And speaking of bait, did you remember to chum the waters just prior to the festival or are you again counting on passing unknown fish to notice and savor your tasty earthworms?

All the marketing in the world won't bring a sardine into shark infested waters, just to go along with the analogy. Conversely, all the oysters in the world aren't going to attract a plankton eating humpback. Okay, even I'm getting a bit sea sick here (although I'm having a lot of fun). Point is, if the art selling around you is similar to yours in beauty, polish and price range, you may be dealing with a fluke show in which you were simply not the lucky one. However, if you notice that everything around you, selling or not, is either much higher end or much lower end than your own art, then you simply may be in the wrong show. Is a "wrong show" worth doing again? Hmmmm…a few more pole-coupler bruises and you will tell me the answer to that question. Is a bad fishing hole worth getting up at 4 a.m.?

Working a show also includes all the marketing and promotion that you are capable of doing before giving up. If your own customers tell you they are not going to that particular show because there is another one, a better one, the week before, listen to them. But make sure you have honestly tried to get your customers to your show (it is YOUR show) before giving up.

Working a show also includes, if your line of artwork permits, bringing the right stuff for the right audience. High end sellers know that every show can't be a winner and many painters and sculptors use the smaller shows as a marketing and promotion tool to bring people in to larger shows. Remember the magic seven? A small show can translate as ONE time that people see your stuff and, even if they don't buy this time around, at the very least you begin to get name and product recognition.

Working a show also includes walking around and studying the show's layout, the composition of the audience, your location within the show, competing shows in the city and so on. Working a show might mean meeting the promoter and getting a feel for their commitment to the show. Working a show definitely means letting your customers know you will be there and thanking them if they make a purchase. I can't stress this

customer relations angle enough so if I repeat myself throughout the book it is because establishing and maintaining great customer relations is a proven, winning marketing strategy.

Through the years, I have bought a few pieces from fellow artists and, when I want a matching or gift piece, it is terribly irritating not to be able to find that artist. Not a business card, not a receipt, not a tag on the back of the piece to tell me the name of the person I bought from.

Basically, in marketing and sales there are really quite a few things that we can control and a bit of control in this business is worth a bunch. Often when I talk to artists about shows I sadly find that they are not even attempting to attract and keep their audience. More often than not, I find that artists treat their relationship with their collectors as a game of "us against them." To me, marketing and promotion are not games. They are two of the most valuable tools I possess in order to assure my success as an artist in business. I don't particularly "feel like" sending thank you notes to all my customers after a busy festival, but the $9.00 investment in stamps and half hour at my database is more likely than not to bring me future sales at the same festival , especially if so very few of us are doing that!.

And I don't particularly feel like keeping a database of customers and sending them newsletters and calendars every once in a while, but when they show up to my booth postcard on hand and thank me for letting them know I was in town…well, the rewards are more than I can express. Database? What database? More on that in an upcoming chapter! Take control of the things you can control; there are enough other unknowns in the business to either slap you in the face or lift you to unforeseen heights. Either way, doing everything you can is the very least you can do.

Chapter 7

Your First Festival: THE GREAT ADVENTURE!

"What a fine mess you've got us in now Ollie."
—Stan Laurel

Several possible names came to mind for this chapter, the first: "Your First Festival: THE GREAT ADVENTURE!" because every festival feels much like an adventure, exciting and luring yet fraught with unexpected and possible danger. Second choice was: "Anatomy of an art festival revisited" because I already sort of explained what is involved in the first part of the book, but that was only one experience and every festival is different and I thought about reiterating the important points anyhow. The last idea for a name was "A Step By Step Plan" because a good guide book should include a good plan, but I started laughing uncontrollably when I remembered that festival where the wind started gusting to 60 mph upon arriving, or the festival where pouring rain greeted us in the desert, or the festival where the gate had a sign that read: FESTIVAL CANCELLED with no further explanation. There is no step by step guide or plan that can help in those occasions. What tends to happen is that everyone just does what they consider the most logical and feasible thing to do at the time.

But there are some logical expectations and perhaps this chapter can clarify some of the events an artist might expect when embarking on their first festival. Really this chapter is as close to a loose and flexible step by step guide to doing your first and every festival as I could muster. The Stan Laurel quote above says it all and I have thanked and cursed a thousand times all those well-meaning artists who have showed me the way thus far.

Scout Master Says: Be prepared!

Organization and preparedness are greatly overlooked in the art festival business. This is because art festival life tends to lend itself to much running freedom and a loose schedule, and when it comes time to tighten the reins, sometimes we buck. But in the interest of ease of mind, diminished stress and healthy survival over the years, tighten the reins we must.

I don't know about you, but when I begin thinking of more than three things, whether be grocery items to get or things to do before my next festival, I make a list. This simple low-tech solution to controlling the approaching chaos will be an important tool in many occasions through a single festival. There is much to do before you embark, I will revisit some of the most important points, but the main strategy is to mentally go through a festival and, as things come up, jot them down. Add to the list, cross items off the list and revise the list, but make sure that you don't just "make a mental note" or that poor item will be forgotten, guaranteed. I am getting ready for a festival right at the moment, so the process is fresh and familiar. I also, and you might also, begin to feel the festival, the jitters, the fevers, the upset stomach, an unusually strong headache—this is perfectly normal. Think about it: you are about to take a long trip to a strange town, put several thousand dollars worth of inventory (your precious art!) under a cloth tent, and hope that you, your inventory (although much much less of it) and your vehicle come home safely again. Your best weapon against the jitters: be prepared, very prepared.

Making motel reservations, getting a map and checking the weather should go without saying, but many artists just embark on the road hoping to land a cheap motel close to the show. Some get lost and appear magically (not in the best of moods) right before the show starts. Yet others come perfectly prepared for sunshine with an open display and have to run to the nearest home supply store to buy a tarp when the predicted rain begins to pour. Getting those things out of the way just make me feel more at ease and eliminate unnecessary stress later. And just keep repeating to yourself that everything is going to be fine, because despite the apparent chaos and panic everything most often turns out that way.

Bare essentials: Product, Display, Office

Other than the typical travel stuff like socks and toothpaste, which I won't get into here or elsewhere, there are three basic categories of "things" that you must have. Product, or art if you prefer, is of course the most essential. With product along you can buy a tent at Costco, some easels at Dick Blick and a receipt book at Office Depot. Honestly, some people do shows that way—I mean with a tent, some stuff laid out haphazardly and a receipt book. But life is much easier if you have a few more things along and long term success is most assured when artists act like they know what they are doing.

Something to sell

Back to the art stuff, it is probably best if your art is well packed in a manner that will protect it from bumps on the road and inclement weather. Upon observing your fellow artists, you will see as many ways to pack and carry product as there are fishes in the seven seas. One basic point to remember is that traveling is rough on things, so pack well and pad plenty. I prefer to pad each framed piece with foam, light and versatile and (notice the double emphasis) *easy to pack and unpack*. Once you begin packing and unpacking 20-50 paintings or pottery or sculptures or whatever, say, 20 times per year, you will find your own way of packing your stuff so that it is easily unpacked yet it remains safe and sound during travels.

A trick I learned in inclement weather is to keep everything off the ground. So my "stuff" is well packed in home-made wooden boxes with wheels. These fit behind my booth or even inside in a corner, they are painted white and I cover them with a display wall. The wheels come in handy when the spot right in front and next to my booth is taken up by a 30-foot van and trailer tandem belonging to the guy that just decided to go to dinner. In fact, near everything that I take along has magically evolved a set of wheels as my back got older and older. Don't forget a hand-cart, wheeled platform or other implement (or two) that will help you take everything from point A to a potentially distant point B through potentially rough terrain and/or up and down sidewalks or steps.

How much stuff and what kind of stuff I've already discussed and soon enough you will learn to sort out your stuff so that most of the pieces that come along get shown. Some reserve stock is necessary because some festivals are known for their early shoppers, but if you ever do "sell out" my guess is that you won't be crying about not having taken enough. Do give me a call when that happens, will you? Most artists take somewhere between $5000 and $50000 worth of stock.

A thing or two to show your wares

Display is another essential and in most cases the most stable item in our trailers. My entire display remains in the trailer and goes with me, whether I'm doing a 10 x 10, a 10 x 20, an indoor show or a quick art walk. I have several configurations in mind depending on what my spot looks like, but I have been known to draw a little diagram of my display walls and stuffing it in my pocket. Eliminating some of the thinking later makes dealing with the unexpected less stressful. And being ready for the unforeseen cancellation by my neighbor, giving me a free double space, has paid off more than once.

I've talked about display choices and there is not enough room here to cover all the possibilities for all the different types of art. But other than the walls or shelves that your stuff hangs or sits on, there are a few more things you might consider. Tables need covers; most shows require tables to be draped to the ground. It is also wise to think of

what you will do with your boxes or crates and please don't just shove them behind your booth without at the very least covering them with something.

Another valuable item might be something to secure the display in case of wind and something to cover it in case of rain. I know I'm a little obsessed with the weather issue, but I've seen clouds roll in within minutes and soak artists before they had time to say: "gosh darn I wish I had set up a tent". Be prepared!

Needless to say, the more professional your display the more likely that you will get those two precious seconds to attract someone's attention. Also note that professional does not necessarily mean "store bought" although most of us have succumbed to such logical solutions. Check around festivals and you will find many artists that make their creative displays from scratch and do a fine job at it.

Another great way to get display ideas is by visiting the web sites of the suppliers in the Appendix. With their fancy products in mind, perhaps starting out with home-made panels that resemble the professional product might be better for those artists who are unsure that they will undertake this crazy life. But I would highly recommend eventually investing in the professional displays if embarking is a sure thing. In any case, panels or shelves, tables or walls, easels or racks, browse plenty before buying.

Selling-matters

Lastly, you will need an office. Think of someone walking into your booth and grabbing one of your precious pieces. They want it. Now what? Oh yeah, take the money, but don't forget to charge tax (you brought a calculator, right?) and write out a receipt (you brought receipts and extra pens right?) and put the precious art piece in a bag (you brought several sizes of bags, right?). Phew! Believe it or not, I once sat beside a woman who made nearly 50 sales and did not bring a pen, not on day one, not on day two, not on day three. I loaned her one the first day, one of my "good" pens. On the second day I gave her one of my cheap pens. On the third day she had lost the cheap pen and borrowed yet another.

Having a little foldable table on which to conduct business is a good idea. People write checks and you write receipts. The guestbook sits there too along with your business cards and brochures. The credit card swiper or imprinter can sit there too. Stapler, scissors, rubber bands and paper clips all come in handy at one time or another. Think small travel office and you will have the beginnings of a list. Are you making a list?

My best method so far is a carry-on sized luggage piece with wheels and has a built-in table that pops out and folds away when not in use. Designed for placing a laptop computer on the table at airports, presumably, it has pockets for everything I need and some things I probably don't. Many artisans have a similar carry-on bag and wheel it in and out of the festivals every day. Important stuff that you can't leave in the booth

goes in there, like receipts and cell phone and cash bag. While you don't need to be that clever right off the bat, keeping things organized in some type of container is highly recommended.

That about covers most of what you will need! Best get on the road…

On the road again

Just a short note here about the horse of choice, make sure it is fresh and fed before leaving. I don't mean just gas and oil. I mean check the transmission fluid, cooling system and brakes every so often because a loaded vehicle going down a mountain road with failing brakes is a thing I don't ever want to see again.

Tires need to be properly inflated and, although breakdowns are inevitable, they can be greatly minimized with proper maintenance and preventive care. Loaded vehicles are particularly susceptive to blow outs and transmission failure. They are also harder to handle during adverse conditions, so check the weather and plan on bigger and better roads rather than that scenic but very steep and curvy short cut through the woods.

Triple A (AAA) or a similar road service could come in handy so it is probably worth the $40 per year. Maps are also free through AAA and you will get discounts on many hotels and campgrounds. Many insurance companies have their own road service so be sure to have those numbers and a cell phone handy. A gallon of antifreeze, quart of oil and a can of fix-a-flat can could mean the difference between a long desperate walk or a careful drive to the next service station. Remember that cell phone coverage is sometimes lacking between large towns. Enough about that, I just thought I would mention that when embarking on a road trip, a vehicle becomes a second home.

Driving directions are a breeze to get these days through the internet, mostly Yahoo Driving Directions or Map Quest but also Rand McNally's website and others. I make the habit of getting maps of the area I'm going to, city maps with exploded downtowns, directions to the festival, to the hotel and from the hotel to the festival. Lately, I look at the entire area on Google Earth, which tells me exactly what the park looks like and where I might park to unload. So I'm a little obsessive… Many promoters include directions to the show and even maps of the nearby areas. After a while you will become familiar with frequently visited cities and roads and trips will be less stressful.

Traveling is a lot of fun but it is also a bit stressful to be caught in traffic in a strange six-lane freeway with no place to sneak out. For that reason and many others, I give myself an ample time-frame when traveling. If set up begins Thursday morning, I consider driving on Wednesday and being nice and rested for set up day. If the festival is closer to home and set up is in the afternoon, I might drive the same morning, but always feel nervous that, if something were to happen on the road, I would have a very tight schedule to fix what needs fixing and make it to the show on time.

My formula is usually: drive one day, set up the next day, show, show, show and break down, drive home next day. Adding a day on each end may not be possible for

those working "real" jobs, but it is highly recommended if you can swing it. I tried several times to drive home right after break down. Why, is a good question; suffice it to say that tearing down for two hours and loading the trailer after a particularly good show all combine to make you do crazy things. I think it must have something to do with adrenaline. Anyhow, at the end of this chapter is a good story that might just come in handy when pondering whether to drive into the night or wait until the adrenaline level—and stupidity level—come down just a bit.

Set-up secrets

Let's back up to the point where you safely arrive at the festival site ten minutes before setting up and...Hold it!!! Here is a relevant quote for this section, origin unknown, brought to me by my husband:

> *"The early bird gets the worm...*
> *But it is the second mouse that gets the cheese."*

Seriously, do yourself a favor and arrive early. I cannot think of a single time when getting to the festival site a few hours early and studying the site did not pay off. I, being of analytical nature (yes, I have also noticed the first four letters of analytical might better apply), like to arrive the prior day if I can and at my leisure get to know the festival area and the immediate neighborhood if for none other reason than to find the nearest grocery stores, home supply stores, office supply stores, gas stations and other bare necessities that might arise.

Promoters that give out such information in their mailed acceptance packets have my vote for promoters of the year. Promoters that give out the specific location of my spot and mark out the site the prior night have my vote for Sainthood. Fact is, the more you find out early the less surprises to be dealt with later on. Some times you might even find a very calm promoter prior to the show, introduce yourself and comment on the appropriateness and beauty of the festival site. Then innocently ask something open ended such as: "I hear set-up is around 3:00 p.m., do you have any suggestions as to how to best bring a small trailer into the site?" Nine times out of ten—okay, make that seven times out of ten—the promoter will say something along the lines that if you are ready and you don't get in anyone's way, you can come now and unload quickly. Bless your luck (and preparedness) and do just that, don't linger and don't push your luck by beginning to set up before your vehicle is tucked away in the proper parking spot.

Yet other times, a promoter won't be quite so calm and friendly and will answer that yes, 3:00 p.m. is a FIRM beginning time for setting up and anyone caught trying to sneak so much as their front bumper into the area will be banished from the kingdom of art festivals forever more. Reply with a very polite comment on how you love promoters

who enforce the rules tightly and high tail your rear out of the area before you call any more attention to your-sneaky-self.

I arrived at one site very early recently and, knowing the promoter and his method, I knew we could set up as soon as our spots were marked. I parked out of sight but lined up toward the grounds entrance, bought a large refreshing lemonade and found a park bench on which to wait in peace. I saw the promoter begin to mark the line of booths that contained mine and was dismayed to see his marking task interrupted by at least a dozen artists who just *had* to ask him when their spots would be marked. Chalk and measuring tape in hand, he politely interrupted his work every time and told them as soon as he could. Artist after artist approached him to stop him and ask the same question. Finally, I lost patience and yelled: "As soon as you quit bothering him, he will be able to finish marking all our spots!" I must have said that quite loudly (what I lack in physical stature, I make up for in lung capacity) because several artists scattered quietly and allowed the promoter to finish marking spots. Sheesh.

Like the mouse seeking the cheese, feel your way about carefully at the festival site. The caution implied in the above quote is that sometimes arriving too early will only serve to get you unfavorably noticed by the promoter. If the promoter is still setting up their tent and bringing boxes out of their car, staying out of the way would be advisable. Other than checking out where your prospective spot might be located, it might be a good idea to investigate the parking location and the easiest way to get there and make a mental note of all those one-way streets. READ the acceptance letter and all those pages on the artist check-in packet. Read all the pages. That's where you find out where you can park after set up, so don't ask me anymore. Seriously, most of the nagging questions you have running through your mind at this point are answered in that magic packet you are holding in your hand.

I like to play games and make a mental plan of how I will drive in and at what time, planning carefully a couple of strategies in case my booth location is hopelessly blocked by the 30-foot motor home with the trailer. If you can find a spot somewhere near your booth right at the moment and it is legal to park there right at the moment, I would strongly suggest taking the opportunity. A little walking from nearby is better than being hopelessly blocked later because you wanted to park right *at* your booth door.

Remember the second year you do a festival, things will be much easier because you can eliminate the excessive pre-thinking; yet another reason to try every festival at least twice. Make a note of changes in the layout or construction obstacles or anything else that makes the next time a bit different from the last. In the more established festivals, things pretty much go the same year after year and this time next year you might be giving some little new mouse a bit of advice. In any case, pre-thinking and

preparing early will pay off later when the chaos begins. Oh, and don't forget to keep your plans in mind but stay flexible, often times you will need to rethink and replan several times during…just the set up!

Decisions, decisions…

Okay, so you have your pile of tent poles and various boxes unloaded behind your spot and your vehicle is appropriately gone and parked safely in the proper artist parking (right?). Trust me, the hard part is done, all the unknowns are now known…until tear-down, but don't even think about tear-down at this point because you have a long weekend ahead of you and much to think about yet.

What you have to think about now is about the two thousand decisions needed to make regarding how to best set up your booth. Here again, some artists just do the same darned thing every single festival come hell or high water and their booth always looks the exact same. There is something to be said for that, that painful thinking part is avoided and things go a lot easier for you. WAKE UP! This isn't about you being comfortable; this is about attracting customers for the next three days, about not interfering with shoppers' browsing instincts, about getting as many customers as possible to walk into your booth, about maximizing traffic flow and about making sales. But let me not be hasty, if the same set-up works every time and works well, there is no need to change anything. But if results have not yet been desirable, then just remember the adage: If you continue to do the same thing, you might expect the same results (or something like that).

I recently attended a festival in which booths were arranged in single rows with traffic on both sides. I do the festival every year and, to me, this is heaven! People walking in front and behind my booth?!! I set up so that the flow of traffic is favorable either way; I make sure there are show stoppers on both sides and that people can walk into the booth from either side. I watched as several other artists completely closed "the back" of their booth and showed only toward one side. I politely reminded them that there would be traffic behind their booth but they never really came up with a reasonable alternative set up scheme. "We have to have a back wall," insisted one vendor. Cryin' outloud, we're artists, the most creative beings in the planet! Be creative in your setup and remember the show stoppers and the people stoppers in the previous chapter. And while it might be advisable to have a basic booth setup, having a few variations to suit different occasions is also of great value. Make a sketch if you must; with a few shows of experience, the perfect setup will immediately come to mind once you get to the site.

One other note is worth mentioning here: Under some circumstances it might be advisable to set up only tent and panels (or only the tent) and come back early in the morning to hang the product. There are many occasions where this might be advisable, such as: raining/windy during set-up, late night set-up, late arrival to your booth, and so

on. But whatever you can do the prior day, the less there will be to do in the morning. Setting up panels and hanging art at 6:00 a.m. and then sitting and selling for nine more hours makes for a very long and dreadful day. I highly recommend setting up as much as possible the prior day and enjoying a sweat-and-dirt free morning where only the last touches are required to make your booth a thing to love.

Welcome to my world

One of my most favorite artists whom I find in various shows around the Southwest has a banner that says: "Welcome to my world". Simple words, yet marketing genius. Not only is her display charming and very representative of *her* world, but the first word in that banner is the most important word a customer can hear from you. Welcome! Please come in and feel free to browse at your leisure, step out from the hustled traffic into my shade. Welcome, welcome!

The main factor bearing on the decision as to how to set up is directed by traffic flow. Again remember you have two seconds, if that, to attract someone's attention away from their cell phone and/or their kids. Whichever way the traffic comes, that is where you have to direct your most priced possession and hope it jumps out at their distracted field of sight.

With that in mind, the walls of your display should be open and welcoming. You are inviting people into your booth. A print rack placed at the middle front of your booth will attract glances but nobody wants to stop in the middle of the traffic aisle to browse. Now place that same print rack just a foot or two inside the booth, just with enough room for someone to comfortably walk out of the stream of traffic and step into your booth, and they will stop and browse all day. Not being able to help themselves, they will look up at your walls while they are inside your booth. The rest is up to you and your sales tricks.

Successful strategies vary, but while setting up, step outside of the booth often and check to make sure that there isn't anything blocking the flow of traffic into your booth. If you place some walls at the front, angle them so that they will funnel the people into your booth. If you have a table with information on yourself, place that at the back of the booth so only interested parties take your business cards and brochures. Kids tend to grab anything that is free and loose, so conserving your promotional materials by placing them nearer you is a wise practice.

First few festivals I attended, I watched everyone. I had closet shelf racks tied with cable ties and closed my booth at the back (you gotta have a back!). I started learning from nearly everyone around me and soon decided the best strategy for me was to build a little gallery of sorts, with walls guiding people in and around the booth. I leave at least two ways to get in and out; people hate to be trapped in a 10 x 10 space with a bunch of strangers. I place my print browse racks just visible from the outside but well inside the

booth so that folks step in to browse. I constantly get up and rearrange matted prints to show people it's okay to browse and to place the most attracting pieces to the front.

Whatever you do, make sure it screams "you are welcome to come in and explore!" People are shoppers, professional shoppers who shop all the time. Don't do anything to stop them. And don't be afraid to change your set-up on the second day or every day. If you miscalculated where the traffic will be coming from, don't get lazy and tell yourself you will make a note of that for next year. Three days are a long time to lose sales due to a controllable factor such as your setup, and you aren't doing anything more important at seven in the morning the next day. Change your setup, swap some pieces, maximize your exposure and you will maximize your sales.

Locking up

All set up? Now what? I leave my stuff here? In a cloth tent? Zippers are the only barrier between me and the horrible dishonest bunch of thieves that surely will walk the grounds tonight? I have seen artists just walk away with their stock in their booths left uncovered and without walls. Some artists take everything down for safety reasons, and some load their artwork back in their trailer every night and set it back up every morning. Most artists bring their extra boxes inside, zip or Velcro their walls and walk out. Make your booth hard to get into, at least twice as hard to get into as your neighbor's booth. A story comes to mind:

> A Zoologist, a Forest Ranger and a couple of tourists are out in the forest bear watching. Suddenly they find themselves in the near proximity of a couple of bear cubs. Fearing the mother bear nearby, they begin to backtrack slowly but it is too late. The frightening roar of the mother bear is followed by the sight of the angry animal who, up on her hind legs, begins to walk toward them angrily. The Zoologist calmly takes off his heavy hiking boots and puts on a pair of running shoes while the rest of the party watches in horror.
> "Fool!" says the Forest Ranger, "you know that there is no way you can outrun an angry bear! What are you doing?"
> "I don't have to outrun the bear," replied the Zoologist, "I just have to outrun one of you."

Festivals have security personnel of one type or another, it is true, but a few security tips are in order. I should mention here that some festivals don't have any provisions for security, so be sure that a nicely uniformed person will walk the grounds before you leave your priced possessions for the evening. I belong to the group of artists that brings all stock inside the tent, zips down the walls and walks off. I go perhaps a step farther and also cable-tie the zippers to the legs of the tent. Everything you can do to make your booth harder to get into is worth doing. There are locks for booths and alarm

systems too, but if you are going to go that far, it might be better to simply gather your possessions every night and unpack them every morning. I shudder at the mere thought.

Inside the booth I cover my tables and print racks with a cloth, more to keep them safe from the elements (dust and dew, mostly) than to prevent theft. But covering up visible stuff may deter someone who manages to poke their head into the booth. Leave them nothing to see.

Theft happens and vandalism happens. All we can do is minimize the likelihood of either. Actually vandalism happens more than theft, which is a really depressing thought for artists: hardly anyone wants to steal art because it has no "street" value. If you plan on selling jewelry, plan on packing every night and setting up every morning. And the impulse thief just takes things because they're there, so be aware and safeguard your art.

...And a good night's rest

Wow! You made it through your first set-up! Congratulations—now go to sleep. I have tried and failed to make dinner plans and party plans with people I know in whatever town I happen to be in. I always cancel. One disclaimer here is that I travel by myself and things are much easier when you have a partner—a strong partner—to help with the heavy stuff and the tedious task of building a temporary shop.

For the first few festivals I would highly recommend at this point a hot shower, a good dinner and a good night's rest. There is more stress to traveling and setting up than we like to admit, even after we are a little used to it. There is a long weekend ahead yet, and more stress involved in selling and merely standing out in the elements (sometimes not so kind) watching your precious paintings swinging in the wind. There is stress in selling and stress in not selling. Rest is your best preventive medicine to assure a great attitude in the morning. And a great attitude is key to making sales.

Good showmanship: Every minute counts

Get to the site early again the next morning. Really, trust me, things happen. You might decide to move a wall. It takes time to take down your canopy walls, fold them neatly, take out and cover your boxes, set up your office space, straighten all your hanging pieces and dust and polish all your standing pieces. The wind blows at night and unstraightens your carefully straightened paintings. Dust seems to appear out of nowhere and candy bar wrappers somehow make their way into your booth under your walls. Besides, artist parking is often, shall we say, competitive? Get a good spot, get done and drink an extra cup of coffee. You are all set up, you have analyzed your booth set up until your brain hurts, you have changed things around until you cursed the day you picked up this stupid book and now you are ready to sit down in the back of your booth and be left alone for three days. And let the sales come to you?

This is no time to get lazy, every minute counts. I hate to leave my seat even for the five minutes that it takes to get to the porta-potties. Only once have I made a sale while I was gone to grab a bite and I left my mom in charge. I have never sold anything while an ambassador (booth sitter) was sitting at my rightful post. Yet I have seen many a vendor leave their booths without so much as telling their neighbor they would be right back. I have heard the MEGAPHONE call artists back to their booth while customers waited patiently in an empty booth.

One thing for sure, you will be "out there" for the next three days. You will both bless and curse your decision to embark in the great festival adventure several times daily. You will be the recipient of both the highest praise and the hurting insult and will be tempted to get a real job while pondering the possibility of making it to the Ann Arbor show next year. Whatever you do, remember you are the sole director of your destiny at this point—I am talking sales! Read the salesmanship chapter again. Keep up that smile and forget about the wind and the clouds in the sky. You only ONLY have three days, sometimes only two days, and every minute counts.

There are a couple of things to watch for during the show. Don't let anyone bring you down; your good attitude is a big key to sales. Kick other artists out of your booth who come in and start complaining about the promoter, the parking, the crickets or the bad food at the artist's tent. Get them out now! Every minute counts. Don't let anyone talk you into closing down early and make sure YOU check the artist packet to see when you need to be in the next day. Early sales happen and late sales happen, so be ready at all times. Call your partner before or after the show, demo if you can, pay attention to everyone that walks into your booth. As many artists like to say, "sell sell sell!!!"

Your neighbors deserve mention here. Every artist in the show is pretty much self-centered upon their own activity, which is a nice way of saying the art festival life tends to be a little "every man for himself." Now, I like to think that people are basically nice and enjoy making grouchy people smile, but I confess I have failed miserably at times and even had to bring my claws out in a couple of occasions just to defend my display space. I also like to think that when artists engage in rude behavior, their motivation is much the same as mine and they are just trying to sell as much as they can in these three days because the rent is due. They are simply not thinking of me and my needs in the same way and for the same reasons that I am not thinking of them and their needs. But for three days, we all have to get along and play together nice.

So, upon being offended by a neighbor, give first the benefit of the doubt and nicely point out the offense. This does a couple of things; if the neighbor in question is an incorrigible rude dork, which happens, they will immediately know that you won't be stepped upon and possibly leave you alone the rest of the show. If the neighbor in question was just being careless, they will correct their behavior and you will probably

become fast "show-friends." So, along with good showmanship, practice good sportsmanship and, most of all, try hard as you can to be respectful of everyone else's space and remind them to be respectful of yours. There, there, isn't that nice?

The unmentionables

That's you. Get out of the way! I have mentioned this before, I know, but it is most important that you let people browse at their leisure yet remain available enough to answer questions or toss out your sales pitch. I have already spoken about sales strategies and will not add much here, except to remind you that this is not J C Penney's and you do not have a 2000 square foot showroom. It is very cramped inside a booth and the less you interfere with your customers the better. Same goes for your lovely adorable miniature Schnauzer and your lovable and bubbly niece and nephew. You are now in business, you have just opened a mini-gallery and rarely do you walk into a gallery and find the owner's children and pets bee-bopping around.

Other unmentionables include stock, tool boxes and empty boxes, just to mention a few. Perhaps it is time to step out in front of your booth again and peek inside. Do you see mostly art? Is your display professional and inviting? Does it scream competence and friendliness? If you can see your cardboard boxes right through that open spot in the back of the booth, so can potential customers. I have actually seen artists leave empty cardboard boxes (neatly stacked, I will grant that) inside the booth in a corner. You will never know what turned someone off to entering your booth or made them decline to purchase, so you might as well do everything in your power to prevent the ugly and the obvious from interfering. A very simple and inexpensive way to keep boxes and crates from looking unsightly is to make a neat stack behind the booth and cover it with a neutral or black colored drape. Do everything in your power to keep the selling space clean, neat and welcoming to all.

Last call

Finish the show, will ya? I'm not kidding! Once I set up by an artist who, after introducing himself prior to set-up said to me: "Tear-down is going to be hell!" Tear down???? We haven't started setting up yet?!!!

Finish the show until the last minute. You have bought temporary retail space for a large amount of money and, especially in fine art sales, late sales are common. Buyers forget, they wait, they watched the basketball game; they return late and they buy late. Finish the show. Don't even talk about tearing down until the last two hours of the show, if at all. Think about it, yes, a little. You will need a strategy. But finish the show first.

The easiest way to not get invited back to a show is to tear down early. Do not let your fellow artists talk you into it. Do not believe them when they tell you that the promoter said it was okay, not until you hear the words from the promoter's mouth. Do not let bad weather or bad sales deter you from finishing the show you have so dearly

paid for. Do not talk about cutting your losses, things happen late and your only loss is in not taking full possession of every minute of the retail space that you bought.

During a particularly horrible local show I sold nearly 80% of my sales in the last hour of the show to a gentleman who was starting a gallery. He approached my booth in the last hour and began taking work off my walls and setting it on the floor. When he mentioned he was starting a gallery I smelled a consignment deal and began to carefully phrase in my mind the perfect words to tell him why I don't consign. But something kept my mouth shut and I watched him as he finished choosing his pieces.

"How much for these?" he asked. "I'm an artist too, I told myself when I started my gallery I would buy outright and today is your day."

"How are you paying?" I asked a bit incredulous still. He replied he would pay cash and proceeded to take out the biggest wad of 100-dollar bills I have ever seen. He was a professional gambler, he explained, and he'd had a lucky month. He bought 18 pieces including some original blocks and I had the pleasure of watching the rest of the show watch me as the gentleman pulled up his Cadillac next to my booth and we somehow managed to fit all the works inside the gargantuan trunk and in the back seat.

Yet another time I had a couple come while I leisurely started placing things in boxes and started looking around desperately. I recognized them as having browsed for a long time during the afternoon and asked them what they were looking for. They described the piece, I pulled it out of the box and quietly walked away to continue packing. Left to look at their leisure, they looked, they talked, they looked a little more and thanked me for taking the piece out of the box. No harm done. As they walked away, she turned around and yelled those wonderful words: "I really want it, honey." How can a guy resist. Needless to say it was a late sale for me, a big sale. It's happened so many times to me that I know it must be happening to others as well.

Finish the cotton-pickin' show, will you?

Tear Down in blissful peace

Oh, this section's title is the funniest yet. Tear-down tends more to be like a horrible mess, always is; yet, in retrospect, it also always seems to work out pretty well. That is truly amazing when you think that there might be as many as 500 artists all wanting to place their over-sized vehicles in the same spot at the same time. Add to that the fact that nearly everyone conveniently forgets the rule that says to wait until you have broken down your display and put away your product before driving in vehicles onto the festival site. Add to that that many of those artists work the next morning and want to get on the road and every minute is another mile closer to home. Also known as break-down (although that term more closely applies to the mental failure some artists appear to experience), tear-down is possibly the most nervous time of all. I don't like to be nervous, so, as usual, I have a plan!

Visteme despacio, que tengo prisa

Loosely translated, that means: "Dress me slowly, I'm in a hurry" Once I realized with fright how potentially messy tear-down could be, I also observed that about thirty minutes to one hour after the majority of artists were gone, there was nobody in sight.

I first observed this curious phenomenon during one of my first huge festivals in California. At the sound of the bell, vehicles of monstrous size started pulling into the festival, honking and yelling and squeezing themselves into the most impossible situations. While packing, I saw that many artists ended up hauling their wares great distances to their vehicles and I was prepared to do the same if I ever got my vehicle past the seven vans that capriciously came and went into the spaces close to my booth. Every time I thought I saw an opening, someone else would quickly pull up and take the space. I was very new and a little scared so my decision to take my time had more to do with fear of being squashed by a fellow artist than with deliberate logic.

Since in those days it took me a lot longer to break down my booth, I noticed that I was literally the only one left in my section when I finished packing everything away. I walked to my truck calmly (in the dark, if I may add) and pulled up just by my booth; another twenty minutes of leisurely loading and I was on the road. The biggest surprise was when I looked at my watch and noticed it was just about an hour and a half after the show had ended. While secretly admiring the lightning tear-down speed of my fellow artists, I also decided at that point, that a slow deliberate tear-down is much less stressful and invariably you get to park right next to your booth. But if you like to walk long distances pushing and pulling a lot of weight, by all means, start early, fight your way into the festival and please be gone by the time I finish.

A plan of attack

Although you should squeeze the last minute of every show before ever touching a packing box, there is nothing that prevents you from thinking, as long as thinking about the exit plan does not overcome the task at hand: selling your art. Think later in the day or in those times before and after festival hours when you can study the terrain and decide on a strategy. I usually give thought to my break-down strategy the morning of the last day. This blissful morning, other artists seem to arrive later and I grab the opportunity of a calm morning walk leisurely studying the possible angles of attack. I have determined that a helicopter would often come in handy, one of those with the big container for water that they dump in forest fires. I could simply lower the container, fill it up with my booth and contents, and pull up, up and awaaaaaaay! Seriously, the main thing you need is a mental road map of how you might get your vehicle into the festival site after the bell rings. Parking in a favorable spot at this time might be desirable but show up early because 400 other artists will soon be thinking along the same lines.

Other than that, a very detailed plan is often trashed at the time when the bell rings and nobody does what they are supposed to, not even you. Somehow, it all works out in the end. Really.

Again, I tend to begin breaking down late by design, usually later than most of my neighbors. Nearly everyone begins doing something about an hour before the end of the show, most begin half hour before; I hold back and make myself sit tight until only a few minutes remain. The main reason for this strategy is that I do shows alone and there is no chance for me to get my vehicle in place while nobody tends my booth in the last half hour of the show. Many artists will send a scout out to the parking lot and line up long before the show is over. Once the flood gates open and the MEGAPHONE yells that the show has ended, artists' vehicles start pouring in at a frightening pace.

Show rules often state that artists should break down their booths before driving onto the grounds. In all these years I have seen few promoters enforce the rule. Fact is, many artists like to put their things away into their vehicles as they break down the display. I do too, but that is a luxury someone traveling alone with a trailer rarely gets to enjoy. No bother, though, my strategy works well for me.

During these last nervous minutes, you will notice many artists talking to each other. The conversations usually involve an informal space reservation (who is going to park where and exactly how they are going to park), sometimes they agree with each other as to who will pull in first, sometimes they are making dinner plans. At this point it is desirable but not necessary to know what your neighbors are planning and they will usually tell you without you asking. Just nod your head, and then do whatever you need to do to get your stuff packed and loaded into the vehicle. At this point, everyone is doing whatever they need to do to get their stuff packed and loaded into their vehicles. Don't be rude but be firm with your space. Try to be polite but don't let everyone around you run over you. Tear down time at an art festival is one of the finest practical examples of the live-and-let-live philosophy and you will get good with practice. You will also make show-friends who will hold your spot while you dash to the parking lot so remember to love thy neighbor.

Once you have decided what the best plan for you happens to be, then be prepared to change quickly according to circumstances. I usually plan to wait, but if there is a clear chance and an open window where I know I can get my vehicle smack in front of my booth, I will take it. I can run to the parking lot with the best of them and it is very desirable to have the vehicle in front of your booth so you can load as you pack. Don't count on it every time, though.

As I said, most artists line up and many are gone within a half to one hour after the end of the show. It's an amazing sight. It is also a blessing for those of us who take a bit longer and don't mind a bit of a wait. The difference between the early departures

and the second shift is often thirty minutes or so; certainly nothing to curse or get the blood pressure up about.

Be sure to pack carefully. Too often I have seen artists carelessly throw their prized possessions into the back of a van. I watched once a not-so-gentleman kicking a box until it conformed to the shape of the empty spot in a corner. I find it irritating to get home and have to unpack and repack because I got careless when loading. More irritating yet is when I get home and my load has shifted, things have fallen down and scratched tables or broken the glass of my framed pieces. So I keep my often volatile temper in check and pack and load as calmly as I possibly can.

Go with the flow

However well you may plan your exit, there are those that will inexplicably drive their 24′ cargo trucks into the festival site, park at such angle as to block the exit lanes, break down early, load and then leave the vehicle in that spot while they go to dinner. Happens every show, I don't understand it. Maybe it's always the same guy. Point is, be prepared for unsportsmanlike conduct at this point, with no referee in sight. Everyone is thinking of themselves, including me and you. Be prepared for all kinds of behavior and just go with the flow. The goal is to get out, sooner rather than later but, most importantly, in one piece.

If you can possibly catch the guy with the 24′ cargo truck before he digs into his slab of ribs, gently tap him on the shoulder and point out that you can't get out. They will move after they give you a dirty look, but who cares about that. And also be prepared for your friendly neighbors to become a bit less friendly. Expect extremely rude and sometimes aggressive behavior on the part of some artists. Expect some promoters to be invisible at this point (I would be!), or perhaps you might expect the promoter to stand guard over the traffic lanes and prevent the 24′ cargo truck to get in at all. Every show is different and there is little sense in getting riled over thirty minutes.

One of the most intriguing things that happen at tear-down is a phenomenon I have termed: "wait-hugs." Wait-hugs are the hugs that artists give each other after they are all loaded and ready to go. These same artists ran at full speed to the parking lot an hour before the show ended, started sneak-packing two hours before the show ended and whined about the long drive home in the dark. Now they stop to hug…and hug…and you wait.

I was trapped by the dreaded wait-hugs in Colorado once. I happened to be the happy recipient of a space in a side parking lot that was basically a cul-de-sac. Once tear-down started I was hopelessly trapped until everyone around me was gone. That time I had the sense to take a dinner break at a Chinese restaurant across the street while I waited…and waited. After about an hour, I drove into the parking lot and had to still wait for the last wait-hugs. I waited a long time, about an hour and a half total after I had

completely torn down. My patience worn thin, I finally got out of my truck, moved the last remaining items from my neighbor's space and pulled in. They never stopped hugging, the sweet darlings.

Somehow tear down is much less stressful for me than setting up. I think of going home, of gathering all my goodies and heading into the sunset (often quite literally). Adrenaline is flowing and the thought of home carries me through. All that, and the realization that tearing down and packing takes around two lousy hours! You survived another show, count your blessings and get on the road.

Going home

As I said in the introductory festival diary, I often toy with the idea of getting on the road right then, with dirt under my fingernails and adrenaline pumping. A fast food sandwich and a large diet coke and I could drive half-way to the opposite coast! You feel awake and energized and ready to take on the highway. Not so. Unfortunately many accidents happen when artists try to reach just another hundred miles down the road. You hear about artists getting in accidents a little bit too often for comfort.

Do yourself and the rest of the highway travelers a big favor: go back to the motel, take a hot shower, have a nice dinner and get up early the next day. Adrenaline wears off in about twenty to thirty minutes and there is nothing to keep a driver awake in the dark roads. It is simply not worth the risk. It's been a long weekend, rest up and, like many of us, get up at 4:00 a.m. and hit the road then, rested and happy and with the roads to yourself. I will conclude this chapter with one of my own horror stories—with a happy ending.

Web Diary Entry: Monday, March 18th 2003

This great weekend started on a very high note, the Scottsdale Art Festival has been touted as one of the best 50 festivals in the US, rated by artists which usually means promoters treat you well and you sell a lot. 1200 applications and 160 spaces, I considered myself lucky to get in. Easy set-up, a 10 x 20 foot booth which allows me to show off my larger pieces, my gallery is up and running and I am psyched!

Friday I sell two pieces before the show opens, we were set up in the City Hall grounds and a city employee wanted to snatch stuff before it was gone. In fact, the entire Friday had that "feel", people coming in and just grabbing stuff because they knew it would be gone by Sunday. Wow, I'm in a dream, right? Saturday is a repeat of Friday, with added clouds off and on but no wind and no nasty stuff. Saturday brought once again bunches of people that grab stuff off my walls and don't haggle about the price. Originals were popular items once more. Saturday night I glance at the weather report and it continues to say a heavy rain will come down on Sunday. We say that a lot in the Southwest, mostly wishful thinking.

Sunday arrives early, I was too nervous to sleep so awoke around 4:00 a.m. and it indeed is already raining, an annoying sprinkle that is sure to keep all but the hardiest shoppers at home. Took a walk, had breakfast, watched all the artists show up slowly and gripe at the weather. No matter, I'm happy...well on my way to making the most ever at any show (including in my dreams) when—MOTHER OF ALL CLOUDS shows up. It looked like the mother ship was coming to get us all, a black aircraft-carrier of clouds barreling across the sky, the dark mass bearing down on us at about 12 knots—I honestly don't know how fast a knot travels—but the cloud was coming fast. I said my prayers, hoped my will was in order, stress level climbed to light cherry—somehow survived to tell all.

The rest of the day is still a bit blurry, dream quickly turning into a nightmare, lending a new meaning to the word "miserable":

1:00 PM

Buckets of rain coming down on us, 200 artists and food vendors scrambling to cover up thousands of dollars worth of artworks, everyone cursing aloud, all my "be-backs" be-gone-home to safety. Many smart artists closed their tents tightly and crawled inside. Everyone's tent started leaking due to the sheer volume of water falling; wind blowing so hard some of the water is coming in horizontally into the booths. Two tents collapsed under the weight of the water.

2:30 PM

Word comes from above—the promoter, I mean; God is obviously tending to more important things—that we can officially go home (oh really?). More buckets continue to fall from the sky; mother cloud has now turned into an entire fleet of monstrous black dragon-things with thunder and lightning to boot. I'm soaked, there is no dry place to put anything, wind picks up so rain comes into my booth, out of towels, stress level turns bright magenta...somehow all my art gets packed up under the tent.

Vehicles are everywhere among the half torn down tents and you could hardly get a bicycle through. Ignoring this spatial reality, I went to get my truck and trailer only to find out that the overzealous rent-a-guard would not let me back into the grounds because I'm pulling a trailer and there are too many vehicles on the grounds already. I just kept inching forward toward him saying, I can make it just fine, I have to get my artwork in the trailer before it gets ruined. I can't believe that I was driving straight into him and he finally had to get his scrawny ass and his puny plastic porta-barrier out of my way or be mowed over by the angry Spaniard. Artists looked at me a bit apprehensively as I crawled confidently (yeah right) snaking truck and trailer within centimeters of their prized possessions. I just kept smiling...maybe I was gritting my teeth.

3:30 PM

Stress level now to deep purple as I, soaking wet, packed everything, soaking wet, tightly into the trailer so that it would get home and still be conveniently soaking wet. Fortunately many big works were gone with new owners on Friday and Saturday so I was able to mentally focus on that fact and get the stress-color-code down to a pleasantly refreshing lavender.

4:30ish

Got to the motel, heart beat around 435 beats per minute, and decided to get out of Dodge while the adrenaline was a-flowin'. Somehow got refund for entire last day, must have been the pleasant disposition and friendly manner in which I asked the motel clerk. Made strong coffee. It is only a five hour drive, I kept telling myself as I peeked over the horizon and contemplated more strange black things in the sky and fought to keep my windshield clear of the incessant falling rain.

6:30 PM

Getting really dark now, scary dark behind all those clouds. Just past Wickenburg there is another mother-ship-cloud, this one looks like a black band of velvet covering the entire sky; the road is so dark under it that I'm sure I've taken a wrong turn somewhere and reached the edge of the world. I'm heading straight into this black curtain of nothingness and I say my prayers again, this time in Latin. I crank the SUV in 4-wheel drive and think seriously about my sanity, wondering how, if I were to somehow survive, I would get along in an asylum; probably would have to carve Styrofoam with my fingernails since they surely wouldn't let me have cherry wood and woodcut tools. I'm pretty sure I'm still awake and this is actually happening.

Just then lightning cracked about as loud as I've ever heard it, and struck all around us ("us" as in me and the chicken cars that snuck behind my trailer hoping I would brave the storm first and lead them to freedom). Immediately after my heart got back into my chest, a sheet of water came down on my windshield like I was in a carwash. Visibility = zero meters, I can't even see my hood. Peachy. Just great.

I stopped right there in mid-road, needless to say, and hoped my air bag would save my nose and neck when I got inevitably rear-ended by some eighteen-wheeler. There was nothing else to do, there was just water falling in a continuous sheet and completely blinding me front and back.

Nothing happened, we all just sat there until we could see again...and just then we found we were smack in the middle of a flash flood. The feeling was that the water was moving the desert across the road. Initially it looked like the entire desert was moving downhill. Rocks and brush going by across my path in a raging stream of mud, very

visibly inching up in height and volume with every second gone by. I look in my rear view mirror and see that the muddy mess is behind me too engulfing me in the middle. Excellent. I'm dead.

At least I could see now, so I cranked the faithful steed in my lowest all-wheel-drive gear and it dug in with all fours and bumpity-slosh-thump-tump I was out of the mud slashing river in another very long thirty seconds, all four tires still on the axels, trailer still faithfully (and somewhat miraculously) hooked behind. I don't know what happened to the cowards behind me; they probably ended up in the Gulf of Mexico.

A strange calm came upon me now as I realized I'm still alive, stress level down to light cactus. A gentle intermittent drizzle all that was left of the mighty storm. As it often happens in the Southwest, the rest of the trip was windy but relatively calm and some parts of the road were completely dry. There was even a full moon shining bright in the sky and Orion guarded my left flank for the rest of the trip.

9:30ish

Got to Hoover Dam, just outside of Las Vegas, where they have decided to place a permanent check point for screening folks that might want to blow up the dam and leave the entire Southwest US without its main water supply. No matter, I'm practically home, I'm so very happy...I know the drill, stop, open trailer, smile and move on.

Not this time—a wannabe terrorist-catcher decides it would be fun to watch me unload half my trailer right there in the raging wind with sprinkles on top. By this time I really thought I was in one of those nightmares where everything goes wrong and you can never get to where you are going. I just knew I would wake up soon, but it was too cold, I felt severe pains in various places from the prior loading-in-a-rush adventure and I was standing fully clothed rather than lying down in my comfy jammies.

Wide awake and sighing heavily, I heard myself talking. I told the nice fellow I do art festivals all the time and could show him some paperwork from this festival, but he kindly insisted that I unloaded the trailer instead, until he could see my entire stock. Not satisfied yet, he even made me open not one, not two, but three of my stock boxes. He must have liked my art because he went and talked to his supervisor and finally let me through. As I smiled waiting I secretly placed an old Spanish curse upon him and most of his descendents. He smiled and sent me on my way.

10:58:12

Got home safely after all and immediately surrounded myself with furry creatures who licked all my wounds away. There is no place like home.

Chapter 8

The Long Haul—Setting Goals and Fine Tuning

"Success seems to be largely a matter of hanging on after others have let go."
—William Feather

"I have learned this at least by my experiment: that if a man advances confidently in the direction of his dreams, and endeavors to live the life he has imagined, he will meet with a success unexpected in common hours."
—Henry David Thoreau

So how did you like it? How was your first show? Good? Bad? To some artists, a good show is one in which they made a reasonable amount of money and they didn't have a flat tire. To others, a good show is one in which they made a predetermined amount of net profit and didn't have a flat tire. And yet to others, a good show is one in which they made a predetermined amount of net profit, bested last year's show by a reasonable percentage, got a bunch of repeat customers to come by, lured a couple of gallery owners into considering their work and...didn't have a flat tire. The difference between those groups of artists is crucial to understand in order to progress into the land of success. No approach is "right" or "wrong" and everyone in this business needs to find their own definition of "good show," and, while they are at it, their own definition of success.

At this point, every artist should know whether they are cut out for this life or not. I admit it is a hard life, especially starting out. In many years in the business I don't think I have talked to anyone that said: "Oh yeah, that was easy money!" When I tell my husband that my job is easy he reminds me that I often come home sore and tired and work 12-14 hours a day pretty much every day and a bit more during the actual festival. If going for the long haul, goals and improvement are essential to make this tough life a

happy tough life. First you have to decide if you are going to embark in the adventure and then how you will approach the many challenges.

Endeavor to Persevere

Refer, if you will, to the first quote under the chapter heading and you will have the first secret to being successful in the art festival business. I don't know how many times I have been talking about the business with someone who "used to do art festivals" only to find out later that one fine spring they did a whole two festivals in their home town, got sunburned in the one in the parking lot of the Church and got insulted at the one in the mall and subsequently hung up their tent poles and got a "real" job.

When I decided to take the plunge I dove in head first; the usual m.o. for most things I do in life. After the first few festivals, hard as they were to swallow, I knew I wanted to be an art festival artist *for a living*. Having been in the corporate business world in a prior life, I set out rather impulsively but with a good business head on my shoulders. Selling art at art festivals is a business, whether you do it full time or part time, and a business needs time to fine tune, grow and ultimately succeed. I personally have only two goals set in stone for each festival: first, make it back home safe; and second, learn something new. The business goal is, of course, always to make a profit, but that profit goal remains flexible because I know how fickle the business can be. The learning part is tough because you slowly learn that you are never really done learning. But I like always keeping an open mind, learning sales tips, display tricks, phrases to say to customers, motels to avoid, good places to camp and so on. If anything at all, I will for certain learn that either I need to do that festival again or that I will never return. Learning is learning.

That constant learning eventually translated in virtually imperceptible changes in demeanor and display. Soon those shows that used to be mediocre turn into pretty good shows and the pretty good shows turn into awesome shows. What changed? My husband asked me that question once when I told him I was finally making good money in my home festivals. What changed? The answer was: a thousand things. I honestly tried to pin-point what I had done differently from one year to the next but my space had changed, my display had changed, I had more diverse choices of offerings, more size choices, fewer larger works but more originals, many more matted works in nicer bins, higher end works, a new tent, floor covering, confidence… I simply could not figure out the *one thing* that made a difference; everything makes a difference.

Most importantly was the fact that I stubbornly continued to do the shows. In a recent festival a customer walked into my booth, grabbed one of my larger original blocks and said to me: "I have been looking at this one for three years and I am finally going to buy it before it is gone." Know what? Fine with me. I silently applauded myself for my stick-to-it-ness; I came back to the same show, I persevered despite poor sales the

very first year. I worked the show and I was more stubborn than the economy and the weather put together. Be very stubborn. First let's set some goals, which come in two flavors, short term and long term. Once we have set some goals we will cook up some magic potions for advancement.

Careful Planning and Goal Setting

When I said I only have two goals for a show, I meant short-term goals. I do want to make it home safe and also learn something. I like to plan things, probably over-plan things, but I also learned in art festivals and hiking, that although it is awesome to be prepared and have a route and a plan, it is even more useful to be prepared by keeping the plans flexible and being able to adapt to unforeseen circumstances. This type of flexible approach to art festival goal setting is desirable because of two things: first, I don't get irritated when things don't turn out exactly as planned; and second, I am able to learn and re-plan on the fly while keeping my sights firmly planted on achieving long term goals.

Keeping goals realistic, specific and attainable is also important. Every artist wants to make six figures by attending perfect shows once a month every month, however having that goal right from the start will make some otherwise very reasonable shows seem depressing. Increasing income over time would perhaps be a more reasonable starting goal. And acquiring a certain level comfort with this tough life can also be a reasonable goal.

Just Up the Trail

As far as short-term goals, there really is nothing wrong with setting a minimum amount of money that you would like to take home for every show. I have found that I usually make a mental note of what I made the prior year and also that my minimums are rather low compared to other artists but I hate to be disappointed when I set a high goal and don't come close to achieving it. Conversely, having those minimum-amount goals in the back of my mind seem to make me work harder at salesmanship; I tend to talk to people more, entertain everyone that comes in my booth and engage in more sales strategies. I really don't want to lose money at any show and haven't for a long time, so once I make expenses (including booth fee, gas, motel, food and miscellaneous) the pressure is off and I just enjoy the gravy. If I decide that I don't care what I make at a show—as in when there's really good hiking around the show—then I watch myself hang back in my booth and tend to not be quite so outgoing. Is there a difference in sales? Better believe it.

But short term goals have more to do more with fine-tuning the festival life. I am a hopeless tinkerer and sometimes I tweak just because I enjoy changing things a bit, but I also observe people who succeed and try out or adopt some of their strategies in order to

improve. Doing the same thing show after show will likely bring the same results show after show, year after year. Basically, planning and goal setting help me run my business more like a business.

Aside from having a flexible short-term income goal, other useful areas in which I set short-term goals are: improving display, fine tuning salesmanship and becoming more efficient in set-up or tear-down, among others. Little improvements in a display can add up and make a world of difference. I now cover the weights that hold down my tent with the same carpeting that covers my panels. Imperceptible detail to some, the nice cover gives the eyes of the potential customer one less distracting ugly thing to catch their attention while glancing at my work. From one show to another I might decide to find a better way to display my matted works or create a fresh configuration for my panel setup. In fact, I make it a game to have a completely different panel setup at every show. When I do two shows back to back in the same town, I am always surprised at the number of people that comment that I have so much new work from one show to the next. The illusion is created by the change in display, and this strategy serves well to get the same people to look at different things.

If I find that a particular task is very heavy (or irritating) or takes a lot of time during set up or tear down, I try to devise a strategy to change by the next show, before the task becomes a permanent irritant. Every little thing can make a difference and the willingness to change and constantly improve in one area or another will keep the artist's life fresh and exciting. I hate to be bored and I never get complacent.

Here are a dozen examples of short-term goals I've set for myself over the years, in no particular order. Keep in mind these were my goals! Every artist will have different artwork, display needs, irritants, and so on. Therefore every artist will have vastly different short-term goals. I also find that some short-term goals become unnecessary and can be discarded after a while.

Short term goals can read much like a to-do list:
1. Carve a wood sign for my booth explaining who I am and what people are looking at "Maria Arango – Original Woodcuts"
2. Make laminated displays explaining about woodcuts, a brief bio and where my inspiration comes from. Also, make signs for particular pieces (expensive ones) to attract people to the piece and tell them "the story".
3. Get a 10' vinyl banner for those shows where everyone else has one.
4. Paint my weights (seasonal task)
5. Fix the legs on two of my panels
6. Clean some stains off my display racks (after the Strawberry Festival!)
7. Demo at EVERY show, include some smaller prints that I can give away to kids

8. Get a more comfortable chair (you sit a LOT)
9. Put wheels on matted bins (still haven't, sigh)
10. Get professional slides made of newer works
11. Send thank you cards/invitations to all customers who bought last year at the upcoming show
12. Try triple matting some pieces to see if they sell better (they did!)

Your turn! Write them down and cross them off as you complete them.

Way down the road

Looking down the long road is tough to do when you are dealing with spurts of rain and windy days, but long-term planning is essential to keep rolling ahead and avoid the trap of simply booking show after show after show without aim.

Long-term goals should be equally firm and flexible all at once. Being stubborn is essential once more and setting realistic but somewhat lofty long-term goals keeps your eye on the ball and your feet from gathering moss. And again, long-term goals can be about income, saving time or simply about general comfort with this generally uncomfortable life. I will also add to that list, the goal to achieve a general happiness with the art festival life. To that last end, I like to eliminate extremely irritating shows. After all, I chose this life to do what I love and left behind an irritating life of corporate-hood. To engage in irritating practices in the life of my choosing is not what I signed up for, although some high tolerance for weather and annoying people interactions comes in very handy.

One of my first long-term plans was to decide on an income and a number of shows to attain that income. When I first started I heard a lot of artists talking about doing 40 shows a year. After my first few shows, I decided quickly that was NOT to be one of my goals. I started at 24 shows and decided that my first long-term goal would be to do less shows while keeping my income level about the same. Easier said than done, especially for a rookie, but I persevered and now I do around 8-14 shows a year and keep my income at a constant if not slightly growing level.

Some artists find that the rhythm of doing shows every weekend or every other weekend suits them best. Yet others will quickly settle on a few local shows offered in the spring and fall. Out West, Colorado artists have a very short but fruitful season in the summer and take time off or travel as the weather turns cold. The variation of number of shows and schedule is endless and can be different from year to year.

Another long-term goal, which really went right along with my first one, was to research and find the "good" shows. I spent the first year figuring out what a good show was to me, and then I concentrated on finding and keeping the shows that matched my

criteria while still engaging in the occasional adventure of trying a potentially palatable new festival.

Quickly I found out that the "GOOD" shows, also known as the top rated shows in the nation, were extremely competitive. So I engaged in some fact finding by asking artists who seemed to consistently get into the better shows and found out what they did, or more to the point, what I needed to do in order to follow in their steps. I still have some goals in that department, but I now consistently get into some of the top shows in the West. I just spoke with another artist that now travels across the country to savor some of the good shows in the East. They mentioned that it took them twelve years to take the plunge into cross-country travel. Perseverance once more!

The research to find good shows took some doing; I had to research a lot of shows and I limited myself to nearby shows, within 500 miles of my home base. I wanted shows that were three days with prior day setup, heavy attendance, established for a few years, and in areas that I know I sell well. Quickly I learned there are hundreds of shows even with those strict criteria. Next I had to somehow separate the wheat from the chaff and find the "good shows."

My good shows, again, are shows that are fairly comfortable to do or even fun to do and that bring me a decent income. I also like to know I can get into shows for sure, so I have cut down on applying to some of the extremely competitive shows after finding out the income level is only slightly higher than what I get in some of my bread-and-butter shows. And there is something to be said for being appreciated and knowing your schedule way ahead of time. Having said all that, I enjoy the occasional "zoo" and still apply, and sometimes get in, to the top shows in the nation.

Here is my personal sample list of long term goals worthy of having, again in no particular order:

1. Get into 6 (10? 20?) of the best 200 shows in the West
2. Improve income in every show compared to last year
3. Plan a series of three shows in Colorado for the summer
4. Cut down expenses by camping at more shows
5. Hike the day before the show in my favorite summer shows
6. Apply for 3 of the best 200 shows in the Mid-West (oh the adventure!)
7. Try a 10 x 20' display
8. Get carpet panels instead of grids
9. Publish an e-newsletter to be mailed to all customers who sign the guest book
10. Improve website/festival connection; make sure people can find specific pieces they saw at the last festival
11. Make a few very large color pieces as "show stoppers"
12. Write a book to guide new artists!

Money isn't everything

Other goals have nothing to do with income. When I first started it seemed like it took me forever and a day to set up my booth. I envied those pros who came two hours before the show, plopped up their tents and walls in about an hour flat and were sipping coffee fifteen minutes before opening hour. Amazing.

Efficiency in doing all the tasks that building a gallery entails is something I constantly work on. I really didn't want to spend my life setting up and breaking down a booth, and I confess I'm a bit obsessed with efficiency. If I can shave a minute or two here and there—minutes add up, you know? I also admit I'm a bit of a stickler for making things as efficient as possible, but to me efficiency translates into ease and ease is…easier?! This life is hard enough without having to deal with things I can change. One firm goal I set was to make it so that shows weren't such a chore, either physical or mental. After all I had sought to eliminate stress from my life along with the pantyhose and high heels when I left the corporate world.

For example, I learned quickly that art festival stuff is heavy. Embarking in this wonderful life at twent-er, forty meant that my ol' body was no longer at its physical prime and I suffered many aches and sore joints for the first year or so. Somehow I had to find a way to make my newly found life a bit easier on my body. I struggled with hand-carts of various shapes and sizes until I found the right combination; sometimes everything has to roll over uneven hilly grass; sometimes curbs, steps and long distances are involved. Everything I own now is on wheels; I have a ramp to load and unload the trailer, which I have learned to back within inches of a desired location; I'm good at sneaking into places where distances aren't quite so long; I get to setups early to be able to take my time. Still by far the most stressful time of any show, I have made set-up and tear-down quite tolerable.

Another big factor in my life is my family and my home. Seems all the great shows are far from home and sometimes they are scheduled back to back. There have been times when I only had one day between two big shows and, much as I enjoyed the income and success of doing two of the best shows, I also realized that I did not particularly enjoy being away from all my furry creatures. I have done two shows back to back, scheduled so that I did not have to come home in between and thoroughly enjoyed camping in between but I missed home. I love traveling and seeing the world, but home is a big thing to me. After a few years I avoid such schedules and am quite content with doing less shows and shows that are closer to home. You might find that more shows or heavy traveling are more suited to your lifestyle.

Along with the home/family issue is a need for me to have studio time. I can't pick up where I left off very easily because of the nature of woodcuts. I can't even get into a creative "mode" until I have been settled at home for two or three days. If I have back-to-

back festivals the schedule really cuts down into my creative time. Selling the same works over and over again bores me to death and I'm sure it bores my customers as well. So I plan and set in stone my hermit time and enjoy creative and manufacturing bouts of a decent length.

Other artists seem to enjoy the rhythm of the more frequent festival and have found a way to create on the road, on the campground or anywhere they might be when traveling from one festival to another. Again, the life of the art festival artist can be as varied as you like and as settled as you need.

One year, my main goal was to simplify. This was tough because art festivals are quite addicting and when you like a show it is difficult to make a conscious decision not to do it next year. But I listened to one wily veteran who once said to me: "You can't do all the shows all the time." Ahhhh, yes, I know that now, master.

So on my third year I chose happiness as a goal. I cut down on the number of shows; I scheduled long breaks between heavy festival seasons and skipped very long trips. Back in the days when I was getting my degrees at the university I would work two jobs during the summers so I could cut down to one job and school during the academic semester. Crazy stuff but I was young and foolish then and could take the beating. After a fruitful career in an even more crazy corporate life, I decided that I would become an artist. After being an artist for several years I decided I would not return to those worlds of madness and frenetic pace.

I now have narrowed down three keys to the happy festival life for myself:

Key Number 1) I control my schedule, which as I mentioned takes a lot of discipline because I always want to be in the festival I didn't apply for.

Key Number 2) I set realistic goals so that I don't beat myself up all the time (I am my own worst critic), yet I continue to set reasonable goals so that I don't stagnate in either my work or my career.

Key Number 3) I pace myself. This is probably the toughest for me because I seem to have two gears, full throttle and exhausted. Over the years I have found some intermediate gears that I grudgingly use when I lack the energy for the full throttle but refuse to be idle.

Here is a sample list of those important "other" goals I have set over the years:

1. Show up earlier to set up.
2. Get a ramp for unloading.
3. Schedule no more than two back to back shows.
4. Skip one "zoo" festival.
5. Take a helper along to some of the festivals (this can be a family member, even if they can't haul heavy stuff, having moral support makes a huge difference sometimes).

6. Make that wonderful new series of works I have been thinking about for a year.

7. Buy (and use) a back support.

8. Get a director's type chair to sit more comfortably.

9. Take an extra day and hike (swim, shop, whatever) before that festival in my favorite summer spot

10. Stop rushing at tear down and wait until I can get the vehicle closer to my pile.

11. Skip Thanksgiving shows to be with family.

12. Draw some possible setup configurations for panels.

A Swig of Progress with a Spoonful of Patience

I "talk" a lot on the internet with artists that find my website and want some tips on how to get started. Once there was an artist that had seen me in a festival and found me later online; she was ready to take the plunge and do some festivals. Her questions were mostly about what types of display to get and I dutifully sent her to my resources online to see a variety of choices. I cautioned her to start out economically until she knew for sure she wanted to do this, but ignoring my advice she purchased the same tent I had and a full "store-bought" display from one of the companies.

To make a long story short, she wrote me after the festival and sounded irritated when she explained that she had not made back her investment. I almost told her that my entire first year was a loss but held back and encouraged her instead. She had wanted to start out at the top and had wanted to work out every little detail before starting. A good plan is good to have, but progress tastes and digests better with much patience, otherwise a case of expense indigestion results and those are hard to swallow.

As wise as it is to continue to make goals, meet them and make new ones, it is just as wise to be patient with the whole adventure. There is no way I could have possibly known what my display needs were when I first started. There is no way I could have known the mix of works that maximizes the potential for a good show for me or that the mix of works would need to change from show to show. All these things take time and tweaking. Too often I have seen artists do the same exact thing show after show. Their display looks the same, their work looks the same whether it is a varied audience heavily attended show or an upscale paid-gate show. The art festival world cannot be approached by formula, a flexible and changing approach to meet the changing business is essential to progress…and all this takes some time.

Never satisfied

One key to progress is self-analysis, an art that is rarely practiced by those who spend their time pointing fingers at the promoter, the weather, the guy selling trinkets in the loud booth…Frankly, I have never had the time in a festival to go looking around through everyone else's booth to see if their reproductions were properly labeled as such

and numbered in proper sequence. But I have had the printmaking police come over to my booth and ask me if I print my own woodcuts. My stock answer: "I design, carve, print, mat, frame and put up the booth all by myself." And I always want to add but never do: which leaves me little time to go around poking my nose in everyone else's business.

Personally, I tend to self-analyze quite a bit. When I have a good festival, when I have a bad one, I always ask myself: did I do everything I could do to make this festival a success? If it was successful, did I do enough to really get all the sales I could have? When the crowds are scant and I find myself recoiling toward the back of my booth looking for a book, couldn't I instead carve a block and try to attract the few passersby into the booth? Did I take the time to study the flow of the crowds to maximize my two seconds of "viewing"?

Over the years I have made some progress in my display to the point where people now comment on how good it looks, yet I still see displays that look more professional than mine. Over the years I have improved my framing to the point where framers comment favorably and customers ask me if I will frame other artists' work. Over the years I have tried to progress in my artwork so that people continue to see new images and perhaps one of this days I will make something awesome enough to drop jaws. Until then, there is still work to do. Every time I finish something, every time I win, every time I lose—I ask myself: Did I do enough? Did I do my best?

I like to watch professional "sellers", especially those artists who consistently sell more than I, and do the things they do. I figure until I am as consistently successful as they are, there is room for improvement in my approach. There are quite a few areas where I would still like to improve. There is work to do still in many areas; salesmanship comes to mind right away. I still get lazy some times and neglect my carving tools and block in favor of a good book, and while learning about the history of color theory is commendable, sales seem to be highly correlated with how interested I am in making those sales. I still watch other veterans and see what they do, how to sell a $5,000 painting at a street festival is something admirable and perhaps something to continually shoot for.

The balance between progress and patience is a delicate one. In this tough life we need to be gentle with ourselves, but not so gentle that much of the time is spent patting ourselves on the back. I tend to err toward too much self-criticism, but then only I know what I really *can* do and only I know how much time I actually spent on figuring out the color scheme for that piece or why I decided to skip the third mat on that other.

Simplicity versus staleness

I watched a veteran gentleman in a recent festival as he put up an EZ-up canopy, brought out three paintings, hung one on each wall from the framework of the canopy

and sat inside his booth in a corner. I'm never one to criticize others, mostly because I'm too busy fighting with my not-so-EZ-up canopy and carpet panels and other things. So when I saw him in such a simple setup I wondered whether simple would work for him. Not being one to go right up and ask, I watched and waited. He didn't sell a thing and let everyone know around him that usually he sold out by the second day. I thought maybe the truth lay some place between the nothing and the all, so in casual conversation with another veteran, I asked about him. Sure enough, many times the old gentleman sold out his three paintings and brought out three more and sold them too. And many times he sat and sold nothing.

The simple setup and approach worked well for him, at least as well as he wanted it too. Something to be said for that.

Having mentioned the one exception, I have more often than not watched many a "simple" approach turn into the "same ol' thing" approach and slip dangerously toward staleness in both appearance and work. Some artists bring out the same work to every single festival, display it exactly the same way—because it's faster to do the same thing than to try something new—and settle into a simplified approach to the whole festival business that borders on the stale. Their motto is that they have found what works for them and want to keep things the same way. Suggesting to them that they should try something new is pointless. After doing about three years worth of festivals with them, their booths begin to look stale—there is simply nothing new to see.

Some artists even go as far as selling the same "original" images over and over and over. This is not only going to displease customers who supposedly bought a one-of-a-kind "original" but it means that artist is always going to be fishing for new customers—with the same old bait. I much prefer to build collectors who flock to my booth to see what's new and collect my works on a regular basis, and at the same time catch new fish that come to see what all the fluttering is about. And it is good to remember that many customers frequent the same festivals over and over and over.

Taking a few risks may or may not pay off, but having new things in the booth or displaying works in a different way make me (the most important person in my business) feel better. Feel better, better attitude; better attitude, more smiles; more smiles, more sales…

Every artist in the end will take an approach that feels comfortable and that they can live with over the long run. The progress curve may be steep at first and then settle a bit to a more comfortable and less hectic pace. Other artists will settle earlier and be happy with smaller shows and a moderate income. Some of us are always pushing. Either way, it is very important to find the way that works for you, set your own goals, and work hard to attain them. And with all the serious work done, it is now time to learn how to also find the time to smell the roses.

Chapter 9

Staying Healthy Through It All

"Happiness is nothing more than health and a poor memory"
– Albert Schweitzer

As I write this I just finished a mini-season of four festivals in sequence. Don't ask me why, I fired my secretary already for booking so many festivals back to back. Seriously, I was exhausted after the first one, in the dead of winter but also in the dead of the desert; two references to the sales at the first festival. With my body appropriately in full winter's coat, I braved a 95 degree set-up and three days in the heat to go home with sales well below expectations. It was *supposed* to be a great festival. No time to linger because I had three more coming and there aren't really that many full preparation days in between three-day festivals.

The second festival was as expected, a run-of-the-mill standard nothing to get excited about kind of a festival which lived up to its expectations. The weather held and I was able to use the short days in between to pump up the tires and frame some stuff and head on into the sunset for the third. With the heat of the first festival and the luke-warmth of the second still in memory (again, a reference to both weather and sales), I was barely able to withstand freezing rain, snow and two days in 30 degree weather. With the wind chill factor, the nice weather people claimed it actually felt like 26—yes, I said twenty six!—and six layers of turtle neck sweaters didn't come close to keep me from shivering all day. Needless to say, chilly sales at that festival and I spent the next three days trying to get my body temperature back to normal. Three down, one to go.

Two days under blankets helped me recover somewhat and I headed off into the reasonable February weather of Arizona for a mega-festival that was sure to break every record. Three days later I'm scratching my head and watching other artists scratch their head tossing theories back and forth on why sales were so horrible this year despite a

healthy attendance and perfect weather and I am almost ready to head back home and get a job. I held out, however, and ended up having a healthy last two hours of the festival. Altogether I tallied sales and decided that it had not been a bad February after all, although usually I had made the same profit in two, rather than four, lovely outings.

I don't know how you feel after reading that, but I'm still tired and recovering from a hacking cough and a fever that won't go away. I also can't quite get enough sleep and, believe me, I've tried hard to imitate my cats on a daily basis. A few web sales have sweetened the disastrous month quite a bit, but I still sit (cough, cough) here and wonder why on earth would I embark on this adventure—as I create yet another woodcut and get ready for the end of March, and a new wave of festivals.

Going back in time to my first few festivals I tend to recall the good times, the great successes and the perfect weather. It's not that I have a bad memory, I think I have a great memory! It forgets the bad times and remembers the good times, how much better can you get than that!? But going back in time, I do seem to recall recurring back pain, an elbow brace, a sudden weight gain, a dislocated ankle, persistent mental exhaustion and a few feverish days. I also might recall elation quickly followed by depression, feelings of hopelessness in the rain, panic on the road and my first ever taste of bitter loneliness.

Through the years, I have taught myself to enjoy and remember most the rainbows and the windless sunny days. I have learned to savor the fine moments, the friendly laughs of other artists, the fascination in children's faces, and the delightful moments when I struggled to keep up with simultaneous and frequent sales.

In writing this chapter, I recall yet another reason why it was so tough to start this business. In addition to the stress of starting a business, it seems nobody warned me about the physical, mental and emotional extremes I would have to endure. Staying healthy through the first year can be a challenge and keeping mind and body in tip top shape might take a bit of preparation and trickery. At least an artist should know what lies ahead and take care of the basic needs that keep us strong enough to withstand the stormy weather. Despite having a prior life as a professional in the health industry, I am really writing more from the perspective of someone who has successfully completed several seasons of art festivals, lately without so much as a sneeze or a slight backache. Oh, if I get preachy it's because of all that leftover higher education, I apologize in advance and will strive to remain under control.

The very bottom line is: you cannot call in sick! There is nobody to take your place, the booth has to go up, art has to be sold, and you can either make zero dollars or several thousand. Festivals do not wait for you to feel better and canceling your attendance at the eleventh hour could affect your chances for acceptance in the future. Unfortunately for

the lone artist, the consequences of "calling in sick" can be unfairly severe both in the short and long run. Healthy living becomes a requirement to withstand the stressful yet wonderful life of the traveling artist and this particular choice of careers presents unique challenges to the mere mortal that we all are. This chapter deals with those challenges and suggestions on how to meet them to stay healthy, wealthy and wise!

Up and Down

I have talked about the business now and what to expect in terms of work and travel involved. But here I must emphasize the degree to which this life will take you to physical and emotional extremes. Art festivals are a continuous "game" of hurry up and wait, up and down, stop and go, full-throttle and complete idle—ready or not, the start and stop leaves you exhausted.

Let's begin with the simple preparation steps that we take just prior to a festival. I might just have finished a blissful week of studio work, dabbling in the peaceful world of fantasy, creating a few pieces, perhaps framing a few. All of a sudden it is the day prior to travel and there is a whirlwind of preparation steps as outlined in some previous chapter, all of which necessitate that I engage my highest gear, load the trailer, pack, check the weather, get maps, fill the tank, and so on. The next day I will spend sitting unceremoniously on my hind end, doing absolutely nothing but keeping the vehicle rolling ahead and hopefully always on the right hand side of the road. Both days are stressful in different ways and both are enjoyable except for the ever present anxiety in the form of the little voice that constantly says: "did I forget anything important?"

No time to linger upon that thought because after arriving, checking into a hotel and perhaps checking out the festival grounds, comes the anxious wait for check in. This first bout of anxiety is usually over once I find my space and begin unloading—unless it is raining or extremely windy. After another few hours spent at full throttle and maximum torque, the tent, panels and possibly even my artwork is all up and ready.

Anxiety prevails until the first sale the next day, an anxiety that is produced by sitting around or standing around while talking to prospective customers. At worst, I sit in the back of my booth seemingly veiled by an invisible wall that prevents customers from seeing my art. If I somehow break the curse of the curtain, there remains the stress of closing those sales. Sometimes I have come so close as to smell the money only to have the prospect walk out after grabbing the dreaded business card.

At best, there is such a flurry of customers inside my booth that I can't keep up with all the conversations and fear losing sales by not being able to pay enough attention to those who demand the personal touch. After the closing bell rings (there is no closing bell, by the way, more like a collective swoosh of cloth walls falling down) I leave my precious artwork guarded by nothing but the aforementioned cloth walls, zippers and cable ties, and the occasional "security" which may range from the available relatives of

the promoter to the local police. Resting easy ain't easy under those circumstances but somehow we get used to all that.

After the ups and downs of two or three days full of flurry-and-calm cycle of sales and other assorted minor stressors like 40 mile-an-hour wind gusts and not-so-gentle spring rains comes the tear-down zoo that I have previously described. All unsold items must sadly go back into the trailer somewhat neatly and without damage, ready for the next adventure. Exhaustion again sets in an hour after all is done and the slide to the biggest "down" of them all commences: the time between festivals when I wonder why I undertook the path of art festival life and at the same time push myself to prepare for the next.

Back to Basics: Food, Shelter and...Naps, Many Naps

All the above activity or lack thereof results in extremes of stress; in art festivals either too much is happening or not enough. Stress, as everyone knows by now, is a potent health hazard. Despite all the hype tossed at us incessantly by the multi-million popular health industry, the basics of staying healthy through trying times have remained the same for centuries—dare I say, for millennia? If you were to find yourself in a deserted island the first thoughts would be to find food and shelter, not necessarily in that order. Art festival locations are hardly deserted (although I've been to some that would qualify!) but these two basic needs must be met first in order to assure physical and mental health.

When I first started out I attended a few festivals where I camped in the artist's parking lot in the truck, ate nothing but energy bars and had poor sleep while listening to the hum of my neighbor's luxury motor-home generator. Although deserving of commendable bravery and commitment to profit, that is hardly the way to go about living this life in the long run. Eventually the body whines and the mind soon follows, not to mention the mouth. But I digress…let's just mention the basic needs that once and again will become essential for well-being and long lasting contentment in the crazy art festival life.

Gimme Shelter!

A home away from home is pretty essential to wellbeing and intimately tied with the nap section coming up. Bad enough to be away from loved family and pets, adding the stress of parking lot camping is a sure way to feel uncomfortable, unsafe and sometimes right down miserable.

A home base is essential to shed off the insults and blissful ignorance of the non-buying public and the hustle and bustle of set-up and sales. Home away from home is where we get most needed rest, kick up the feet, shower with very hot water and find a comfortable horizontal position under clean sheets. Much more than that, our temporary home is the cave we return to after the hunt, the shelter from wind and rain, and the place where we can call or email home for a much needed digital hug.

Splurging on luxurious shelter is not necessary and there are a variety of reasonable accommodations in nearly every city, some downtown tourist destinations being the exception. One note of caution deserves mention: the "festival special" rates on hotels near the festival grounds. The law of supply and demand will dictate that the special rates are simply marketing stratagems directed toward the masses that are sure to come to the festival. When I first started and profits were uncertain to say the least, I got very familiar with the wide variety of bargain motels. Some times I had to drive an extra mile or two but I often stayed at half the price as that "host hotel" with special artist rates. Many artists use Priceline, Expedia, Hotels.com and other online bargain price reservation brokers in search for the cheapest rates.

Depending on when set-up time is scheduled and the distance to the festival, I often save money on the first night by driving straight to the festival location the same day of set-up. Sometimes I even drive out the evening of tear-down and get a bit down the road. That's my night to find a rest stop and crash in the back of the truck for a great night of sleep followed by a happy drive home. Yet other times, usually while wallowing in the optimism of the beginning of the season, I do splurge a bit and arrive a day early and stay on the last night of the festival enjoying a hot shower and great night of sleep prior to the drive home.

In any case, early reservations are a must, especially for the better festivals in the heart of the tourist season. I overhear artists while waiting in the check-in lines and some don't yet have a place to stay after they arrive. I enjoy low stress living and make my reservations the day I receive the acceptance letter. Since I have plenty of time to research the area, often I get better rates, have my home away from home assured well ahead of time and am therefore free to worry about other things as the festival nears (where did that storm system come from?).

You are what you eat

The old adage, "you are what you eat" means that, in a festival, you are likely to be barbequed pork and fried bread unless you make some serious plans ahead to have something…er, healthier! Ah, yes, I know the nutrition experts keep changing their minds about nutritional needs of apparently healthy adults, and we continually make the science of nutrition so very complicated, but the basics are well known to everyone. In simple terms: carrots good, doughnuts not so good.

Seriously, what does food have to do with art festivals anyway and who is this lady telling me I can't have my morning doughnuts? Well, I wouldn't dare do such a thing. I am merely going to point out that the food that is usually available at art festivals and the nourishment the body needs when placed under the stress of doing art festivals are often worlds apart.

But first, of course, I have a story. I was at a particularly long festival, one of those that stays open until the late p.m. hours and goes on four days. My usual routine is to have oatmeal and fruit at the hotel, arrive at the grounds early and stay until I am absolutely sure nobody that still walks the festival grounds wants to buy one of my works. Needless to say, this requires a healthy morning dose of that wonder-drug: caffeine, brewed in the form of rather strong espresso coffee.

Sipping I was the sweetened delicious beverage, when my neighbors show up just about ten scarce minutes before the festival gates open to the public. After an admirable albeit hurried preparation, they opened their booth nearly in time to receive the crowds. I could tell that much partying had gone on the prior night and, during a break, one of the gentlemen came over to my booth to confirm my suspicions with a funny story about their drunken outing.

After a few laughs, he confessed to be suffering from repeated need to use the restroom facilities to relieve his digestive system and refresh his ailing head. I offered some sports drink and suggested that he was probably dehydrated and in severe need of electrolytes. He laughed and said: "What I need is some of that coffee!" and proceeded to grab my cup and take a sip. "Goodness gracious, lady! This is some strong coffee!" he continued, "nobody needs this much caffeine!"

I repressed a chuckle and let him go off believing he had just given me a valuable lesson in good health habits. He continued to use the restroom for the rest of the morning and finally his body gave out and he lay down on the grass right behind his booth for the better part of the afternoon.

Moral of the story: art festivals are like workouts, the better you feed and hydrate your body, the easier to endure. Excessive alcohol or any other abuse, for that matter, tends to upset the delicate balance of good health, and good health is an absolute necessity to feeling and acting like a great artist engaged in the task of selling art.

Back to the health stressors! Most outdoor art festivals require some type of weathering the elements. I can't remember the last festival that had perfect weather. Mother nature delivers too much sun and heat, too much cold, winds and sand storms, clouds, rain and even snow, hail and ice. Under those circumstances, just as when hiking in the mountains, the body is placed under the stress of exposure. The first recommendation is to stay hydrated.

Water is a great choice; occasional sports drinks as an aid to recover dwindling electrolytes are even better. Alcohol and caffeine are both diuretics and will increase dehydration (alcohol tends to also enhance sarcasm, which I am told is not my best sales strategy). Soft drinks have an excess of sugar and often caffeine, both require more water to process. "Power" and "Vitamin" waters are expensive and often contain sugar and additives such as ginseng and an excess of vitamins that end up in the nearest port-a-potty. Sticking to hydrating with water is really the best and easiest choice. This is not to

say soft drinks or vitamin drinks or teas are unhealthy and will result in a bad festival; everything in moderation, except water.

Eating at art festivals is also a trick, but really healthy eating is not as difficult as some have come to believe. Art festival food tends to be tantalizing and designed to delight the smell and palate, hardly to feed a body under stress. Most of the time I am tempted to either starve all day or overeat, depending on how many people visit my booth, so I have come to make myself try a bit harder and bring my lunch and snacks.

A great day starts with a good breakfast. Since many art festivals don't really get going until 9:00 or 10:00 in the morning, I have acquired the delicious routine of eating a hearty breakfast at the hotel or campground prior to getting to the festival location. With a belly full of oatmeal or cream of wheat, yogurt and fruit, I am less likely to partake in the "artist's breakfasts" composed mainly of doughnuts and muffins. I also tend to drink fruit juice and milk if I stay at the right hotel. I make my own coffee rather than drink what's available since I do like my coffee strong but not so much of it. I then sip throughout the morning the equivalent of two cups or less.

Other than the breakfast routine, I prepare my lunch in advance and carry a small cooler. Aside from lighter fare such as wheat tortillas with lunch meat, tomatoes and bananas (if I can find a grocery store), I also carry nutrition bars for those days when I am just so deliciously busy that stopping to wolf down a turkey-and-tomato wrap is impossible. Snacks of carrots and fruit are excellent because they entertain the palate and belly, and are high in both vitamin and moisture content.

If you must eat festival fare, it is better to stick to the booths that offer healthier fare and savor delicious grilled chicken or beef and rice dishes, among many. Unfortunately, the booth that is usually most near me is the fried bread booth or the fried burgers booth, and man! does that twelve-inch pile of French fries smell delicious or what?! Most of the time I am able to resist, only because I like to stay in my booth rather than go off and stand in a long line waiting for a bucket of fries larger than a football. Most of the time I am "good" because I know that excess fat will just make me tired later without taking care of my "real" nutritional needs. I am under stress, after all, and I like to stay healthy. A lighter dinner tops my day, although many artists like to enjoy a hearty meal after a day in the trenches. Again, the choices are many and the important issue is that choosing what the body needs is often conducive to better overall health.

Time out!

The third key ingredient for continued health through the festival roller coaster is: to get off the roller coaster! Just like the office worker who, come quitting time, rips off his tie and heads for the warmth and calm of home, so the artist needs to get away from the festival and find a nook that serves as the home away from home.

Many socialites will hang out together, go to dinner together and exchange war—er, festival stories over a beer. Others will enter the sanctity of their motor homes and have a nice family dinner. Many of us usually do festivals by ourselves and like to keep to ourselves. I'm the type that likes to rip off my festival clothes, put on something comfy, take out my frustrations on a nice long walk and end up sipping noodle soup and a glass of red wine with my feet propped up in my motel room.

Point is, we all have to get away from the "office" and go "home," both for physical and mental health. The stress fountain has to be turned off and somehow, we have to find the feeling of home; a rest away from the bustle.

The entire day has been about selling, about the customer, about being polite or at least tolerating other artists, about putting up with people of all walks of life and all ages. I have heard people saying they would be back, how beautiful my art really is, handed out cards by the bucketful and wiped tiny sticky fingerprints off my glass while sporting a smile on my face. If I hear one more: "do you have a card?" or "did you really do *all these*?" I think I'll just scream. The evening belongs to me. Although I enjoy the festivities as much as anyone, I personally want the noise of the world to stop for a few hours, recharge the mental and physical batteries and get ready for the next day at the zoo.

My mental break usually also includes getting away from other artists, especially those that tend to immerse themselves in misery, anger or despair. I've had enough of that all day long, I've heard about the wind, about the heat, about the slow sales, about the "other row" and how much more traffic "they" get. Artists are wonderful and I love almost every single one of them, I certainly have great admiration for anyone who sticks to this hard life through the years and have gotten to know some wonderful people. But right this minute, after the curtains come down, I would like to *not* hear about how much money they made or didn't make or about how much better or worse last year happened to be. I'm done for the day; I need a long nap in my cave so that I can love everyone again tomorrow.

And speaking of naps, don't discount this wonderful invention to refresh the body and mind. The days are busy to say the least, but there are minutes in between minutes that can be squeezed to sit back and steal a quick refreshing nap. Sigmund Freud, the famous psychiatrist, would sit back on an easy chair with a silver spoon held between his fingers just above the hardwood floor. He would relax and close his eyes and…just at the moment when he drifted off to sleep, his fingers would release the spoon, the spoon would crash to the hard floor with a loud noise and he would awaken refreshed and ready for another long bout of work. A nap doesn't have to be long to refresh.

I see a lot of artists with helpers or spouses who take turns in and out of the booth; one sits at the helm while their partner relaxes behind the booth or in the vehicle. One sells while the other takes a nice walk or a nice nap on a cot. Some of us loners have to be

wilier and catch a few minutes before the show opens or while allowing a booth sitter to watch the goods for a few minutes. Obviously when I get enough rest during the night naps are unnecessary, but a slow festival or one with extended hours has a way of numbing the senses, and a good nap is a sure refresher. I tend to subscribe to the "early to bed, early to rise" philosophy but I would like to edit the old adage with: "and a 12-minute nap"!

Strengthen Your Mind: Attitude and the Illusion of Control

> *Do not burn yourself out. Be as I am-a reluctant enthusiast... a part time crusader, a half-hearted fanatic. Save the other half of yourselves and your lives for pleasure and adventure. It is not enough to fight for the land; it is even more important to enjoy it. - Cactus Ed*

The quote above illustrates the perfect philosophy with which to approach this tough and wonderful life. After five years in this crazy world, someone else finally had to teach me how to have fun. I had made the mistake of taking this whole life way too seriously, possibly due to leftover training from the corporate world. In the quest for success, I approached my business so seriously that I didn't listen to my own advice and forgot to look at the rainbows and enjoy the sunsets.

My good friend kept reminding me: "You're so lucky, you have a show!" Ah yes, lucky indeed! I remembered that, unlike many other artists, I am making a living as an artist. I get to actually make art for a living, a living that includes traveling to beautiful places and celebrating creativity and people. I actually get to control my schedule, within reason, and do as much or as little as I choose. If I don't like a festival, I have the choice of not repeating the experience. If I don't like a particular town, I can avoid it for the rest of my art life. Conversely, when I enjoy a festival or a particular drive, I can choose to attend every year. I love to go to Lake Tahoe in Nevada, the Rockies in Colorado, the mighty Tetons, and the long mystical drives through my beloved desert lands. There is indeed pleasure and adventure to be found in every art festival by those who carefully look for such things.

But before I get too poetic, let me just hand you the two secret weapons that most of us have come to possess after a couple of years of being art festival artists.

Perk up your inner-Pollyanna!

When I first started I was grunting during a particularly tough set-up. The festival grounds were on a challenging hilly park, the parking lot was crowded with cranky artists who fought for the closest spot in order to save a few yards of hauling, all 200 of us had been given the same setup time and, of course, the wind was blowing. In short, the experience was enough to make me hang up my poles and dust off that old diploma. I spotted an older couple hauling their goodies from a distant motor-home. Both the

street and parking lot were so narrow and congested that they had been forced to park about a good 400 yards farther than any of us. The woman smiled as she huffed and puffed pulling an old garden cart and said: "Ain't this a wonderful way to get your exercise?"

I was instantly ashamed of myself since one of my former careers was as an Exercise Physiologist. Here I had been a professional exercise advocate in the past and now I was cranky at a nice little work out that was part of my "job"? I smiled and responded: "Yeah, some people actually pay to go to a gym!"

Keeping a positive attitude is not just good but imperative in this business. The health effects of a positive attitude go far beyond a feeling of well-being; optimists are actually healthier people. I am a physiologist at heart and touchy-feely explanations don't really hold much water with me, but I have seen the studies where regular people (that includes artists!) live better lives and improve and maintain better physical health by improving and maintaining better mental health. And a huge component of better mental health is a positive outlook on life. The mechanisms have to do with the avoidance of depression and the avoidance of stress, both of which can be controlled by turning negative life events into something easier to swallow.

I can't think of all the times when a festival has been too cold or too hot or too windy or sales too slow or non-existent. I caught myself in a bad mood in a cold rainy festival and almost missed a photo opportunity that caught a double rainbow against a dark sky. I know too that a double rainbow doesn't pay the rent, but it may lessen the pain of having to book an additional festival in a hurry and it certainly gives a spark of beauty to an otherwise ugly day.

Attitude, a good one that is, is the most valuable weapon in the war of well-being. Attitude helps cancer patients combat the deadly disease; attitude helps people withstand the devastation of wars. Compared to what soldiers and children of famine go through, the traveling artist is just talking a walk in the park. Finding the proper perspective in life is a very individual task. For me it involves avoiding negative things and people first, then always forcing myself to think positively. Usually when I get really "down" I am struck by the life of the homeless, without a hotel room or a booth or a studio or a vehicle or a place to go next weekend. When someone exchanges a couple of hundred dollars for one of my creations, I wonder how long it would take for someone to make that much holding up a sign that says: "will work for food."

At the end of each day, everyone has to find their own attitude adjustment devices and their own positive inspiration because invariably, there is yet another day to endure. There are always other festivals, other years, other opportunities, and more good times to come to do what we didn't do this time, to try what we didn't try.

Control what you can, accept the rest

Stress is a killer of health and a spoiler of good lives. Controlling stress is essential in this life to assure longevity in the business and allow for continued creativity and success. The second secret weapon that will allow you to remain happy and healthy in the business of art festivals is control, or at the very least, the illusion of control. Easier said than done!

I have spent most of this book pointing out the uncontrollable situations that arise in any given art festival, but I have also suggested plenty of strategies for keeping as much control possible over anything that the world may toss your way. Controlling stress is about exerting as much control over the things we can control and learning to accept the rest.

Key to controlling stress is learning in advance what affects us the most and devising a strategy to prevent the loss of control. Weather is out of anyone's control and it seems a continued source of extreme stress affecting many artists in the business yet many artists, when asked about the weather forecast, shake their head and shrug their shoulders. I have learned to accept the weather as it comes, mostly because starting ten days before a festival I log onto weather.com and keep a very close eye on the Doppler radar. If I see that the wind will be particularly strong, I take extra weights and rope and mentally devise my booth plan to guard against the wind—what I call my "windy setup". Rain on the forecast? I bought transparent rain walls for my booth prior to a particularly annoying rainy summer in Colorado; they safeguard my matted works and still allow people to fully appreciate my art.

In short, I have learned to exert the illusion of control over the weather by accepting whatever comes, learning what's coming, and being somewhat prepared for the inevitable. Although the gusty downpours never come along stress-free, I guarantee I am a bit less stressed than the artists who failed to take two minutes of looking up the weather report and are now rushing to their trailers to grab their walls as the rain begins to splash about. And, while I was heavily sighing about the gloomy rainy prospect, I also mentally prepared myself for the dip in sales that result from such occasional gifts from Mother Nature.

Enough about this business is largely at the hands of fortune and destiny; exerting some control over what we can control simply makes this life a bit more bearable. Simply being ready for a calamity is one key to surviving the worst and many "smaller" disasters can be altogether averted. While it takes time and effort and dedication to prepare both mentally and physically, the reward is in the peace of mind that comes later, while everyone else scrambles. We can only do what we humanly can to lessen the stress and maximize the fun and pleasure of being an art festival artist.

Body Check!

Sometimes you find yourself a bit crankier than usual or with a few more bruises than usual or simply not enjoying life and festivities as much as usual. One of the keys to great health is early detection of whatever ails you, and one of the keys to good mood and good times is good health. I'm not much of a subscriber to the mind-body connection stuff, but if your body is feeling sick or if you have a backache, chances are you will be in a foul mood. Conversely, if you are feeling a foul mood coming on and staying on, the most likely culprit is some physical ailment. Well, I guess I am a bit of a subscriber to the mind-body stuff after all. As a physiologist, I look at the body like a vehicle: a warning sign is a signal that something is wrong and soon more things will be wrong if the thing that is wrong in the first place isn't fixed. Persistent clicks in the engine that won't go away are a clear signal that the car needs to go to the shop and get fixed. And persistent aches or bad moods that won't go away are a clear sign that the body needs some attention. In our case, this means a long rest, some TLC and maybe medical attention.

Bumps and bruises are okay and broken fingernails a part of the business; I really should have trimmed them as part of the preparation routine. But when aches and pains persist, it is time to figure out what is wrong. Things not to worry about are the aforementioned bumps and bruises and slight soreness pretty much everywhere. Things to worry a little about are persistent joint aches and pains, a persistent back ache (you do wear a back-belt to set up and tear down, don't you?), sniffles during and after shows and a sense of slight fatigue that goes away after a few days of rest.

Things that should be clear warning signs the engine needs to go to the shop are:
- Persistent back ache or joint pain that does not go away between festivals
- Overall fatigue that does not go away after a few days of rest
- Persistent fever after festivals
- Easily bruised, persistent bruising
- Unusual or sudden shortness of breath while setting up and tearing down

Use your best logic, do a body check before and after festivals and stop when you need to. No sense ruining a good old car—I mean, body, when we only have one without a spare. I have heard of artists collapsing in the parking lot after bragging about an "all nighter". I much prefer to take a break to stay healthy than to have to add the worry and anxiety of an impeding and inevitable visit to the nearest hospital.

Be Good to Yourself

Oh, here we go, she's getting preachy! Well, maybe a little. Art festivals place a very specific demand on the body and mind which is not really all that horrible and certainly not difficult to avoid, so I'm just going to offer some quick tips for quick counteraction to the abuse that the festival itself places on the body.

First and foremost, avoid abusing yourself. Excessive alcohol and partying accompanied by lack of sleep can knock down the strongest and youngest of us (is there anyone out there still feeling young?). As outlined above, taking care of the basics, food and rest can do wonders for the inevitable exhaustion that will set in with the first few festivals.

For psychological stress there is only one strategy: find a release. We can all say that the customers don't bother us or getting up early didn't bother us or forgetting our canopy was funny, but saying and acting like nothing bothers us doesn't make the stress any less. Festivals are stressful and knowing that in advanced is already winning half the battle. As for letting stress go, no strategy works like a little exercise, a nice evening walk or a restful swim in the hotel swimming pool. Many hotels also have hot tubs and many people find them relaxing.

Distractions can also be very therapeutic and easy to find. Movie theaters and such mindless entertainment is everywhere and many hotels have more channels than I do at home, although I'm particular to the Discovery Channel and Animal Planet (a bit geeky but works for me!).

Finally there is the cure-all, the medicine that is within everyone's reach: exercise. I am a big subscriber to the walk in the evening prescription. I also start my day with a brisk trod down the road and back or, my favorite: I walk or ride a bike to the festival grounds from the hotel. Through the years I have found the perfect backpack that carries all my festival goodies such as wallet, camera, credit card machine, food and drink, and all those little stupid tools I carry around. It's a big backpack, granted, but I can ride my bike with it and not worry about forgetting anything.

I also invested in a fold-a-bike that—well, folds! I carry it everywhere and it sits patiently on the back seat of the truck until I need to use it. I use it for recreation or transport depending on bike trails and traffic. Aside from having had a few beer bottles thrown to the back of my head in my past, I still consider bicycling the perfect way of sneaking exercise into a daily routine.

More important than stress release and daily exercise though, is avoiding physical injury. I have said before that art festivals are a tough way to make a living and that the "job" is physically demanding. Most of that demand is concentrated at set-up and tear-down. Hauling weight and lifting tents and panels demand a strong body. Looking around any festival I can see that most of us are a bit past the strong body time of our lives, so we have to be careful.

Along with being careful, the first few festivals will place a sudden demand on muscles, tendons and bones to work harder than they have in the past. The best way to avoid injury and get ready for that demand is to stretch. Through the years I have only

seen a handful of artists stretch prior to setting up and even less prior to tearing down. I have, however, seen plenty of artists with back braces or weight belts, a good sign for sure. Stretching simply warms up the muscles and gets the tendons to their elastic best, as well as getting the whole "engine" to "operating temperature" prior to heavy hauling. Easiest thing an artist can do to preserve their physical health, really, and I promise I won't tell anyone.

Too Much of a Good Thing

Right after a good festival I find myself with annoying amounts of extra energy, which usually force me to do things that might be just a bit beyond my psychological and physiological reach. One of the most common "side effects" of a good festival is the dreaded "overbooking syndrome," whereby you will scour the listings for suitable festivals like the one you just did that was SO good, and poke at your calendar in an effort to fill every hole and squeeze every weekend. Endeavor at this point, to engage in a little self control.

Among the things nobody told me when I began on this wonderful adventure was that, once you get past the first few obstacles, the art festival life is very addicting! After good festivals, the above mentioned syndrome strikes and you find yourself overbooking. After a bad festival, you vow to do better and, really, you do the same thing, try to book more festivals to make up for the bad one.

Fighting art festival addiction, fortunately, is not as difficult or serious as fighting a real addiction. But a little like with any other addiction, it is easy to feel good, do too much and end up overdosing. Unfortunately, this festival overdose leads to burn out and I can't count the times when I have seen artists just sitting and reading books in the back of their booth under a weather-beaten old tent and attitudes firmly stuck in the "us versus them" mode. Those tell-tale signs are the signs of an overworked artist and the general public generally would rather stop at the brighter looking booth with the smiling artist and probably buy from a happy artist©—generally speaking.

To avoid overbooking, make a planned calendar and stick with it. Pay attention to back-to-back festivals, especially if they are larger and more demanding. After finishing a well planned season, only add festivals in extreme circumstances such as a festival being cancelled due to weather or a sudden "bad" festival at a time when money is needed to pay bills. I still get very tempted to sign up for new festivals and sneak an "old faithful" in between the regulars in my calendar. In an effort to avoid the inevitable overbooking, I have now taught myself the simple trick of scheduling all my applications into my electronic calendar.

When I receive an application and get a twinge of temptation, I simply look up the dates and see how the previous two weeks and the following two weeks look. If I have to travel back-to-back to different places, I hesitate to schedule anything before or after.

Even when scheduling home festivals, two in a row is enough, three at most. I might do three consecutive festivals only when they are in different parts of the city and my regular collectors expect me to be there. After a run of two or three, I take a week or two off the festival circuit and regroup in the sanctity of my studio. This is tough to do during "the season" which happens to be spring and late fall in the Southwest, as it seems like all the festivals fall within a week or two of each other. Logical planning and a good calendar are key to avoiding a four-week festival run, which will leave you tired, with a burned out attitude, and with a whole bunch of catching up to do in order to get inventory ready for the next festival.

Most of us chose this life to have control over our schedules and our working life in general. Keeping the life fun and as much under control as possible is a big part of assuring longevity as an artist and long lived success as an artist.

Finally, let's take care of all the loose ends, just in case you *still* have questions!

Chapter 10

Frequently Asked Questions and Other Practical Matters

"I must create a system, or be enslaved by another man's"
—**William Blake**

When I first started the art festival guide I had a somewhat clear organization and, once I decided on the main points to cover, I kept to my outline more or less faithfully. During the course of art festivals, I would think of bits and pieces and almost all of them fit neatly into my chapters…almost. Another phenomenon that occurs in art festivals is that some of us get a lot of visits from artists that want to entertain the idea of embarking upon the art festival adventure. Most of them ask the obvious questions that are answered throughout the book, but some pose a few practical and sometimes not so obvious questions. There is so much more to know!

The fact that I left all these items for the practical chapter does not mean to diminish their importance. Most of the book has been focused on the matters of preparing yourself physically and mentally for the business of selling art at art festivals. But it is a business and a good business background or at least an understanding of what it takes to run a one-person business is essential. Nobody likes paperwork or taxes or permits but they are as much a part of the art festival business as a good tent and an umbrella, and running a business takes a bit more than propping up a tent on a weekend or two and exchanging some paintings for cash.

But to the new artist, starting out with a wall of licenses and paperwork and accounting and taxes might prevent even the most determined from even taking a little taste of this wonderful life. Trying out a festival or two does not require a business manager, tax lawyer and accountant. Continued engagement in the art of selling art will require licensing and a good accounting method, as well as paying taxes and keeping business records necessary for reporting and, most importantly, essential for success.

This book is meant to be only a primer on the art festival life. As the artist embarks on the adventure, many other doors open and many questions are left to be answered. I do not cover in much depth things like incorporating, insurance, taxes, accounting, and so on. I did, however, want to mention all these things because they will come up after a very short while and will become more important as the business grows and flourishes. In fact this last chapter can be expanded into a business book in itself.

On an average year, whatever that may be, I figure I spend about 30% of my time making art, 30% selling art, 30% on the various business tasks and 30% taking care of the home front. If you notice, that adds up to 120%, not counting sleeping and eating, which is the appropriate amount of time to dedicate to making a living as an artist. Seriously, I have never worked so hard or so long on anything, although the rewards of making a living as a living artist are without question worth every minute of every day and the minutes in between. Nobody said it was going to be easy!

About That Code of Silence: Why Nobody Tells You Anything

You see, the art festival artist is a rare bird. Solitary, for the most part, resourceful, stubborn for sure, but also a bit leery of strangers. There are solid reasons for that. When I first started I was overly friendly and talked to many people—my assigned nickname *Sparky* came from that era. Then there were those mornings when I would come to my booth and find my zippers had been opened through the night and, while I never found anything missing, the feeling that the world isn't entirely safe and friendly began to creep in. Another time I returned to my vehicle in artist assigned parking and found my gas cap dangling. Not thinking much about it, I closed it and, upon starting the engine I noticed someone had sucked about three quarters of a tank of gas out of the truck while I was at the fair. I have seen indications that my trailer locks had been "tested" and through the years I have lost a few wheel chucks, clamps, art hangers, print racks, and even my nice booth weights were missing one fine morning.

All these things and the common sense principles of traveling safe tend to make us, well, not talk to strangers too much. Thanks to the trade publications, we are all aware of scammers that frequent larger shows and engage in friendly conversation designed to find out who is traveling alone and who is not. To avoid being targeted, most of us keep to ourselves and get to trust one another only after having seen each other for quite a few festivals. Most artists will not talk about the business to anyone who comes into their booth.

There is also the matter of taking time during a festival to chat with someone that isn't about to buy something from me. This happens all the time, fans and would be festival artists show up very enthusiastically and want to engage in a long drawn out conversation about how to make a living as an artist. I usually say: "I could write a book!" Now that you read the chapter on selling and now that you know that a few seconds can be the difference between selling something and not selling something, you

might better understand why an artist during an art festival seems a bit reluctant about taking some time to chat at length with you. When buyers looking around see the artist talking to someone they may not even stop to come into the booth. So most artists who talk to each other keep a sharp eye on the entrance of their booth and avoid talking to new artists and other curious folk about anything that is going to take any time and attention away from the matter at hand: selling art.

As a result of all these very pressing matters, for the artist starting out, there is the feeling that nobody tells you anything. Until I learned some of the very logical reasons for this "code of silence" I found it infuriating that no one would so much as tell me how to lock up my booth at night or where to park, let alone how much income I would usually expect to make or where to keep my money during a festival, or where the good shows are or what shows I should avoid. The answers to some of those questions are just not safe to give out, not to strangers and not during a festival. To this day, I sometimes try to engage artists I don't readily know in conversation and may tend to take a very guarded attitude and give very curt answers to my questions. A little paranoia buys us traveling folk a lot of privacy and, more importantly, safety and security.

The good thing is, after you have been around for a while and other artists get to know and love you (or at least tolerate you), trust and truthful conversation will inevitably follow. It is then that you will feel that you are "in" and you will reap the rewards of having found a whole bunch of good friends and neighbors that help and look out for each other, much like a family away from home. We will talk to you then, promise, even about how much we "really" made on that windy and cold festival.

But while you are starting out and still not knowing who to ask, I will just answer the most frequent questions that came pouring to my booth and my website and that logically made me fashion this last chapter as a summary of Frequently Asked Questions. They are arranged in no particular order; I simply jotted them down as people asked both in person and online although I guess I tried to address them in order of importance or at least relevance to the business. You might call them tricks of the trade, nuts and bolts, tips from the experienced or frequently asked questions. I will also try to answer them succinctly since I have already explained most points in the previous chapters. Well, I might throw in a story or two, but that's to be expected by now. So here are my loose ends, whatever didn't neatly fit into the previous chapters, I kept for this last one. Now you can't say nobody told you!

Where can I get show supplies to get started?
The short answer to that question is, anywhere and everywhere. Scrounging for cheaper supplies becomes a way of life because the immediate future is so uncertain and most of us, when we started, didn't really know at all how this new life was going to turn

out. Also depends on what supplies we are talking about, specialized show equipment or a cash box? Hand-cart or credit card processor?

In the beginning, think cheap and see if you like the life; invest in the best later after you have had a few good shows under your belt.

Here are some sources:

1. For festival specific display supplies, try first some of the trade magazines classified ads and online listings (see Appendix of Resources). Someone might just be going out of business at the same time you are trying to start yours.

2. Second source for festival specific display supplies are the dedicated art festival online suppliers. These are suppliers that deal with artist and art festivals on a regular basis and their dedicated websites or someone on the phone can recommend some choices. Once you see some of the choices for displays, some money can be saved by initially purchasing some materials and equipment locally. A short list follows in the Appendix of Resources section.

3. For general office supplies and things such as tools and other miscellaneous (clamps, bungee cords, cloths to cover tables, display tables and such), three of my favorite places to purchase locally are discount stores like Dollar Stores or Wal-Mart; home supply stores such as Home Depot or Lowe's, Costco and other membership stores can be a good source for low cost canopies and make-shift panels and shelving, and for everything that can wait a little, eBay.com is a great place to find anything and everything at huge discounts.

4. Do not overlook free and complimentary supplies such as free credit card slips from Discover Card and printer paper at the office supply store for turning in your empty ink cartridge. Cardboard boxes to take your supplies to festivals can be had for nothing by scrounging around the dumpsters of some industrial complexes; packing/padding materials are available by the dumpster-full at the back of your nearest furniture store.

Should I take credit cards?

In a word, YES! Do you shop with credit cards? Do you go to the mall with $500 in cash? Well, actually, there are many professional shoppers out there who will carry cash to a mall or an art festival as a way to limit spending. Still, you want to grab the impulse shopper who really didn't want to spend any money but just fell in love with your stuff. I got set up to take credit from about my third show or so; I also take personal checks and traveler's checks and occasionally offer lay away programs. I have never been burned.

Many artists insist on a cash-only business in order to keep things easy. I insist that they are losing sales they never knew they had. At this point, it really isn't about

what is easiest for you but easiest for the customer. Selling isn't about the seller, it's about the customer. Many artists do not choose to take credit cards citing that it is a hassle to get set up and costs money to take credit. I would bite my tongue before I tell a customer that yes, they can have that beautiful piece of art but please run over to the nearest ATM to get cash for me. Many simply will not return to your booth, I guarantee it.

Any time you are faced with a decision on whether to spend on a commodity like credit card processing weigh the pros and cons and remember that selling is about the customer, not about what's easiest for you.

Here are a few reasons for taking credit cards:
- Make it easier for the customer to purchase from you
- Remove a potential pre-set spending limit
- Remove the obstacle of not having brought enough cash (or any cash)
- Allow you to have very high-end items for sale, potentially "making" a show in one or two sales
- Allow for impulse buying of smaller items and gift items
- Increase sales, repeat sales and multiple item sales

How to take credit cards? There is an application process, a setup fee, often an equipment rental or purchase fee and monthly fees. Start by applying with your own bank or research online processors; shop and compare. I would recommend using a credit card processor that advertises in one of the art festival trade magazines since many of them deal with art festival artists. We have slightly specific needs that need to be worked out in advance, such as irregular income flow, periods of no transactions at all, and mobile wireless equipment needs.

Research, research and then research a little more to make sure that the credit card processor fits your needs. Watch out for high monthly fees, limits on transactions and/or monthly limits, and a huge cancellation fee if the processor does not meet your needs. Get set up with someone that has a website and explains all the fees and application process prior to signing the dotted line.

One suggestion would be to start out with a manual processor, a.k.a. "knuckle buster" or manual imprinter. The investment in equipment is minimal, free credit slips are available from the major credit card companies, and you can see how it goes. If later there is a need for automatic equipment, such as a quantity of smaller sales, or instant approval, such as the consistent sale of high-end items, upgrading is painless. If you do two festivals, get rained on, break most of your stock in travel and decide to dust off the college degree after all and seek greener pastures (and perhaps an easier way to make money), then the loss in investment is minimal and also painless.

Do I need a business license?

Everywhere you go! As a business you will undoubtedly need a business license to operate a business in your own state. Every state is different so the best course of action is to head on over to the website of the Department of Taxation or Department of Revenue for your own state and find out what the licensing requirements are for your particular situation. I know that sounds scary and complicated but most states will simply not let you conduct business without a license and really, aside from paying a fee and the initial application, it's not so bad.

Doing business outside of your own state will often if not always also require a temporary permit or a temporary vendor's license, often for the state, county and/or city. Many of us carry out of state business licenses for every state we work in and renew them yearly. Some are free, some require a nominal yearly fee. The bottom line is that you cannot do business anywhere without a license or permit and playing around with tax authorities is not my idea of fun.

The promoter of the show is usually the best source of information for the required licensing and tax requirements of each show. Many promoters will require a state license number with applications, some will include the county/city license fee with the application, others do not. Ultimately it may be up to you to investigate and obtain the proper permits and pay the proper taxes, which neatly leads me to the next question.

Will I have to collect and/or pay taxes on my sales?

You better believe it, and remember that there are two flavors of taxes: income taxes and sales/use taxes. Every city, county and state will require you to collect sales tax on every transaction conducted within their jurisdiction with the exception of very few states. The proper governing body will then require you to forward the sales taxes collected to them; you are merely the middle man collecting sales tax for the state. It is a royal pain to keep track of all the diverse regulations, but usually just more annoying than truly complicated. Most state filing forms just want you to report income and where you got that income so that the state can forward the tax collected to the proper city or county.

Again, your best source of information is the promoter and whatever paperwork you received when you applied for the show or checked in. The amount of sales tax you collect will be different in every state and some times, different depending on the city you are conducting business in. Some times the state will forward the taxes to the city, some times the city will require you to pay them separate taxes, some times all this is included in the booth fee. It is a great idea to find out and keep your taxes paid up after every show.

I happen to file sales-use tax yearly in the state of Arizona, so I calculate sales taxes after every show I do in Arizona and deposit that amount in the bank. The money goes into a savings account and when the end of the year comes around I have my little tax-nest-egg ready to forward over to the Arizona tax authorities. Every state is different,

and, in my opinion, the best system is to pay state sales taxes at the end of the show and be done with it. That way I am always caught up with sales taxes for states, cities and counties.

The other tax issue is income tax. Your business will have to file monthly, quarterly or yearly depending on the tax laws of your state. Income taxes are separate from sales taxes, so make sure you fully understand tax laws and abide by them. You only have to pay income taxes in your own state, where your business is located, unless you live in the great state of Nevada where there is no state income tax at all. Much information about taxes, both local and federal, is available in publications at your nearest library or in the vast knowledge expanse of the internet.

And, of course, you will have to file yearly income taxes with the Internal Revenue Service (IRS) on any income gained in your art business. Funny story about the IRS…well, not so funny, really. Let me finish this tax thing and then I will tell the story. Here I am treading dangerous waters and will default to the standard advice: "Seek an accountant" and the standard disclaimer: "I am not an accountant so take my advice with a grain of non-accounting salt." I will elaborate a little on an upcoming FAQ about keeping track of stuff, but many artists just hand over their business accounting, including the yearly/quarterly filing of taxes, to a professional.

Having said that, it is not difficult to "keep the books" of a cash based business, nor is it necessary to burden yourself with the expense of an accountant if you have a good head for math and a good computer program.

The IRS Story

There I was, just like any other afternoon, walking over to the mailbox to gather my daily dose of acceptances to great shows (and junkmail), invitations to great shows (and junkmail), and other assorted interesting pieces of daily mail like trade magazines and supplier catalogs (and junkmail). Unsuspecting and naïve, I frolicked back to the house when suddenly! GASP!!! a letter from the IRS??? Addressed to my business??? Oh no, oh no, oh no (breathe breathe), "it's not an audit, it's not an audit!," I told the cat who ran for the closet. It WAS an audit. Sigh, double sigh. Surely it must be a mistake, surely little old me couldn't possibly get audited, "But I pay! I pay!" I yelled helplessly scaring the remaining cats into the other closet.

I suppose it had to happen some time. The audit in question concerned a claim of a loss on my second year of business. The letter stated that, in essence, the IRS had declared me a hobby and the burden of proof was on me to prove otherwise. Along with the "hobby" designation, as opposed to a business designation, come several very bad things such as not being able to claim many of the business expenses and definitely not being able to claim a loss on any given year and, worst of all, I would also be deemed a hobby for subsequent years.

Wait! WHAAAAAAAAT!!! A hobby?????? Do you think I would pick being an art festival artist as a *&^*%$!! HOBBY??? No, no, no, no no! Hobbies are like knitting sweaters for grandkids and gardening petunias. Breaking my back hauling show supplies and building tents, traveling and staying in cheap motels, being insulted by the general public ten times for every one sale, standing in the wind and cold and heat while smiling at prospective customers that are seeking hot-dogs with much more desire than they are seeking art…THAT is NOT a hobby!

But there was no time for whining, I had to get my act together and call the IRS Agent to make an appointment to defend myself. Having a psychology background, I quickly ran through the 15 stages of outrage, grief and despair to get the emotions out of the way before I desperately started gathering the necessary paperwork for the year in question. Fortunately, I am somewhat more organized than the next artist. Unfortunately, organized people go batty when they can't find something. Needless to say it was stressful to gather every single piece of paper that had a financial bearing on my business for the year audited. Since I file taxes as a sole proprietor and my husband and I file jointly, our home financial records were also relevant (mental note to incorporate one of these years). The way the audit process works, the IRS will basically demand to see all your business records, re-compute your taxes for the year in question (and only that year) and send you the bill. Defending yourself is up to you. Since my future as a business was at stake, I chose to grab the proverbial bull by the proverbial horns and defend myself.

The happy day came. IRS Agent walked through the door and took out his laptop…I took out my laptop…he pulled a single manila folder out of his briefcase and opened it…I brought in an entire file box full of file folders and nervously twitched my fingers on the table as I stared at him squarely in the eyes…the theme for The Good, The Bad and The Ugly rang softly in the background…

Okay, enough theatrics. In the end, the audit went well but it was a gruesome, stressful experience. I had toyed with the idea of hiring a tax attorney to handle the audit but was glad I didn't. During the course of the interview, the IRS Agent explained two very interesting things:

One, was that once a tax attorney is hired, that is, once the audited party in effect says that they do not want to engage in conversation with the IRS, the issue becomes one of how much the IRS is willing to settle for. There is no further conversation, no proving the case for the business, only how much the business is able to pay and the subsequent setting an appropriate payment plan. I was happy that I was willing and allowed to defend my case on my own merits.

Interesting thing number two, was that the IRS has just opened up and dedicated an entire branch to the sole purpose of auditing small businesses, namely the self-employed, since we report sales on the honor system. Red flags that catch the attention of the IRS are things like excessive traveling or entertainment expenses, reported losses against other income, low reported revenue against high standard of living, and excessive home-office deductions. Of course there is the lottery of being picked "just 'cause" but usually something brings to the attention of the IRS that there is money for them to recover in any given audit. There is no income threshold to be audited, the amount disputed by the IRS in my case seemed completely ridiculous to me since, if the case went against me, I would have only had to pay around $2000. So be warned.

Post-traumatic therapy aside, I was glad that I took on my own defense. There were many questions asked that a tax accountant would not know the answers to, regarding the way I conduct business, the way I advertise and gather new collectors, plans for increasing income in the immediate future and long-term plans, how I choose shows, why I sell what I sell (and not women's shoes, for example), why I lost money and what I am doing to not lose money again ever, how to decrease expenses in my particular business, and so on and so on.

The IRS Agent wanted to know everything, I explained everything. He wanted to see every record, I showed it to him. In the end, I knew I had been honest and given him all he wanted to see (and then some!). Happy resolution in my case resulted: I was declared a business and did not owe any additional taxes. Although relieved and vindicated, I did not take the time to pat myself on the back, instead I vowed to keep even better records and balance my finances monthly come hell or high water.

Without further exciting plots and embellishment, here are some key things that I learned during the course of the audit:

1. Knowing your own business is essential; if you choose representation, make sure your representative knows everything about how you conduct business as an artist. Be prepared to defend your choice of business, your choice of venues such as festivals and galleries, the business potential for your medium and your marketing ability to profit from it.

2. Keeping accurate and organized accounting records is a must. Even with my great organization skills I had misfiled a couple of things and had to find them before proceeding. A good accounting program or a good accountant are two ways of keeping good records and keeping them balanced month to month.

3. Full disclosure to the IRS is essential. The IRS is most concerned with Revenue (it is their middle name!) and will come to your home or office to audit your records. If you have a $100,000 sea-faring boat in the back yard, your income or debt must show that you can afford such a luxury. Be prepared to show bank statements, credit card statements, receipts for purchases, receipts for $2.00 cokes bought while traveling, supply receipts, motel receipts, vehicle mileage records. Anything that was mentioned in the tax return must be proven with a paper receipt or printed record.

4. Printed materials are required. Lately I have been keeping electronic records and I had to actually go buy a printer in the middle of the audit so that I could print records off my laptop on the fly.

5. Prove that you are conducting yourself as a business and actually trying to make a profit. Keep databases or mailing lists with customer names, file away marketing materials, keep spreadsheets showing profit/loss for particular shows and trends from year to year.

6. Prove that you desire to be successful and have a plan for growth, a business plan. Newspaper clippings with your name on them, awards received, competitions won, applications sent and rejection letters. You have to at least be trying your honest very best to succeed on a regular basis and be able to prove that you are trying.

7. If you claim a home-office deduction and show home improvement or home maintenance deductions, purchased a new Hummer to pull your trailer, or built an addition to separate your studio from the main house, be prepared to prove need. Any deduction you take must be backed up by printed records, receipts and good reasoning (according to the IRS, not you).

What is the easiest way to keep records? How do I keep track of all these numbers?

The short answer to both of those questions is: very carefully. The long answer starts by asking another question or two: How comfortable are you with numbers? What method will be easiest for you? Keeping the books and records necessary to run a business "ain't rocket science" but if numbers and statistics scare you a little, then seeking help might be the thing to do. Following are a few suggestions and while the business end of the art festival business isn't overly complicated, there are many books on running a one-person business that can simplify and explain quite a bit. Some of the resources are provided at the end of the book.

Organization Tips

Let's start with the records issue. The simplest system might be to use a couple of set of folders labeled by month. One set of folders is for receipts you give for **money-in** or income and the other gathers receipts you get for **money-out** or expenses. At the end of every month, every sales receipt that goes into the income file must equal the deposits on a business/personal bank account and equal the reported income for that month. Also at the end of every month, every purchase receipt for expenses that goes into the expenses file should be added and equal the expenses for that month.

I keep a third set of monthly folders (I call these "Show records") for show applications and their corresponding acceptances or rejections. This record set was important for the IRS because it showed my application activity, whether admitted or not, proving that I was actually trying to make more money by applying for bigger and better shows. Once I have attended a festival, I file booth layout maps and other pieces of crucial information I may need the following year in this set of folders. These folders are a complete yearly record of shows applied and attended.

If I get accepted to a show, I place all the paperwork for that show in a fourth set of folders which make up my Calendar folders. I keep those on top of my desk so I know what shows I need to attend and when. I take the folder for the current month with me to the show so I have all the relevant paperwork on hand. Motel reservations and my copies of the application and acceptance letter plus any instructions from the promoter (such as tax information) go into the Calendar folders. I've used the same set of folders for a few years.

I use the calendar on my email program to keep me on track and to plan my year ahead. I like to use different colors to highlight the dates for shows I might apply for, shows I have applied for already and shows I've been accepted to. When I finish making my hotel reservations, I label the show confirmed and completed. I do tend to over-organize, mostly because I no longer trust my memory (in fact, I forgot the last time I trusted my memory) so the trick is to find something that works for you. I like to know where I am with respect to my positioning in space and time at any moment, so keeping track is both easy and necessary for my own peace of mind.

Oh, I forgot, at the end of the year I file away the Show Records and the Income and Expenses folders. Since I emptied my Calendar folders into my Show Records folders as I finished the shows, the Calendar folders are now empty again and ready for next year. Everything else gets labeled and boxed up and stored for about seven years, after which I look for one of those "shred-a-thon" programs where the city brings industrial size shredders to specific locations and toss my old records into the recycling monsters.

Here is a quick reference summary for a simple monthly 4-folder system of organization:

FOLDER 1- INCOME	FOLDER 2- EXPENSES	FOLDER 3- SHOWS	FOLDER-4 CALENDAR
Invoices for ALL SALES	Receipts for ALL EXPENSES	Applications for ALL SHOWS	Packets/info for ACCEPTED SHOWS

Databases and Spreadsheets (oh my!)

Aside from the monthly folder system, I have two main computerized tools that help me keep track of everything else. The first is a home-made database where I input all the shows, all my customers, all my sales, and all my artworks. It is literally the lifeline of my business and the IRS was very pleased to see this tool. There are some programs out there in the market that can help the artist keep track of an art business. Mine is custom made from an Access database, a program that is usually already resident in most computers, and I like it that way. There are pre-built templates to keep track of customers and inventory that are very easy to use.

With a database I can not only keep track of all the art, all the people (customers, suppliers and promoters) and all the shows (and all interactions thereof) but I can get reports of anything related to my business. Some examples of information I might want to know for any particular time period are:

- Shows attended in a year and their profit margins
- Shows attended per state and the state profit margins (maybe I need to expand to Florida?)
- Art works completed and art works sold
- Mailing list of customers in Arizona (so I can mail them a postcard)
- Mailing list of customers who bought more than two pieces (so I can mail them a bigger postcard with my calendar and repeat customer discount incentives)
- List of shows applied, including gallery shows
- Provenance of a certain art work (history of the art work, or in the case of my woodcuts, who owns what number of the edition)
- Inventory currently in the trailer and what best selling art works I need to mat or frame
- Email list of all my customers (email announcements are FREE)
- Best selling art works (and worst selling)
- Artistic resume

A much simpler tool to keep track of shows for the database challenged is a spreadsheet. At the very least every artist ought to be keeping track of how much they made in a show and how much they spent doing the show.

Here is a very simple layout (all shows and numbers are bogus):

Show	Location	Entry Fees + (inc.app fee)	Expenses = (travel/food)	Total Expense	Sales (less taxes)	Profit
Art in the Park	Vegas NV	485	65	**550**	4965	4415
Main Avenue Fair	El Angel CA	385	925	**1310**	4940	3630
Eagle Arts Affair	Rocky CO	295	885	**1180**	2965	1785
Fantastic ArtsFest	Small AZ	225	660	**885**	1590	705

Jot down the show name and the city and state in the **Show** and **Location** columns. Entry fees include the application fee and any other added show fees like parking passes and special location fees; they go in the **Entry Fees** column. Next tally up (and keep receipts for!) traveling expenses, including gas, hotel, and every morsel you eat along the way and while at the festival and enter the total in the **Expenses** column.

Add up **Entry Fees** and **Expenses** to give you the **Total Expense** column. Enter **Sales** (less taxes collected, this is not your money but the state/county/city's money) in the **Sales** column. Lastly subtract **Total Expenses** from **Sales** and you have a rough Net Profit for the show. This is a very minimum record keeping format for art festivals and does not include other expenses that will become relevant at tax time such as vehicle depreciation, insurance, etc. These and other overall expenses can be divided at the end of the year by the number of shows attended to get a more accurate picture of Net Profit.

But, to begin with, this simple format allows me to evaluate at a glance where I'm making my money and where I should either be more careful and try to fine tune or avoid altogether. A quick look at the spreadsheet and I can see I'm making the most money at home in Vegas, Nevada, easy to spot because the expenses are very low even though the booth fee is the most expensive. Since I have a list of collectors and got my name in the paper prior to the show, I made a handsome profit.

El Angel, California is not a bad show because the show is close to home, and, even though my expenses are much higher, the sales were very good. Notice how even though I made about the same amount of sales as in my local show, the profit was less because of the outrageous hotel prices in El Angel. Still, definitely a market to work with and keep.

Rocky, Colorado is a longer drive, so in addition to the higher hotel expenses I spent a great deal of time on the road and put much wear and tear on my vehicle (in my accounting system, I have a way of keeping track of this too, but this is a very simple approach suitable for starting out). I like traveling and it was a fairly decent show. Next year I may or may not do the show, depending on what else is available at the time and how my spring goes.

This particular Small, Arizona show needs to be dumped. Even at the very low entry fee and average expenses, an out of town show is too much work and time invested for only a $700 profit margin; sales just do not warrant repeating this show. If this were an easy home show I would probably give it another chance.

In real life, my spreadsheet includes the date of the show and a comments section where, from year to year, I can jot down things like: "promoter very nice" or "windy as hell" or "no parking within six miles, bring bike". I make year to year comparisons; I love to run trend analyses on my data; I compare state to state; whether booking a 10x20 or a corner pays off (it does!); what shows to dump immediately; trends for profit margins; I LOVE STATS! The reason I do all these and more is because I like to keep a tight pulse on my business and I do not like to waste a minute of my precious time on something that is not giving me results. I'd rather spend the time hiking (read: doing landscape research) or making more art.

Whatever tool you use, make sure it is useful for you. A notebook and a pencil might be good enough to start until you figure out what it is you need to keep track of. Also, a simple spreadsheet like this one is not really an accounting tool, more on that in the next section. As I said before but worth repeating here, a couple of books on running a one-person business will be a valuable resource, as well as a book or two on running an artist business.

How do you keep track of all the accounting?

I know I touched on this in the previous question, but good accounting is crucial to good business practices. Basically there are three ways to approach the accounting problem.

The manual method is probably good enough for starting out, especially if you don't know if you will continue to sell at art festivals or just want to try out the life. Your local office supply store has accounting logs with instructions, mileage logs with instructions, tax logs with instructions, pre-labeled file folders for the small business person, receipt books and all kinds of goodies that are pre-printed and ready to use. I know many artists in the business for many years who keep their books manually.

The computerized method is for those who feel confident with computers, have one available at all times and like the efficiency. Setting up the business can be done on spreadsheets and databases or with a one-size fits all and do-it-all software designed specifically to run a small business. Quicken, QuickBooks, Microsoft Money are three programs for accounting and come with business templates, receipt generators, inventory, employee paperwork and much much much more. There are other dedicated programs out there as well that are designed specifically for running a one-person business. Searching online or visiting the nearest office supply or computer store are great ways to start.

The "I can't deal with this, hire a professional" method is for those artists that have a headache right about now. If numbers and aspirin come usually together in your life or if you are notoriously and self-reportedly "bad with numbers", by all means hire an accountant. There are many accountants that will do month to month accounting, quarterly taxes and yearly income taxes for very reasonable rates. Be sure to find someone you trust and that understands the business of being an artist.

CAUTION! Keeping track of the numbers is not difficult and it is essential to the health of any business, whether you do two festivals a year or forty-five. Be sure that this part of the ship is run tightly and honestly.

Should I have a website?

Great question! In fact that is the most frequently asked question by people that happen into my booth, customers, galleries, other artists, promoters…everyone wants to know if I have a website. The answer depends on who you ask. In this day and age, my answer is a resounding YES, you should, you must have a constantly updated website, a blog, some kind of online presence. Many old timers are coming around as well and are seeking some sort of online presence. Why? A) Your competitor has one, and B) Makes you easy to "know" and, more importantly, easy to reach.

Collectors love to browse your entire website before coming to a festival, after coming to a festival and any time in between. Keep your website interesting and they will talk to you about it. They will talk to you about your dogs and your garden and about your latest piece. People love to know the artist.

Customers also like to know that they are buying art from someone they know and someone who is serious about being an artist. Even in the fleeting world of art festivals, many customers buy art, as opposed to sports posters, as an investment. Customers preview my art before festivals and many times, buy from the website after a festival. All my art is updated as I finish it and arranged in online galleries so it is easy to browse and easy to search.

The most glanced at piece of material in my booth is a little ditty I have entitled "About the Artist". Customers want to buy from someone they feel they know. Website material! The second piece is about my art, so my website includes all about woodcuts, how to make them, ongoing projects, pictures of woodchips flying off the block in my studio, and so on.

Then there is the all important exhibit-festival schedule so people know where to find you, plus any galleries that are currently or permanently showing your work. All that good stuff belongs on the website; make your art easy to see both in person and online. The more people look at your art, the more familiar it will become and the easier it will be to sell once they are ready to buy and find you in a festival near them.

Spend some time browsing other artist's websites and find something you like and might be able to live with. I would highly recommend building your own website because it is ridiculously easy these days and ridiculously expensive to have someone else do it for you. But, again, if you just broke out in a rash at the mere mention of making your own website, do find someone who will make one for a reasonable amount. Many web hosts have very easy interfaces that allow you to build a website in a couple of

hours by using their templates. Blogs (web logs) are easy and free and make it absolutely a snap to update content, including pictures.

All that said, I wouldn't rush out and get a website before I get a tent. Although I think it is essential to have web presence after your business is established, a website is certainly not the first thing to invest on. Get a few festivals under your belt and you will see that "Do you have a website?" will also become your first FAQ.

Should I get insurance?

Again, the answer depends on how many festivals you plan on doing and whether this will be a major part of your life a year from now. Insurance for artists is cheap enough and obtainable through online artist's groups or many other insurance companies. Again the best resource might be a thorough online search or the trade magazines specifically written for artists.

There are various types of insurance to think about as well to be absolutely sure your equipment and inventory are covered. If you have a business location like a gallery or rental studio, it might be wise to keep all festival supplies at that location so that they are covered under the business insurance. If you work at home like most of us, make sure that your home-owner's insurance policy will cover your studio and show supplies as well as any finished inventory. Remember that most insurance will not cover retail value, only materials are covered in most cases unless specified otherwise in the policy.

While on the road, your vehicle insurance will cover most of your vehicle contents including those being towed in a trailer, but it is essential that you communicate with your vehicle insurance carrier and understand the limits and deductibles. A rider to your policy may be necessary and, in any case, you better tell the insurance company now than later.

While set-up in a festival neither the vehicle, business location nor home-owner's insurance will cover a darned thing. I have asked many artists and seems as though some carry only liability insurance in case someone sues them after their child knocks over a display glass case on their tiny head. The promoter will more than likely NOT cover the content of your booth or even liability for accidents occurring in your booth. Think of your booth as a small gallery or shop in a mall. While the mall ownership will be liable for the spills in the general hallways and restrooms, each shop owner is responsible for their little shop.

Both liability and comprehensive (to cover inventory and equipment in case of a hail storm, fire, vandalism, etc.) can be purchased for a very reasonable amount. Finding an insurance policy for the art festival business can be done, you guessed it, through an online search or in the trade magazines.

In all cases, make sure you have an inventory of your show supplies and equipment and the artwork that you take to the shows. A catalog of digital photos is an accurate record and easier to update than written inventories. Just open the trailer, snap

as many photos as needed to show all the contents. Snap some photos of your booth set up as well so you know for sure all that you haul. And, of course, you will need to keep receipts for all equipment such as tent and panels and that pricey credit card machine!

Again, if you just have a few tables and home-made panels and are just trying the business on for size, insurance is not an initial concern. For those of us in for the long haul, it does become a necessary business pill to swallow.

How do you find shows and reviews? How do I keep up with the industry? How do I get good weather reports? How do you know where to stay out of town? How far is Nothing, Arizona? How do I get directions? Why am I asking all these questions?

The Information Superhighway

Well, the answer to the last question is that you are already suffering from festival anxiety, a well known and very exciting syndrome that means you might already be addicted. All the other questions can be answered with one word: the internet! (okay, make that two words and an exclamation point).

Everything and anything that comes up will either be answered with experience by your own common sense or you can find it on the internet. I search for supplies and shows, I search for reviews, for artist's blogs and diaries that talk about the business. I look up the weather a week before any show starts. I find driving directions and mileage and hotels or campgrounds in the town of the festival. I print maps (yes, even to Nothing, Arizona), locate GMC dealers and bike shops near the festivals (just in case), restaurants, Wal-Marts and Home Depots.

Of course, read whatever information is contained in your acceptance packet where many of those questions will be answered (including the weather report!) Anything and everything else can be found online. Many shows are allowing you to send applications and photos online. Hotels are best found and reserved online; cheapest gas prices can be researched ahead of time online. Get online already, and enjoy the whole world at your fingertips.

All trade magazines that I'm aware of are online, some are exclusively online. Supplies can be bought online from your laptop while you sit in the booth watching the rain fall. You can order pizza online and have it delivered to your hotel as you walk through the door or investigate the show schedule of the nearest movie theater. Anything important and everything frivolous can be found online.

Your fellow artists will help, really!

Finally, don't neglect your fellow artists as a source of information. Code of silence aside, most of us are happy to help and most of us will give you at least the answer we think it's the right answer to whatever questions you have.

Aside from asking directly, observing other artists unobtrusively, especially those in your medium, is a great way to learn tips and tricks of the trade. Most of us learned that way, read a little, asked a little, and watched a lot! Although we are probably no substitute for a good accountant, we can at least tell you what we do and point you in the right direction regarding paying your taxes or something similar. And most of us carry a bunch of spare bungee cords or know where the nearest Home Depot is located so you can go get your own.

So come on out and ask away! You will be immediately admired by most of us for embarking in the great festival adventure and many of us will welcome you heartily into the great festival family.

In conclusion...

A man of words and not of deeds,
Is like a garden full of weds
—**English Proverb**

With all that said, the essentials of beginning a life as an art festival artist are basically covered. There is much much more, of course, and every chapter in this book could become a larger discussion in itself—and some of them will! Hundreds of books have been written about sales and marketing, for example, and within the sales aspect there are books about closing the sale, getting prospects and every part of the sale. But all the books in the world are not a substitute for the experience that will come with actually doing the first few festivals.

And Now...Seek Your Own Way

Everyone, in fact, has to find their own way in this business, because one key to success is the individuality of each one of us. Creativity in art should translate to creativity in your approach to being a successful artist. I've known artists that book three shows a year and make a living from commissions and special orders gained at those shows. Others prefer the adventurous traveling life and the charm of smaller shows, and make a fine and fun living with 30 or more smaller festivals.

I would say the average artist does *this many shows* and makes *this much money* per festival, but frankly there is no such thing as the average artist. In ten years I have gotten to know a huge variety of artists and as many approaches to making a living as an art festival artist. About the only thing we all have in common, those of us who survive the first few meager outings, is that we survived the first few meager outings and persevered in our quest for success.

Many along the way had to modify our approach. Many artists I have known changed their art form to maximize their buying public, others simply stuck firm to what they knew and sought their own niche within that public. All of us that are still in the business today have only one thing in common: we persisted. All of us adapted to good and bad times, and all of us continue to this day to enjoy the life and love the art.

Starting out is as easy and as difficult as taking the first step. Book a festival, see how it goes, get a few bruises and break a few fingernails, get tired, sell something beautiful. The most important thing is to get your art out in front of the buying public; the next most important is to stay out there until either you succeed or die trying. So get out and stay out!

Early to bed, early to rise, work like hell, and advertise.
–**Laurence J. Peter**

A Short Letter to Artists

Dear Fellow Artists,

Through the years I have met many of you and have had the pleasure of learning from you or simply withstanding the elements side by side. First of all thank you for your help and experience or for putting up with me if I got loud. Here is a list of things that stick in my head:

- *Please follow the rules, except the real stupid ones, but mostly park…you know where.*
- *Please unload and load quickly and don't let your vehicle linger in everyone's way. There are, after all, 500 of us doing the show with you.*
- *If you come in to set up late, don't scream at the rest of us to get out of your way. Get up earlier, sunrise is a beautiful time of day.*
- *Place your booth within the marks, not six inches just ahead of your neighbor. And don't stand even an inch in front of my booth during the festival; I have great aim with small rocks.*
- *Keep your stock and boxes neatly stacked and covered, out of sight of your and my customers.*
- *Pick up your trash. Don't be a pig.*
- *Start the shows on time and close at closing.*
- *Be civil to your neighbor. Treat everyone the way you like to be treated.*
- *Don't talk trash about other artists or promoters*
- *Be careful out there and let's look out for each other.*

A Short Letter to Promoters

Dear Promoters,

First of all, thank you for all the good shows and the learning experiences. Thanks for letting me in or for the nice rejection letter that helped me improve. Most of all, thank you for being good partners through the years and let there be many more to come. Here is a list of things that stick in my head:

- *Don't make up so many rules, I get tired after six pages and I love to read. Bad artists won't follow them and good artists follow common sense, just like you.*
- *Take responsibility for the show. Enforce the rules you wrote. We rule-followers hate watching others get away with breaking them.*
- *Be fair to all.*
- *Treat us like your partners in business, not children in a playground.*
- *Give refunds; you can't just take people's money in exchange for nothing. Be fair.*
- *Give us plenty of notice for your show dates, we love to book your shows way early.*
- *Tell us what you expect from artists. Tell us in advance about your shows and what you like.*
- *Advertise or say you won't.*
- *Don't talk bad about artists or other promoters.*
- *Be careful out there and let's look out for each other.*

Appendix A: Glossary

Glossary of terms and expressions encountered in the business, seriously! These might become more or less humorous as you gain some experience; all I wanted to do was clarify some simple and not so simple concepts.

50% (from last year, "Last year's show")

A comparison report from an artist or two who did last year's show. They may have and they may keep track of their shows and the statement may be true. They may have not and thus the statement may be false. You decide. If a lot of artists are present, they may revert into the "remember the 80's" conversation and roll their eyes and sigh all together.

Acceptance/welcome packet

A packet of stuff that the promoter kindly sends artists upon acceptance (usually mailed) and upon arrival to the show. This packet may be large or small and contains important goodies and information such as parking passes, name tags, discounts, hotel lists, taxes and permits, parking maps, tear down instructions and so on. Contrary to popular belief, artists ARE supposed to read the whole thing.

Ambassador (booth-sitter, volunteer)

Usually an enthusiastic volunteer who will come by when you do not need them and repeatedly so. When you have to "go" or you are blind from low blood sugar they are slightly harder to find. Remember they are volunteers and thank them anyway. Ambassadors are NOT expected to make sales for you so don't leave for long periods of time.

Application

The initial point of written contact between artist and promoter, usually contains contract wording and has to be signed. Probably a good idea to follow all the instructions, pay attention to things like "don't call regarding your status", number of slides to send, additional materials requested and SASEs. The early bird gets the worm!

Artist

Show participants who make art or something closely resembling art. Also called vendor, participant, crafter, craftsperson, dude or simply hey!

Artist-parking

A place nearby or farther-by, usually secured and free, where the artists are supposed to park. Why is that so hard? The function of this seemingly elusive

concept is so that patrons (them being the ones with the wallets) can park closer to the show and thus purchase things. Expressed in mathematical formula: 1 < (less) parking spot = 1 < (less) customer 4 U. Although one less parking space may or may not make any difference in the number of customers that attend the show, it is easily expressed in mathematics that, if all 220 artists park in customer parking: 220 < parking spots = 220 (or twice that many, since people usually don't drive alone to festivals) < customers for all of us. 400 less customers is a significant number. Mathematics don't lie.

Artist's Oasis

A wonderful place reserved for the artists to kick back and relax during the shows. As in any oasis, food and drink are often present. Watch carefully when the oasis opens because shortly thereafter there will not be much food left. Artists are a hungry lot.

Be-backs (not to be confused with Really-be-backs)

Customers who swear they "will be back". Really-be-backs are customers that swear they "will really be back". Less than 20% do, in reality and in my experience.

Booth (Display)

An artist's temporary place of business, most commonly a white 10 foot by 10 foot tent and its surroundings. May be odd shaped or roomier. A tiny cloth covered gallery. Your office, shop and studio for the next two days. Make it pretty and talk to everyone that gloriously enters.

Booth Sitter

See Ambassador, Volunteer

Boy-scouts

Real boy-scouts are often present in many of the bigger shows to help load, unload, set up and tear down. Give them clear instructions and money when they are done.

Breakdown (not to be confused with "break down")

Also known as Teardown, Load Out, or more commonly The Stampede Home. This is the act of dismantling the booth and loading all the contents and equipment in whatever vehicle brought it all to the show. Can be a messy time so just be patient. In my experience, thirty to forty-five minutes after the initial messy

rush there is a much calmer period where the rest of us peacefully finish our breakdowns.

Bring hand-cart/dolly

This expression usually means that you have signed up for a serious walk from the parking to the show grounds and some artist complained in the past. Artists know that we should *always* bring a hand-cart or dolly, sheesh.

Buy-sell

Short hand for goods that have been bought wholesale and are being sold as handmade by the artist. Probably should be brought to the attention of the promoter; if they don't care, fine artists should probably not repeat that show, especially if they advertise their show as hand-made by the artist only. Not so tough to spot, really, and buy-sell hurts everyone's sales by cheapening the show year to year and making the art festival less of a unique experience for the audience.

Canopy

Some sort of tent, commonly 10 x 10 in size and usually required to be white. There are many brands and constructions which all have pros and cons. A cheap tent from Costco looks cheap. The canopy is probably the single-most important piece of equipment for an artist, as it has to withstand sometimes severe elements and attract people inside.

Category

Within an application, the classification given by promoters to different kinds of art. Usually the categories are pre-set and artists pick the one that best describes their art form. Sometimes it is necessary to check *Other* and explain if the art form is unusual or not listed.

Contract

Within an application or separately in some cases, there is a paragraph or page of legal verbiage that often contains disclaimers, indemnity clauses, refund policies and such very important matters. Read before signing. I have been accepted to shows and, once I saw their completely ridiculous contract, withdrew my application. Remember that promoters are more likely to have lawyers on retainer. Most contracts are really very straight forward and harmless, designed to protect the promoter and the festival as a whole.

Deadline

The last day an application can be post-marked or accepted. Used to be a line drawn in the sand and anyone who crossed would be killed; fortunately most promoters now a days are a lot nicer than that. Apply early, apply often.

Dinky show

A small show, usually held in a parking lot, with fewer artists (50 plus or minus). Some dinky shows are put on by small art organizations and some are set in park settings. Some can be extremely profitable but most are smallish affairs with easy everything, no advertising beyond the local PTA and small return for investment. Gems are born out of dinky shows.

Display

Same as Booth

Do you have a card/website?

A phrase uttered by customers when they want the hell out of your booth and can't make a graceful exit without making you waste .03c. Some think of it as a polite exit. Most artists think of it as "the coup de grace". No sale for you, at least not today, probably not ever, but "do you have a card?"
How we suffer at the hands of the buying public...

Drapes

Drapes are required in many shows, especially the good ones. A drape is a cloth that covers tables, especially, but also any other bench or display fixture, in an effort to hide ugly metal legs and those carefully placed cardboard boxes that look so darned ugly even when neatly stacked. Even Tupperware containers and nice boxes just look like boxes. Drapes should cover the table down to the floor and be of a color compatible with the booth, as well as made of some material that does not need ironing and repels (or looks like) dirt.

Electronic submission/application

This is the new way of submitting applications and images, thank the gods of modernization. Using a computer and sometimes right from the promoter's website, you can submit your completed application and upload images or send images by email. Saves paper all around and valuable slides or photos.

E-Z Up

A specific brand of tent that unfolds, pops up, and sets up in minutes. Other brands are Caravan and K-D. This tent has the advantage of being lightweight

with the disadvantage of not being as sturdy and weather proof as the heavier pole-based tents. They are also lower in ceiling space than the pole-based tents because of the armature that holds up the canopy. The term E-Z Up is used to refer to any brand of pop-up tent. They are commonly 10' x 10' and also available in 10'x15' and 10'x20'.

Flexible space

This expression is used to refer to a space that commonly will NOT accommodate a 10' x 10' tent but it is irregular in shape and size. Sculptures and stand-alone 3-D art displays very well in a flexible space, as does 2-D art in easels and under umbrellas. The advantage is that a creative flexible space seems to allow and attract customers to walk through artwork more easily than an enclosed booth. The drawback is that there is often no real weather cover.

Gallery panels

Carpet covered panels used to display and hang artwork, usually 2-D artwork but the carpet paneling can accommodate shelving as well for smaller 3-D works. Head to head, carpet panels are probably the best looking, come in colors, are lightweight and allow artists to arrange in creative arrangements. Drawback is the panels are expensive. Everyone told me that I would sell more if I got carpet panels and they were right; they seem to attract more people to my booth.

Gem

This is a small show (see Dinky Show) that attracts a good herd of buying public, produces high-income, load-in and out are easy, the promoter is wonderful, artists are well behaved, parking is available for all, the setting is beautiful, the weather always cooperates…well, you get the idea.

Grid walls

Another type of display walls, also lightweight and also adaptable to 2- or 3-D works. These are and look less expensive and we all started there. They are notoriously sturdier in the wind because they don't act like a sail like carpet panels do and they let light through.

How-you-doin'?

This is an expression that means different things when uttered by different people and it never really means how are you feeling. When "How-you-doin'? is said by:

- A promoter, it means "how much money are you making?" or "how is attendance?"
- Another artist, it always means "are you selling anything?"

- A vendor of credit card processors or any other of the many solicitors that will approach you in an art festival, it means "can I start my sales pitch now?"
- A customer, it may mean "can we talk about these prices?" or "let's talk about this piece" or "I don't understand a thing I'm seeing, can you explain to me what a woodcut is?" or a myriad of other conversation starters. That's a good thing.

The appropriate answer to any of those, vendors excluded, no matter what is meant is: "Awesome! How-you-doin'?" It will throw them off every time.

.jpg, .jpeg (also .gif, .bmp)

These are extensions for digital image files. The standard is usually .jpg and can be created with any imaging program, many of which will come along free with your expensive digital camera. Most Windows or Mac computers come pre-loaded with some type of imaging program that will allow you to convert camera images of your artwork into .jpgs. Be sure to follow the often specific instructions for file size and resolution.

Jury, jurying, juried show

A sole person or group of people that reviews slides or images and chooses artists for any given show. The process can be elaborate and impartial or a glance at a bunch of slides through a light bulb as they come in. The jurying process was explained ad nauseum in the Choosing Shows Chapter. A juried show is often a better quality show than a non-juried show and allows artists according to some criteria. Non-juried shows might have an influx of hodgepodge stands which may include buy-sell goods.

Last Year's Show (closely related to: "last week's show", "the summer show", "two hours ago" and, of course "the 80's")

This is a fictional time and place in which EVERYTHING was better: the weather, the customers, the sales, the setup, the parking...absolutely everything was perfect last year's show or, roll your eyes to the heavens here, in the 80's. I have actually heard someone say that "in the 80's" you just brought your five-thousand dollar paintings and customers lined up to grab them off the back of the van before the show even started. Then the same customers that had just dropped 50 thousand dollars on the artwork of an unknown artist fought to invite you out to lunch in their mansions and baptized their first-borns with your name.

Seriously, I don't know why artists come around and speak about last year's or last week's nirvanas so often. I can only think that they either: like to make you feel bad just for kicks, or like to make themselves feel good just for

kicks, or maybe they are just bored. Either way, an often too long colorful diatribe about "last year's show" makes for very interesting conversation, but is hardly ever based on actual fact. My best guess is that it rained like hell last year.

Load-in (setup)

The act of getting to the show grounds, finding your booth, and finally unloading your goods and building your display. Often this can be the day before the show or the very early morning of the show. Usually a nervous time until you get unloaded and the car is parked, then you settle into a familiar (sometimes very rushed) routine.

Lights

Lights are required in many shows and optional in others. If the show is scheduled past 7:00PM probably would be a good idea to bring the lights or be literally left in the dark. Obviously lights require power, but more importantly, they must be energy efficient as there is always a wattage limit per booth when power is supplied. Power either costs extra money or is supplied as part of the booth fee; make sure you check in advance. Clip on lamps or track lights made for temporary displays work well. Don't forget an extra extension cord and, usually, surge protectors.

Manufactured goods, mass produced items, kits

These are often craft items that infiltrate the fine art and fine craft shows meant for the hand-made art and craft created by the artist. As a fine artist, I tend to pick shows that do not allow these items because the buying public likes to spend $5 twenty times rather than spending $100 one time; it's just a shopping fact. Kits are craft items that come pre-manufactured and are assembled by a craftsperson. Manufactured items and/or mass-produced items are also often found at malls and variety stores near you.

On-site (refers to: parking, food, pets, etc.)

Self-explanatory, on-site usually means within the festival grounds and, more often than not, within walking distance. On-site parking and food means that you will be able to park and eat close to your booth. Off-site parking sometimes means that you need to bring a bicycle.

Originals

The term original can refer to:
- A one-of-a-kind piece of art such as a painting or a sculpture. An original may be reproduced, thus creating reproductions of the original.

- An artwork designed uniquely and the sole creation of an individual.

Often, an originals-only show refers to a show where only one-of-a-kind pieces are exhibited. Multiple originals such as some bronze sculptures or fine prints are often excluded.

Preview, Sneak-peek

This is a before-the-show show where a select portion of buyers are allowed to preview the artists attending a show. Often they are best-of-show judges, sponsors, gallery owners, wholesalers, museum curators, private collection curators (I met Steve Wynn's collection curator once) and such individuals. I would say it is a good idea to have the booth ready and all artwork shining during preview, although many artists use the "extra time" to set-up late.

Prints (and Graphics)

Generic term used to bundle together any work of art that is created in an edition. Included are fine prints (etchings, engravings, stone lithographs, serigraphs, woodcuts), digital prints, and manipulated reproductions or photographs.

The term "print" is also used to refer to reproductions of original paintings, which can cover the vast range from exquisite professional giclees printed on archival papers to cheap inkjet artist-produced reproductions and note-cards. Posters are also bundled neatly into this nebulous category, weather offset lithographs or printed at home on the HP.

Due to the "print" confusion, many shows limit any kind of prints altogether (all of the above), allow fine prints but limit the amount of reproductions of originals that can be shown, or allow reproductions as long as they are labeled as such.

Promoter, also Organizer

The person or group responsible for putting on a show. Good to get to know them and establish a good rapport with them; they are the artist's business partner in the art festival.

Really-be-backs

See Be-backs. Really-be-backs will really maybe possibly be back to your booth or they know about "be-backs" and want to separate themselves from such people.

Reproductions

See Prints and Graphics. Reproductions are photo-mechanical or digital copies of an original work. Quality and price varies widely usually depending on the process that was used to make the reproduction. They may or may not be produced in limited editions.

SASE

Self Addressed Stamped Envelope. Most promoters require these, sometimes multiples of these, in order to communicate with artists and return slides or photos. I actually had someone ask me how they were supposed to send an envelope inside of another one of exactly the same size. Folding is one of many strategies.

Security, roaming security

Security is provided by promoters to assure the safety of booths after the show closes. Not all shows provide security and security can vary from the City Police Department (best) to hired Security Guards to the promoter and his volunteers. Sometimes security folks sit on one end of the show, hopefully the entrance gate, sometimes the shows are open and they roam the show. In any of the cases, your booth is hardly secure. In the beginning most of us tear down all our precious artwork every night and take it home; after a few shows, we trust the gods of art festivals and the security provided and zip lock the zippers of our walls hoping for the best. Vandalism is more common than theft.

Setup

See Load-in

Setup begins at 1:00pm, 3:00pm, etc. "sharp"

This means that most of us will show up an hour before X:XXxm sharp. Since promoters know this, they will assure that they tell us setup begins an hour after setup really begins, which leads some of us to start showing up really early. Some times though, sharp really means sharp and then we're all in big trouble. It's confusing, I know.

Show-food

Food that is offered for sale at the show in order to give be-backs something to do while they plot how to get away without coming back to your booth. Food can vary from very good stuff to snacks and drinks. Some shows forbid vendors to bring coolers so that we can be enticed to purchase show-food.

Show-friends

These are friends that you make at shows, see at shows and never see outside of shows. This does not mean they are not real friends, there are very good show-friends, it just means that outside of shows you don't really see each other. Show-friends are good to have and many give great show-hugs.

Slides

35mm transparencies of your work. Many festivals use slides to project to the jury the works of prospective artists. Professional slides are often recommended although about half of artists I have spoken to choose to take their own. Slides should represent your best work as accurately as possible, should be sharp and color-true, well lit and show only the work against a neutral background or filling the entire slide.

Special Location, special location request

A request for a usually favorable or favorite location made by an artist in the process of applying or after acceptance to a festival. Special locations may be corners, face sun, space behind booth, no music, near food, drive to booth, facing North, certain streets or rows or even specific booth numbers. Many promoters charge for special locations, almost all charge extra for corners, although some promoters do not charge and it surely never hurts to ask for what you like. Special locations are never guaranteed.

Spikes

Spikes are usually tent spikes used to secure the legs of a tent to the ground. Many park shows prohibit spikes due to underlying sprinkler systems, some require them. *Absolutely no spikes* in the ground means that if you spike down your booth you must do it covertly and hope you don't hit a sprinkler line. *Spikes required*, on the other hand, indicates a show that usually gets strong winds so be prepared.

Sponsor

These are folks that have given the promoter a bunch of money for advertising and also buy the privilege of setting up their booth in the festival grounds. They can range from very friendly and generous to the artists (such as the case of bringing us food or goodies) or very annoying (such as the case of loudly approaching passers-by with surveys and causing them to hurriedly skirt their, and your, booth). In either case, they have probably paid money in the thousands and are a feature of every larger show.

In some cases, sponsors will be nearby businesses which set up a retail tent right next to yours. In the best of cases, the sponsors will have their own little area and everyone is happy.

Vendor

Anyone that pays for booth space at the art festival. Includes artists, craftspeople, food booths, sponsor booths, musicians, etc.

Waithugs

These are hugs that artists give to each other after having broken down their booth and loaded up their wares in their vehicles. They are called "waithugs" because the rest of us have to wait until all the hugging is over before said artists pull their vehicles out of the way so that we may bring ours. The longest wait hugs have been measured in hours, while more commonly they really just take a few minutes…per hug. Once I actually had to wait for about 20 minutes for about six people who engaged in multiple and generous inter-hugging with a couple; they finally left as they said: "We will see you later at dinner, OK?" (ok…sigh).

Wait list, also known as Alternate

This dreaded limbo is the place where a promoter places the artists that have not yet been accepted but have not been rejected either. The wait list serves a purpose for the promoter: to fill in the spaces that artists will void when they either don't pay or don't show. The wait list can be held "live" until the morning of the show, at which time those alternates that showed up grab the spaces that accepted artists forfeited. Or the wait list can have a cut-off time, say a day or two before the show, at which time the promoter decides no more artists will be given the go-ahead. To be wait listed for a great competitive show may be a way in, if you have the patience.

Weights

Because tents are like sails or like balloons, depending on which brand you buy, they must be weighed down to be secure. Weights are almost always mentioned in the application because there is the Great Greek God of Festival Weather (his name is unpronounceable but ends in 'hole') that invariably makes the weather especially windy during art festivals. Many festivals will not allow stakes on the ground and many festivals are set on streets where stakes are tough to pound and usually not allowed by the city anyway. Most artists start out with either weight lifting weights or lengths of 3" sprinkler pipe filled with sand or concrete. Whatever weights you choose, tie them down from the top corner of the frame of your booth and let them touch the ground to avoid placing undue stress on the frame (don't hang them).

What are you doing this summer/winter/spring? Where you going next?

These expressions are asked by other artists in an effort to find out "what show is hot?" Since the industry is largely unregulated and shows are not very well publicly rated, all artists have is each other to find out what shows are good and what shows are not. When answering either question, you are expected not just to

say where you are planning to go, but also what you think of the show and how you rate it and how it compares to other shows in the same area, how much money you made last year, the average weather for such time of the year, suggest a motel or two, give away the secret perfect location where sales are the best and so on and so on and so on.

Zapplication, Zapp

An online application organization that accepts applications for a growing number of larger and prestigious art festivals. Their requirements for promoters are fairly strict in an effort to standardize application procedures for art festivals. Artists can keep a portfolio of images online and apply for many shows simultaneously as well as receive notices when show deadlines are upcoming. Read all about it on their website www.zapplication.org.

Zoo

Arguably, a larger well-established show commonly with well over 300 artists and usually a wide variety of arts, crafts, food and entertainment attracting over 100,000 people. The term "zoo" may refer to the rushing loud audiences, the variety of music (some resembling monkeys howling), the stampedes during load-in and load-out, or the general "feel" of the show, resembling a bunch of people and animals, some cute, some not so cute, some people like animals and some...well, I think you get the idea. Usually great shows, by the way, if you can withstand (with a smile) the strawberry juice and barbeque sauce on your freshly matted prints.

Appendix B: List of Resources and Online Links

The following is a non-comprehensive list of online resource which I have found useful. Feel free to send me show listings and festival links for inclusion in the website (www.artfestivalguide.com) and the next edition of the book. In fact feel free to send me any links you have found useful in the business.

ArtFestivalGuide - Yellowpages

Books

abebooks.com - the world's largest source of out-of-print books!
 - http://www.abebooks.com/
BookSense.com
 - http://www.booksense.com/
HamiltonBook.com ! The Lowest Prices Anywhere.
 - http://hamiltonbook.com/
Lulu.com - Self Publishing - Free
 - http://www.lulu.com/
OZONeBOOKS.COM - The New Generation Bookstore
 - http://www.ozonebooks.com/
USED BOOK NET ... Search for Out of Print, Rare, Used, Antiquarian & Hard to find Books
 - http://www.abebooks.com/home/usedbooknet/
Welcome to Bibliofind! Find any book in the net.
 - http://www.bibliofind.com/
www.amazon.com
 - http://www.amazon.com/
www.barnesandnoble.com
 - http://www.barnesandnoble.com/

Business Supplies & Resources

ABX - Arts Business Exchange
 - http://www.artsbusiness.com/
All Art Biz.com - Everything you need to know about art
 - http://www.allartbiz.com/bofa/index.html
ArtAdvice.com
 - http://www.artadvice.com/advice/
Art-Smart art index of artists and galleries test
 - http://www.art-smart.com/
Carbonless Forms
 - http://www.quickprint.com/custom_imprinted_discount_carbonless_business_forms.htm
CraftSmarts Business Help for Arts and Crafts Professionals
 - http://www.jiverson.com/
Internal Revenue Service
 - http://www.irs.gov/

National Association of Independent Artists - Resources
- http://naia-artists.org/resources/index.htm
National Association of Independent Artists
- http://naia-artists.org/
Nolo Law Books, Legal Forms and Legal Software
- http://www.nolo.com/
VistaPrint - Business Cards - Full Color Printing - Digital Printing Company VistaPrint
- http://www.vistaprint.com/vp/ns/default.aspx?xnav=welcomeback
What's New - Arts and Crafts Business
- http://artsandcrafts.about.com/hobbies/artsandcrafts/blnewadditions.htm
WorkingArtist - Business software for artists.
- http://www.workingartist.com/index.html
www.artmarketing
- http://www.artmarketing.com/
www.selfpromotion
- http://www.selfpromotion.com/

Credit Card Processors

Credit Card Processing, Merchant Accounts, Accept Credit Cards
- http://www.charge.com/
How to Evaluate Credit Card Processing Companies
- http://www.businessknowhow.com/money/tips5.htm
Welcome - PayPal
- https://www.paypal.com/
www.mobilemerchants.com
- https://www.mobilemerchants.com/

Everything Else

AAA
- http://www.aaa.com
BrassPack Packing Supply - Shipping Supplies
- http://www.brasspack.com/t/bpsprink.html
Discount ramps .com - your loading ramp, hauling and transport superstore
- http://www.discountramps.com/index.htm
eBay - New & used electronics, cars, apparel, collectibles, sporting goods & more at low prices
- http://www.ebay.com/
Expedia Travel -- discount airfare, flights, hotels, cars, vacations, cruises, activities, maps
- http://www.expedia.com/
Extra Large Capacity - eBags
-http://www.ebags.com/
iprintfromhome.com
- http://www.iprintfromhome.com
mapquest.com Maps, Directions and More
- http://www.mapquest.com/
National Association of Independent Artists
- http://naia-artists.org/
Paper Mart Packaging Store
- http://www.papermart.com/Pages/hello.htm

Storage organizers, home office furniture, racks, carts, stands, boxes Stacks and Stacks
 - http://www.stacksandstacks.com/
The Postal Store
 - http://shop.usps.com/
Travel, Airfare, Flights, Hotels, Rental Cars, Vacation Packages, Cruises at Priceline
 - http://www.priceline.com/
USPS Domestic Rate Calculator
 - http://postcalc.usps.gov/
Velcro products and Velcro straps - FASTENation
 - http://www.fastenation.com/
Yahoo! Driving Directions
 - http://maps.yahoo.com

Festival Listings & Publications

Art and Craft Shows, Street Fairs, Festivals, more
 - http://www.craftmasternews.com/
Art fair and craft show listings featuring juried shows
 - http://www.artfairsourcebook.com/about.html
Art Festivals and Craft Shows - Searchable database of events
 - http://www.artandcraftshows.net/
Art Festivals Craft Shows Exhibitor Listings Magazine
 - http://www.sunshineartist.com/
ARTLister - Free Link Exchange
 - http://www.artlister.com/linkexchange.htm
Arts and craft show listings and reviews by the Craft Fair Guide
 - http://www.craftsfairguide.com/
Colorado Artists Tour
 - http://www.coloradoartisttour.com/home.htm
Craftmaster News Art and Craft Shows, Street Fairs, Festivals, more
 - http://www.craftmasternews.com/
Crafts Report Online -- www.craftsreport.com
 - http://www.craftsreport.com/
Festival Network Online art & craft show, music festival, fair & event guide
 - http://www.festivalnet.com/
Internet Art Fair - Fine Art and Crafts
 - http://www.internetartfair.com/
Nationwide Directory of Art Shows
 - http://www.artshows.net/directory.html
Welcome to ArtFest - #1 Art Festivals Arizona, Nevada, San Diego
 - http://www.888artfest.com/
ArtFair SourceBook, the Best Rating and Tracking System for Fine Art and Craft Shows
 - http://www.artfairsourcebook.com/about.html

Presentation & Framing

Archival supplies - photo storage boxes, archival boxes - acid free storage
 - http://www.archivalmethods.com/
Art Cartons for Packaging and Shipping Paintings, Drawings, & Prints
 - http://www.propakinc.com/art_cartons.html

ClearBags.com
- http://www.clearbags.com/
Custom Picture Frames from eFrame.net
- http://eframe.net/
Frame Tek, Inc.-Picture Frame Spacers-Rabbet Depth Extenders-Security Hangers
- http://www.frametek.com/
FrameFit.com...your best source for custom picture frames.
- http://www.framefit.com/index.cfm/action/home.htm
Frames By Mail - Your source for picture frames.
- http://www.framesbymail.com/
Picture Frames .com
- http://www.pictureframes.com/
Save on Wholesale Picture Frame Supplies
- http://www.framingsupplies.com/index.html
Talas Professional Archival, Conservation and Restoration Supplies
- http://talasonline.com/
universityproducts.com
- http://www.universityproducts.com/
Welcome to United Manufacturing
- https://www.unitedmfrs.com/

Tents

Ace Canopy
- http://www.acecanopy.com/
Canopies and Display Products by Flourish Company
- http://www.flourish.com/
Caravan Products Price List
- http://www.bobwhite.com/pricelist_c.htm
Dealers Supply - supplies for show booths
- http://www.dlrsupply.com/
Ez Up Canopies - Pop Up Tents - Display Canopy- Free Shipping - HutShop
- http://www.hutshop.com/
EZ UP Express II Instant Portable Canopy
- http://www.ezupdirect.com/
Norstar Canopies Norstar Canopy Parts
- http://www.westcoastsupply.com/canopies/norstar.html
Pharos Instant Canopy
- http://tarps.com/popup.htm
Welcome to Modern Display.com
- http://www.moderndisplay.com/

Walls & Display

Armstrong Products, Inc. Art, Craft and Trade Show Portable Display Panels. Safety Stair Treads.
- http://www.armstrongproducts.com/
Canopies and Display Products by Flourish Company
- http://www.flourish.com/
Graphic Display Systems
- http://www.graphicdisplaysystems.com/

Propanels Professional Panels for Professional Artists
 - http://www.propanels.com/
Storage organizers, home office furniture, racks, carts, stands, boxes Stacks and Stacks
 - http://www.stacksandstacks.com/

Appendix C: Useful Checklists and Booth Layouts

After many years of doing festivals I realized how much we rely on either routine or checklists! I took this summer off festivals so I could produce some new work and finish this blasted book. This is funny now, but at the time I vowed never take the summer off again. I get to my first festival in three months on Friday, set up is Sat morning, which I hate because I have to get up at 4 a.m., rush over to the festival site, wait for the promoter to tell me where my space is, then rush my little temporary gallery setup. So, all was well until around 6 a.m., at which time I realized I did not have my legs with me. Well, not MY legs, but the bottom section of my tent legs!!!! Agh agh agh, I'm ready to cry, just barely daylight and my proud tent is sitting there...on half legs, about 5 feet from the ground. I would have set up like that except my display panels are 7 feett tall. Artists begin to notice, we are all like a very dysfunctional but close and supportive family, and offer suggestions, one of which was to find a hack saw and make some legs out of my awning poles. Heck why not, they only cost about 15 bucks and the alternative is a five-hour drive back home to find my legs!!!

Low and behold, someone produces a hack-saw; I would dare say that between all the junk artists carry we could build a small town. An artist (I think Dorothy was her name) points out that with as many poles as I carry I should be able to find something that works and, sure enough, I had some short poles that made fine legs. Another artist (we call him Scarecrow) had the same type of tent that I have and he too had some short poles, …you could say…you could say… I had legs all along! So anyhow, that will teach me to take time off between festivals...or to no longer use checklists!

Following are some helpful checklists. I am just going to jot down what I take so eventually you will need to make your own checklists.

Checklists

Display essentials
- ✓ Tent, including all poles (like legs), awnings, walls
- ✓ Display walls or grids and small stuff display shelves and all poles and hardware to secure them and tie them to each other
- ✓ Weights for tent
- ✓ Chair and desk or small table for writing up sales
- ✓ Tarps or extra walls for rain cover and a couple of towels
- ✓ Tools: at minimum, hammer, screw driver, pliers, bungee cords, zip plastic ties, trash bags, spring clamps, duct tape, scissors, box knife, velcro
- ✓ Cover for extra stock and drapes for tables

- ✓ Art work
- ✓ Hardware to hang artwork, anything else needed to support artwork
- ✓ Framing supplies or repair supplies for your type of artwork (touch ups)
- ✓ All purpose cleaner and rags or paper towels
- ✓ Guest book
- ✓ Banner (optional)
- ✓ Floor covering, lights (both optional)

Office (traveling office) essentials

- ✓ Receipt book
- ✓ Pens and calculators
- ✓ Credit card processing and/or cell phone; extra credit card sales slips
- ✓ Cash box or fanny bag or purse
- ✓ Bags of various sizes for purchased work (so tacky not to bag your sales)
- ✓ Padding for picky and traveling customers
- ✓ Stapler, tape, rubber bands, clips, clamps
- ✓ Camera and cell phone
- ✓ Change, bills of various denominations, ones if you have smaller works
- ✓ Promotional materials such as business cards, postcards, calendars
- ✓ Trash bags
- ✓ Paper towels or rags

Just before a show...

- ✓ Check weather to take appropriate clothing and gear such as extra tarps or weights
- ✓ Check vehicle, especially tires, and top off fluids
- ✓ Send announcements or emails to customers
- ✓ Check or make reservations for shelter (really should be made long before)
- ✓ Get directions
- ✓ Repair or replace any equipment that needs it (I make a list during the shows)
- ✓ Load up and rest up
- ✓ Read festival packet one more time

After the show...

- ✓ Do accounting for show
- ✓ File sales and expense receipts
- ✓ Send thank you cards to customers with calendar of remaining shows
- ✓ Make notes on show (repeat, bad weather, horrible setup, etc.)
- ✓ Rest

Display Suggestions and Booth Layouts

I have already given suggestions and ideas for booth layouts and, given the vast diversity of art categories, it is an impossible task to cover the many possibilities for displaying artwork and laying out an attractive booth. Following are some basic observations on typical traffic flow, general display guidelines and other relevant points. Exceptions are many and duly noted.

Traffic Flow

Customers "travel" generally to their right, just like when they drive and glance well ahead of their path and at an angle, not directly aside. This is why customers passing directly in front of your booth appear to be looking directly ahead; your booth is not invisible, they simply are "done" scanning it by the time they get to walking in front of it.

- If given a wide lane, they will prefer to stay to the right and see those booths first, then make a u-turn, come back down the same lane and again view the booths on their right.
- If given a narrower lane, they still seem to view mostly to their right, although they will scan both sides of the aisle and cross over "against traffic" when they see something that catches their attention on either side.

Traffic Flow and Customer View Points

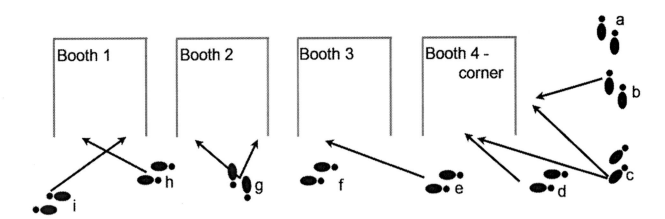

Taking the diagram above as reference, notice the following:

- *Customer a* is talking on the cell phone looking at absolutely nothing, maybe scanning for the bathroom or the kid's area.
- When approaching booths, **customer b** will glance toward their right. Notice that **Booth 4**, a corner booth, has many more points of view than in-line booths (**Booths 1-3**). This is why we pay more for corner booths.
- At the corner point, **customer c**'s glance is scanning much of **Booth 4**, and **customer d** is still savoring that same tasty corner **Booth 4**.

- Now notice that *customer e* is still technically in front of **Booth 4** but already looking ahead at **Booth 3**.
- *Customer f* is in the "dead zone", too awkward to glance sideways at **Booth 3**, still not quite up to **Booth 2**, easily distracted at this time and likely to pick up cell phone and engage in conversation with their long lost high-school sweetheart.
- *Customer g* has stopped, not a very common occurrence, and is viewing **Booth 2** directly. This just doesn't happen all that much because *customer g* will get repeatedly bumped by baby-strollers, however this is the way many artists set up their booths, to be viewed ideally from a point straight ahead.
- Finally, and to reiterate the last point, notice that *customers h and i* are glancing at the side walls (not the back wall) of **Booth 1**, the most viewed walls as people walk by from either direction.

Booth Layouts

Good booth layouts need to take into account traffic flow and viewing area of the customer. Following are some suggestions that will work in different circumstances. I can't stress enough that the booth display and layout must remain flexible enough to accommodate diverse circumstances. I have seen artists that neglected to expand their display when their neighbors did not show up and the promoter gave them the go-ahead. Corners are to be approached differently from in-line booths; double booths allow for a much more relaxed gallery-like setup. A smaller festival with sparse crowds will require less attention-getting tricks than in a larger festival where crowds seem like a flowing flock of hypnotized sheep.

The following suggestions should be a starting point to be customized to your needs.

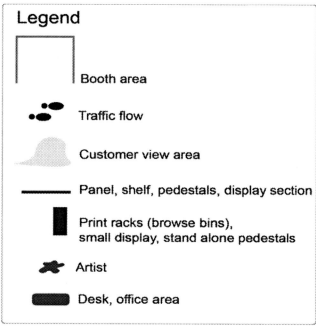

Basic 10x10 setups

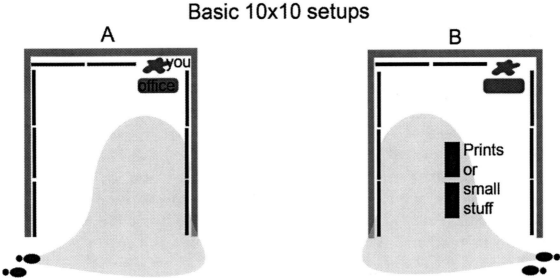

Shaded areas are customer view points

Above are basic 10'x10' setups, with no room in the back, an in-line booth, and a minimum of panel variety, print racks or smaller item displayed in the center of the booth. Setup B allows for traffic flow inside the booth around the center display arrangement. Short, easy, sweet and to the point. Notice the (shaded) typical viewing area of a customer passing by.

Below are two alternative setups that allow for hiding stock inside the booth and expand the customer viewing area due to the angled panels which catch the attention of the passing customer by facing them as they glance at your booth, as in Setup C.
Setup D should only be used when you positively know the direction of the traffic flow, with angled wall facing the main flow.

Alternate 10x10 setups

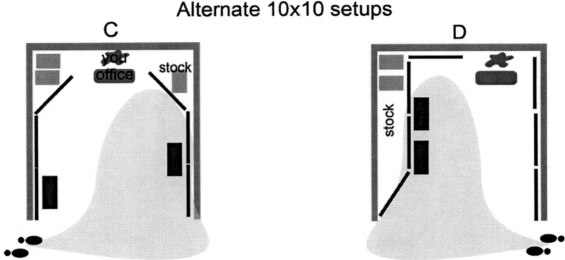

Shaded areas are customer view points

Expanded 10x10 setups

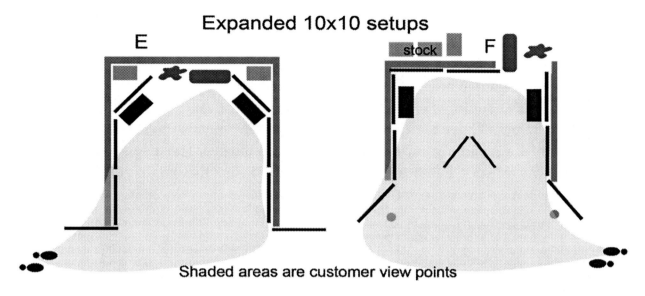

Shaded areas are customer view points

Expanded 10'x10' setups (when allowed by the festival) are ideal for attracting a maximum of viewing area from passing customers. Angled walls, walls placed outside the display area and inside "gallery" smaller walls or display stands all serve to attract the glance of the customer and guide their browsing eyes inside the booth. The more intriguing the display, as in Setup F, the more the customer will want to see around that center angled display and walk around the little gallery. Free-standing walls are angled to attract in, not to push out.

Finally, corner setups are ideal for attracting customers coming from two directions. Leaving the corner walls open should encourage customers to "cut through" your booth and thus view the entire display inside your booth. In addition, artwork can be display on both sides of the free standing walls, thus doubling your display space.

Corner 10x10 setups

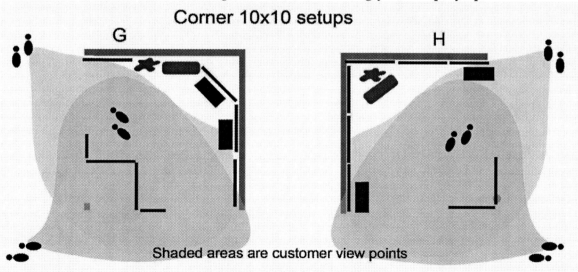

Shaded areas are customer view points

Three basic display tips

Much of displaying successfully is really common sense and very personal to the individual artist. Just when I become firmly convinced that I know what a "good" display looks like, I see an alternative I simply had not thought of, or a slight variation that makes a huge difference.

First and foremost, when looking at your booth critically, you should see mostly artwork. Sometimes I have set up my booth so that I saw mostly the sides of my display bins, edges of walls and not enough artwork to catch the eye. The display should take a back seat to the artwork. Following are three very basic tips that might guide you before you come up with your own creative display solutions.

Space work evenly.

On the walls or free standing on the floor, leave room between works, more between unrelated works. Related works or pairs can be closer together to suggest a multiple item sale. If unrelated works are too close together, there isn't enough transition space between the works to allow proper "savoring". Crowded displays are confusing.

Most of the work should be at eye level, with lower works "standing-by" to be raised once the higher works are sold. In the case of free-standing artwork, works closer to the front of the booth should be most prominent although not occlude the entire back display.

Lure customers inside.

Don't let customers glance at your booth and see everything there is to see. More sales are made when you can lure the customer inside your booth to browse for a longer period of time. This is easily done by guiding them in with print racks, smaller displays toward the back, a great show-stopper on the back wall, or an "aisle" guiding them toward that print rack in the back as in the photo above.

Take advantage of corners and extra space.

Extra viewing area is wasted if you close off customer traffic, wall a corner, or ignore the rare opportunity of expanding your display space. Be ready for these fortunate happenings and maximize your sales by expanding tastefully while maintaining a cohesive booth display.

When receiving news that your neighbor will not show, be sure to talk to the booth that will share the gained space. Many times a cooperative display arrangement is best, as this maximizes sales for both artists. Otherwise, just grab half, and only half, the space and let your new neighbor do the same.

Corners are worth more for a reason, there is more display space, more viewing space, more traffic potential and more inside the booth traffic flow.

Corner display above allows more traffic through the booth. Notice how much artwork can be seen just by glancing toward the booth. Larger works are inside to attract customers in. With the open air display, if it rains I'm in big trouble!

Below is a joyous occasion in which my neighbor failed to make the show. Well, joyous for me. I set myself in the back corner, put up some extra walls in front and expanded my entry way and display space by about five feet while gaining free corner exposure.

Appendix D: Suggested Readings and Reference Resources

Becoming a Successful Artist: 21 Inspiring Tales…,1st Ed,Lehrman,1992, North Light Books, Cincinnati OH
Keeping the Books: Basic Recordkeeping and Accounting for the Small Business,2nd Ed, Pinson/Jinnett,1989, Upstart/Dearborn, Dover NH, "Business, Accounting"
Living by Your Brush Alone: A step by step approach…,1st Ed,Piersol,1989,North Light Books, Cincinnati OH, "Business, Art"
Making a Living as an Artist,1st Ed, Art Calendar Eds,1995,Lyons Press, New York NY USA, "Business, Art"
Photographing Your Artwork: A Step by Step Guide…,1st Ed,Hart,1987,North Light Books, Cincinnati OH, "Business, Art"
The Business of Art,3rd Ed,Caplin,1998,Prentice Hall, New York NY , "Business, Art"
The Business of Being an Artist, 1st Ed, Grant, 1996, Allworth Press, New York NY, "Business, Art"
The Fine Artist's Guide to Showing and Selling Your Work,1st Ed,Davis,1989,North Light Books, Cincinnati OH, "Business, Art"
The Visual Artist's Business and Legal Guide, 1st Ed, Victoroff, 1995, Prentice Hall, Englewood Cliffs NJ, "Business, Art"
Running a One-Person Business,1st Ed, Whitmyer et al, 1989, Ten Speed Press, Berkeley CA, "Business, General"
The Home Office and Small Business Answer Book,1st Ed, Attard, 1993, Henry Holt & Co, New York NY USA, "Business, General"
Home Book of Picture Framing: Professional secrets…,1st Ed, Oberrecht, 1988, Stackpole Books, "Harrisburg, PA USA", Display & Presentation
Picture Framing & Wall Display,1st Ed, Sunset Eds, Lane: Sunset Books, Menlo Park CA, Display & Presentation
Business and Legal Forms for Fine Artists,3rd Ed, Crawford,1999, Allworth Press, New York NY, "Legal, Art"
Legal Guide for the Visual Artist,6th Ed, Crawford, 2001, Allworth Press, New York NY, "Legal, Art"
Patents, Copyrights & Trademarks,1st Ed, Foster/Shook, 1989, Wiley & Sons, New York NY ,"Legal, Art"
Art Marketing 101: A Handbook for the Fine Artist,1st Ed, Smith, 2002, North Light Books, Cincinnati OH, Marketing & Promotion
Do It Yourself Direct Marketing: Secrets for Small Businesses,1st Ed, Bacon, 1992 ,John Wiley & Sons, New York NY, Marketing & Promotion
Getting Exposure: The Artist's Guide to Exhibiting the Work,1st Ed, Art Calendar Eds, 1995, Lyons Press, New York NY, Marketing & Promotion
The Photographer's Guide to Marketing & Self Promotion,1st Ed, Piscopo, 1987, Writer's Digest Books, Cincinnati OH, Marketing & Promotion
The Art of Selling Art: Between Production and Livelihood,2nd Ed, Ritchie, 1991, Perfect Press, Seattle WA USA "Sales, Art"
Sun Tzu Strategies for Selling,1st Ed, Michaelson, 2004, McGraw-Hill, New York NY, "Sales, General"
Zig Ziglar Selling 101,1st Ed, Ziglar, 2003, "Thomas Nelson, Inc", Nashville TN USA, "Sales, General"
Zig Ziglar's Secrets of Closing the Sale,1st Ed, Ziglar, 1985,Berkeley Books, New York NY USA, "Sales, General"

Meet the Artist/Author: Maria Arango

Hello fellow artists and visitors, and thank you for taking the time to read my book.

I was born in Havana, Cuba, in 1959. A one-and-a-half year old child cannot remember what it was like to have our homes and businesses taken over by the regime of Fidel Castro. In any case, we took a long ship-ride to Spain right about when Cuba turned communist. I was raised in Barcelona, Spain until 1974. In a sense, I still think of Spain as home, a home that will be undoubtedly changed if and when I return to visit. There again, hard for me to remember the political turmoil of Franco's impending death and the threat of socialism. Time for another long trip! This time my family and I moved to Las Vegas, Nevada, USA, where we were reunited with my father's family, also previously exiled from Cuba. I have loved art all my life and earned a few stripes at the University of Nevada, Las Vegas, although I basically learned the art of the woodcut on my own. I am now making a living as a full-time artist.

ARTISTIC BIOGRAPHY

Maria Arango earned BS and MS degrees in Psychology and Exercise Physiology from the University of Nevada, Las Vegas before taking a variety of fine and graphic art classes. Printmaking changed her life forever and she spent a few years of honing her skills and amassing a body of work, primarily in woodcut prints.

Maria has been exhibited in several galleries in the Las Vegas area as well as the Las Vegas Art Museum, and has quickly expanded to regional, national and international shows. Maria's accomplishments include Best of Show/Category Awards in the Art Fest of Henderson, Boulder City Art in the Park and Tempe Festival of the Arts and purchase awards including works in the Springfield Museum of Art. Most recently works have been accepted in the prestigious Brand Gallery and Art Center in California in their annual juried works on paper exhibition, the Parkside National Small Print Exhibition and Hunterdon Museum of Art. In 2005 she was honored with the Nevada Governor's Visual Arts Commission Award. She has been represented by various galleries through the Southwest and her works reside in permanent collections in the US and Worldwide. Art Festivals throughout the West continue to be Maria's favorite venue for meeting her fast growing audience of dedicated collectors.

A lifetime goal of completing 1000 Woodcuts progresses heartily as do many various other projects in printmaking, writing, and life in general.

For much more on life projects and art, please visit the website
www.1000woodcuts.com
And the dedicated website for this book
www.artfestivalguide.com

259989BV00001B/31/A

9 781430 319764